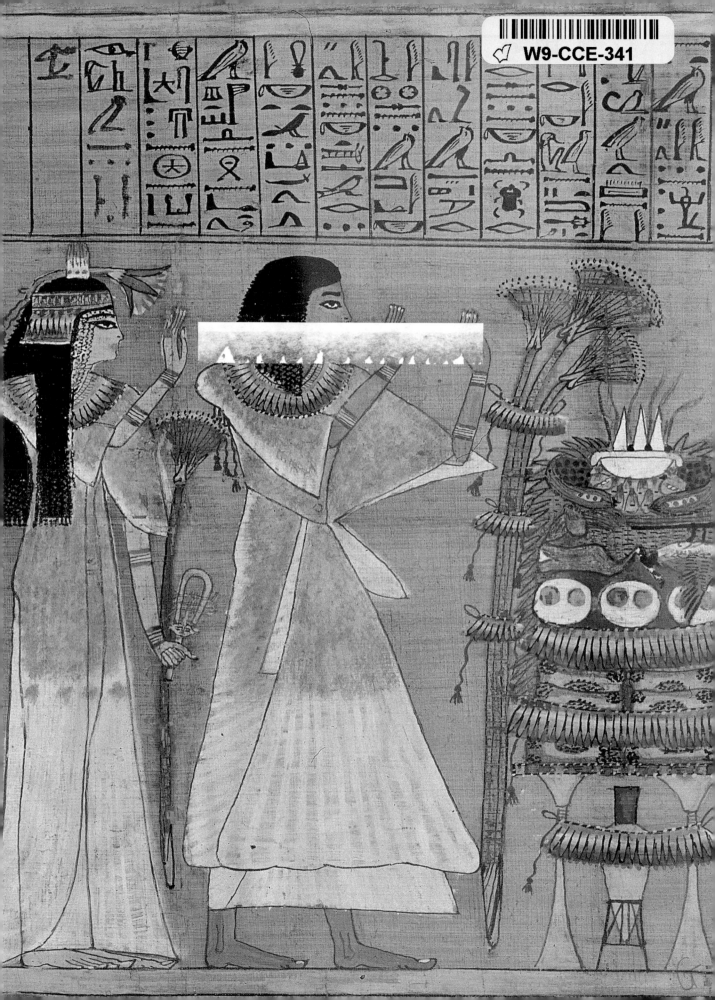

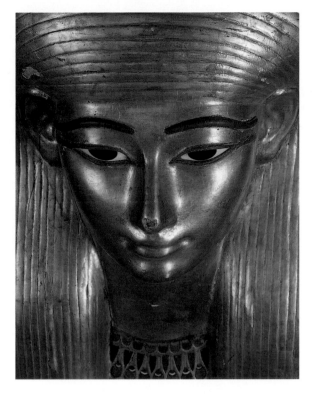

THE CIVILIZATION OF
ANCIENT
EGYPT

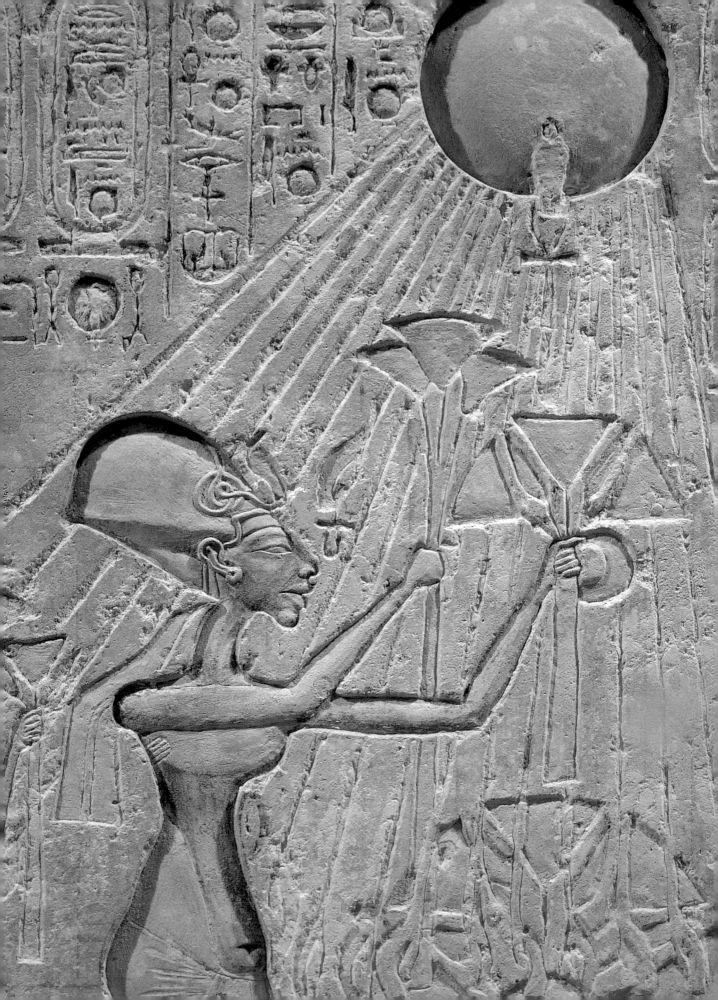

THE CIVILIZATION OF
ANCIENT
EGYPT

PAUL JOHNSON

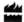

HarperCollins*Publishers*

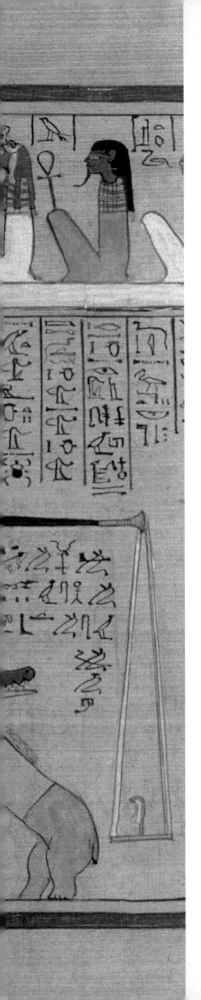

CONTENTS

Mediterranean Sea

Rosetta

Alexandria

Sais

Mendes

Tanis

Bitter Lakes

Heliopolis

Giza
Abusir
Sakkara
Dahshur
Memphis

Lake Moeris

Meidum

Fayum

SINAI

Beni Hasan

Hermopolis

Akhetaten (Amarna)

Asyut

UPPER EGYPT

Nile River

RED SEA

Abydos

Dendera

Deir el-Bahari

Karnak

Valley of the Kings

Thebes

Luxor

Hierakonpolis

Esna

Edfu

0 25 50

Miles

EGYPT AND
THE NILE DELTA

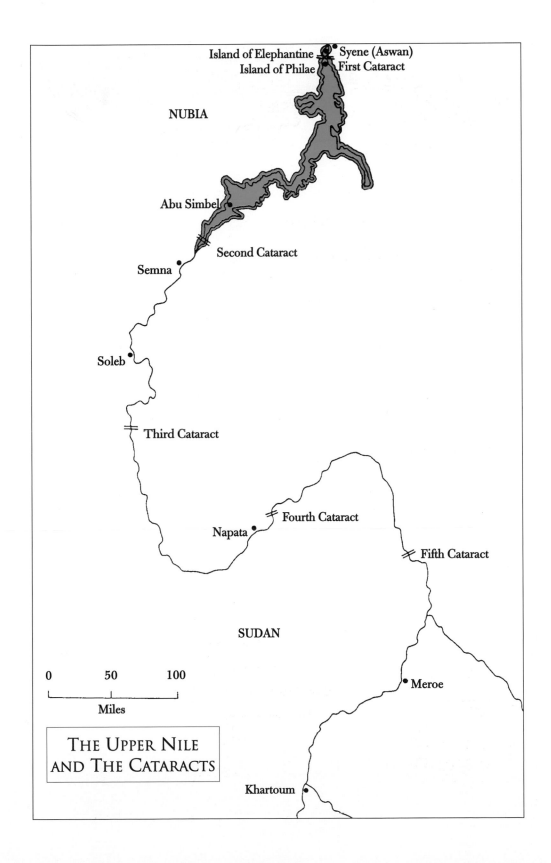

Island of Elephantine — ● Syene (Aswan)
Island of Philae — ✕ First Cataract

NUBIA

Abu Simbel ●

Second Cataract

Semna ●

Soleb ●

✕ Third Cataract

Fourth Cataract
Napata ●

✕ Fifth Cataract

SUDAN

0 50 100

Miles

THE UPPER NILE
AND THE CATARACTS

● Meroe

Khartoum ●

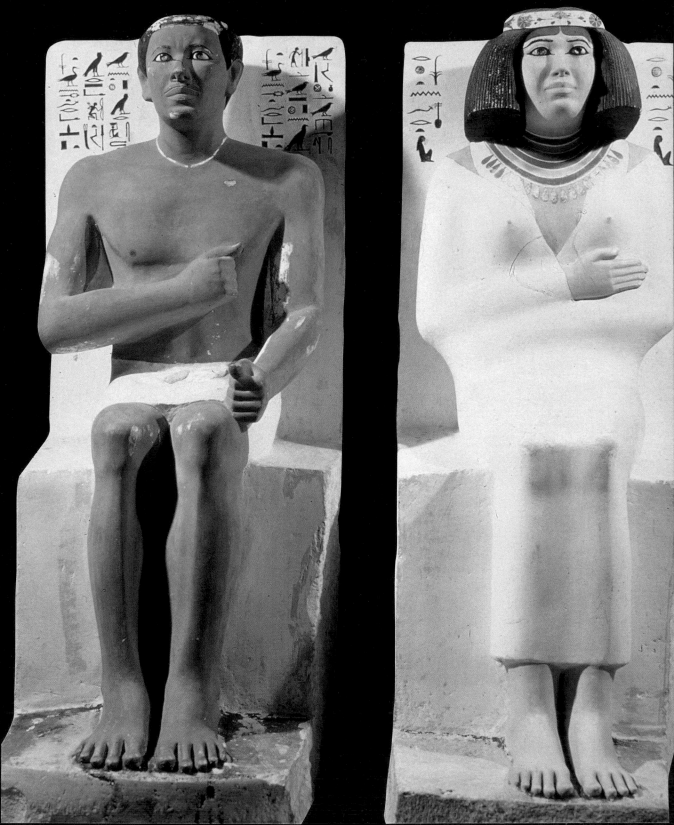

THE TAKE-OFF OF EGYPTIAN CULTURE

A t one time scholars believed that the civilization of ancient Egypt was the first in the history of the world and the progenitor of all others. We now know this to be untrue, but the ancient Egyptians retain one unique distinction: they were the first people on earth to create a nation-state. This state, embodying the spiritual beliefs and aspirations of the Egyptian race, was in all its major manifestations a theocracy. It served as the framework of a culture of extraordinary strength, assurance and durability which lasted for 3,000 years and which retained almost to the end its own unmistakable purity of style. In the Egypt of antiquity, State, religion and culture formed an indisputable unity. They rose together; they fell together, and they must be studied together.

Previous page: *These painted limestone statues from Meidum are of Rahotep and his wife Nofret. Rahotep's eyes are inlaid with quartz and rock crystal, while Nofret is wearing a diadem of silver – a metal rare in the Old Kingdom. Fourth Dynasty.*

Moreover, there was a fourth essential element in this creative unity: the land. It is impossible to conceive of the civilization of ancient Egypt except in its peculiar geographical setting. It was nurtured and continued to be dominated right to the end by the physical facts of its setting: the rhythm of the Nile and its productive valley, and the circumscription of the desert. They gave the Egyptian people and their culture certain fundamental characteristics: stability, permanence and isolation. The Egyptians, indeed, were self-consciously aware of their national immobility and separateness. They assumed they had always inhabited the Nile valley as a distinctive race; and that the valley, with its enclosing deserts, had so existed since the Creation.

In fact neither assumption was correct: even Egypt and its people were subject to the slow transformations of time. At one time all Egypt, like most of Africa, was inhabitable. In the later part of the Middle Paleolithic Period, about 10,000 BC, there was an accelerating decline in local rainfall. The pastures and savannahs of the Egyptian plains became desert. Even as late as about 2350 BC, average rainfall in Egypt was much higher than today – up to six inches a year – but it was decreasing and continued to do so throughout historic times. Much of the country, therefore, became increasingly inhospitable to animals and men. The hippos, the gazelles, the buffaloes and ostriches gradually became fewer. Wild asses, wild cattle, ostriches and lions continued to be hunted well into the time of the pharaohs; Amenophis III boasted that in the first ten years of his reign (*c.*1413–1403 BC) he had killed 102 lions with his own hand; and

Below: *A fowling scene from the tomb of Nebamun, Thebes.*

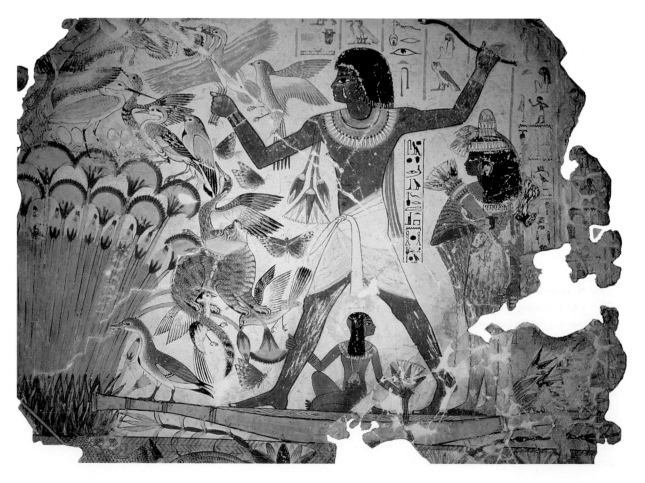

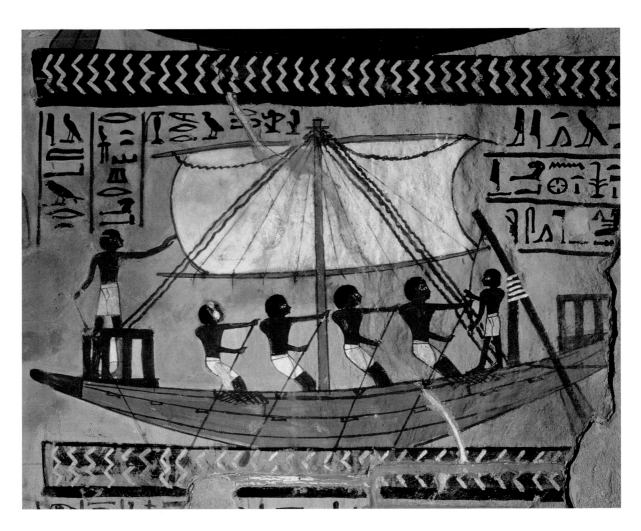

200 years later, Ramesses III had carved onto the stone pylon of his temple at Medinet Habu the splendid panorama of a royal hunt for wild asses and bulls. There were, in fact, many hippos in the Nile delta even in Roman times. But, in general, the encroachment of the desert was inexorable, driving the fauna of the plains ever further to the south, and mankind to the desert oases and, above all, to the Nile valley.

The Nile seems to have begun to assume its present course about 10,000 years ago. At the time when the plains were drying up, the rainfall of the African forests and the melting snows of Ethiopia were creating its annual flood and transforming the great river into a geographical constructor. It drove its way through the granite rocks to the south of the First Cataract, through the sandstone stretching almost as far north as ancient Thebes, and then through the limestone plateau to the Mediterranean Sea. At the sea itself, it piled up the alluvial delta, and in the series of terraces and valley bottom it carved out of the rocks, spread with the alluvial soil carried down with the flood, it created a continuous oasis 750 miles long from the First Cataract to the sea.

As the savannah turned into desert, palaeolithic man began to descend to the Nile terraces and then to the valley bottom. Of course the valley was initially marsh. For many millennia, the tract from the First Cataract to Thebes was a lake; and much of the delta remained marsh throughout our period. But potentially this was rich agricultural

Above: A river-boat steered by a stern-oar, from a fresco in the tomb of Sennufer at Thebes. Some Egyptian boats were built with the unsatisfactory wood of the sycamore.

land – 13,300 square miles in the valley itself, and a further 14,500 square miles in the delta. The Nile supplied not merely reliable water but equally reliable alluvial deposits and fertilization. By 5000 BC the palaeolithic hunters of the plains had transformed themselves into the neolithic farmers and herdsmen of the valley and delta, and the agricultural economics of historic Egypt had taken shape. What remained to be done was to complete the conquest of the marshland and to begin the harnessing of the river, by dyke, barrier, basin and canal – and therein lies the story of the Egyptian State, and the culture it begot.

The Nile alluvium makes the soil black. From the very earliest times, the Egyptians divided their country into *keme*, the black – that is, the cultivable, inhabitable part – and *deshret*, the red or desert. Such dualism seems to have been part of the Egyptian character. The country itself was seen as divided into two distinct halves: the Valley or Upper Egypt, and the Delta, or Lower Egypt; and the Delta in turn into a western, or Libyan, and an eastern, or Asian, half. The physical configuration of Egypt was completed by its external barriers: the cataracts cut if off to the south, the Libyan desert to the west, the Eastern Desert, the Red Sea and the Sinai Desert to the east, and the Delta, which with its marshes and myriad, ever-shifting channels, constituted as much an obstacle as an exit, to the north.

Thus isolated from the world beyond, Egypt was dominated by the seasonal rhythms of its river. Not only the river but the inundation itself, termed *Hapy*, was worshipped as divine. Hapy was bearded, with water-plants sprouting from his head, and with female breasts, symbolizing fertility, hanging from his body. The Egyptians believed that he drew his power, that is the waters of the flood, from underground basins around the First Cataract and long after this explanation had been shown to be false they worshipped the gods of this region fervently. And so they might, for the Nile is perhaps the most beneficent and dependable great river on earth. The conjunction of its two sources, the White and the Blue Nile, and its long journey through the plateau, give the annual flood the character of a reliable annual system rather than an unpredictable catastrophe.

Egyptian civilization was growing up at roughly the same time as that of Mesopotamia, another alluvial valley-plain. But whereas the Tigris and Euphrates brought savage and irregular destruction, as well as life, and so imparted to the cultural philosophy of the people an element of insecurity and pessimism, the Nile was not a fury but a friend. Of course its performance varied, as it still does. Between low water and flood, the volume of water in the Blue Nile, for instance, rises from 7,000 cubic feet per second to over 350,000 on average; and within this average there is considerable variation. At Elephantine, near the First Cataract, and at Old Cairo, where the Valley effectively joins the Delta, the ancient Egyptians set up stone markers, or Nilometers, by the riverside, to record and to some extent predict the river's behaviour. The evidence of these venerable devices shows that a rise of twenty-one feet was dangerously low, twenty-eight or more would bring damaging floods, and some twenty-five to six feet was desirable, or 'normal'. Until the recent construction of high dams, the river behaved much the same as it did in antiquity. It began to rise between Aswan and the Delta in June, when green water appeared. The river rose sharply in August and became reddish-coloured. The rising continued until mid-September and then, after a three-week pause, rose again in October; thereafter it fell slowly throughout the winter and spring, until the lowest point was again reached the following May.

Opposite page: Pool and Nilometer at Dendera, Egypt.

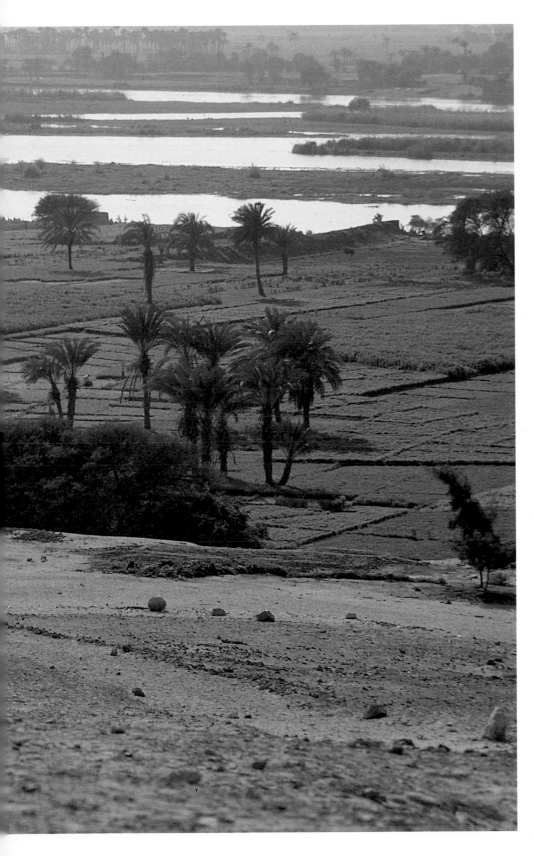

Left: *The Nile landscape, provider of transport and fertility for agriculture.*

This slow, deliberative and predictable annual river-cycle was and is accompanied by an exceptionally regular climate. The skies in Egypt are sunny and cloudless. Rainfall in Upper Egypt is virtually nil; it is about two inches a year in the Cairo area, and about six, or a little more, in the Delta, these rains falling in winter. The combination of reliable sunshine and adequate water (plus natural fertilizer) makes for highly successful crops. Herodotus, writing in the fifth century BC, asserted that the Egyptian peasant had an easy time of it. This was not true: at certain times of the year, especially after the flood water subsided, he worked extremely hard. It was when the waters fell that the agricultural year began, and planting had to be rapid while the earth was still soft; at the same time all the multitude of ditches and canals had to be cleared out and repaired. The crops ripened under the winter sun and were harvested in the spring while it was still cool; the process had to be completed by the end of May, when the waters rose again. There were thus three seasons in the agricultural year: flood, sowing and harvest; and it was fortunate for the Egyptians that the flood, when there was least to be done, coincided with the hottest weather.

The river provided not only fertility but transport. The inhabited land of the Valley varied from about five to fifteen miles in width. This was where all the basic crops, emmer wheat, barley and flax, were grown. The Delta, chiefly used for pasture, was bisected by innumerable channels, running from north to south. Every part of Egypt where men lived and worked was within a few miles of river transport. Thus the wheel came late to Egypt. We find it on an early depiction of a siege-ladder, but not on carts. Wheels had been in use in Mesopotamia for a thousand years before chariots were common in Egypt. All the same, thanks to the river, Egypt had the best internal communications of any country of antiquity. From the moment when they descended from the Nile terraces the Egyptians built river-boats, using with considerable ingenuity the unsatisfactory wood of the sycamore, the only tree the country produced in any abundance. Boats steered by stern-oars could descend the river, travelling with the current, throughout the year, even at times of low water. Rafts and barges could and did travel down-river with colossal weights of stone aboard; and during the flood, in late summer and autumn, they could easily deliver their burdens to points several miles above the low-water mark. It was the river which made the logistics of Egypt's ponderous stone culture not only possible but comparatively cheap. And transport upstream too was cheap, for the prevailing wind in Egypt blows throughout the year from the north, another example of the beneficence of nature. Oars needed only to be used during the infrequent periods of total calm, for the Egyptians quickly developed the highly efficient triangular sails still in use today, which catch the slight but persistent north breezes. In Egyptian hieroglyphic script, the determinative 'go north' is a simple boat, and 'go south' a boat with a sail.

Hence, despite the desiccation of Egypt, the Nile made it one of the most desirable regions on earth for ancient man. Yet in prehistoric times, this enormous natural advantage was an inducement to improvement rather than lethargy. The Nile never failed, but it was sometimes sparing. The early Biblical story of Joseph and the seven lean years following the seven years of plenty, which refers to a date in the Second Intermediate Period itself, reflects a much more ancient Egyptian tradition of seven consecutive low Niles. The waywardness of the river was a spur to organization, and to the creation of a storage economy – the river itself making it possible to ship grain easily from one end of the country to the other. Even more important, the river was a

perennial spur to extending the area which was drained and irrigated. This too involved powers of organization and much hard labour.

What Herodotus does not seem to have noticed was that much of the cultivated area was not touched by the inundation. While the basic crops were covered by the river waters in season, and thus self-irrigating, garden produce on the higher land above the floodline had to be watered throughout the year. The water was brought direct from the river by means of that ingenious antique invention, still in use, the *shaduf* – a well-sweep with a counterpoise-weight – or it was captured in floodtime in a multitude of artificial basins, then channelled to the fields and gardens by an infinitely intricate series of ditches. These varied in width from an inch or two to many feet; they could be opened or closed throughout the growing season, and they had been constructed over many centuries, even millennia. Engineering and working this system, and keeping it in constant repair, involved perpetual toil, a point which did not escape that economic legislator, Moses. As he said to the Israelites, to induce them to migrate to Palestine, a reliable rainfall cut out much hard work. And they had seen with their own eyes that Egyptian peasants whose land lay above the floodline not only had to operate their individual irrigation systems but, like all agricultural workers, join in the compulsory *corvées* (a day's work of unpaid labour) which maintained and extended the communal canals and flood barriers.

Below: *A wall painting from the tomb of Nakht, scribe and priest under Tuthmosis V, depicting the grape harvest.*

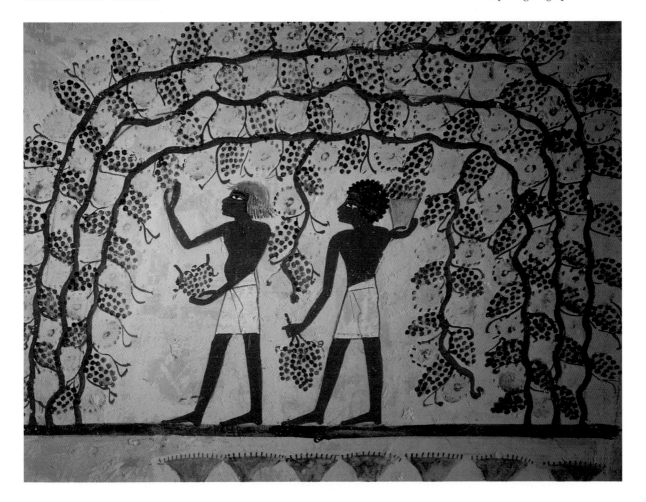

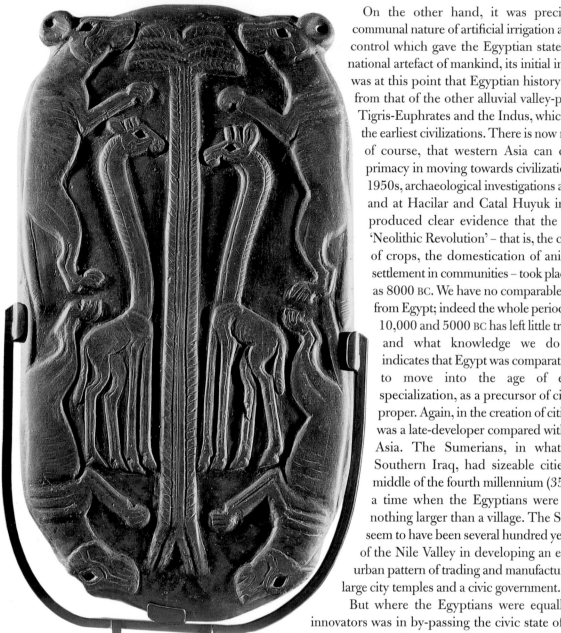

Above: *An early dynastic make-up palette with relief decorations of a palm tree, giraffes and dogs.*

On the other hand, it was precisely that communal nature of artificial irrigation and flood-control which gave the Egyptian state, the first national artefact of mankind, its initial impetus. It was at this point that Egyptian history diverged from that of the other alluvial valley-plains, the Tigris-Euphrates and the Indus, which cradled the earliest civilizations. There is now no doubt, of course, that western Asia can claim the primacy in moving towards civilization. In the 1950s, archaeological investigations at Jericho, and at Hacilar and Catal Huyuk in Turkey, produced clear evidence that the so-called 'Neolithic Revolution' – that is, the cultivation of crops, the domestication of animals and settlement in communities – took place as early as 8000 BC. We have no comparable evidence from Egypt; indeed the whole period between 10,000 and 5000 BC has left little trace there, and what knowledge we do possess indicates that Egypt was comparatively slow to move into the age of economic specialization, as a precursor of civilization proper. Again, in the creation of cities, Egypt was a late-developer compared with western Asia. The Sumerians, in what is now Southern Iraq, had sizeable cities by the middle of the fourth millennium (3500 BC) at a time when the Egyptians were living in nothing larger than a village. The Sumerians seem to have been several hundred years ahead of the Nile Valley in developing an essentially urban pattern of trading and manufacturing, with large city temples and a civic government.

But where the Egyptians were equally clearly innovators was in by-passing the civic state of political development, and in effect moving directly from the large village to the nation-state covering a wide area, and unified by a common culture and national economy rather than by a city boundary. This process of leap-frog allowed the Egyptians to achieve national unity around 3100 BC, when Mesopotamia was a collection of small city-units, and more than half a millennium before Sargon the Great created the first Asian state. And, in this unification process, it was the Nile, a centralizing factor by its mere physical existence but still more so by the patterns of communal effort it encouraged, which played the determining part.

It was in the Badarian period, the second half of the fifth millennium, and still more in the fourth millennium BC, divided almost equally, for purposes of archaeological convenience, into the Early Naqada and the Late Naqada periods* that the determining

characteristics of the Egyptian people emerged. Although sprung from the same stock as the nomads who still lived in the deserts, their descent into the Nile valley and delta had turned them into self-conscious farmers and sailors, whose life-pattern diverged from the desert-dwellers. This divergence was a matter of situation, not race: the nomads, and the people of Libya to the west and Nubia to the south, remained trapped at an earlier stage of development, while the Nile-dwellers progressed steadily by means of their exploitation of the river and its banks.

The first social organizations of the Nile valley were autonomous villages, each with an animal totem-god (very often cows or bulls). In time, during the fourth millennium, more important villages, or groups of villages, emerged as the *foci* of districts. These were the precursors of the later *nomes*, the administrative areas into which dynastic Egypt continued to be divided after unity had been secured. The local chieftains were ancestors of the future nomarchs, who could often trace their lineage of power as far back as the pharaohs themselves. The district totems became the emblems of the

Below: *Nakht and his family on a bird and fish hunting expedition in a swampy area from a wall painting from the tomb of Nakht, scribe and priest under Tuthmosis V, Thebes.*

Named after the village site in Upper Egypt where the first systematic predynastic excavations took place. An alternative system of classification for the predynastic cultures, also named after village sites, is Amratian (early), Gerzean (middle) and Semainean (late).

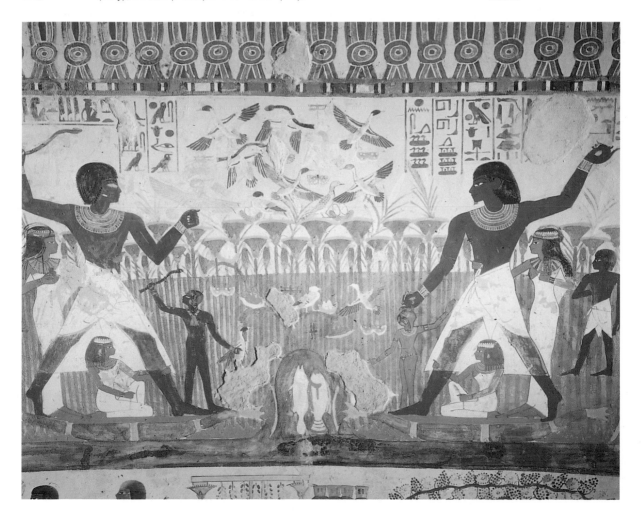

nomes, emblazoned on shields and standards, and gradually making their appearance on artefacts. These emblems constitute the original pantheon of the Egyptian gods. They also provide our earliest documentation of Egyptian history. From remote times the Nile dwellers had painted their eyes for both medicinal and aesthetic purposes, and the palettes on which they moistened the powder evolved into an important ceremonial art form. From the fourth millennium BC, more than a dozen of these outstanding votive palettes have survived, and they depict the emergence of ever-larger social units, represented by their emblems and accompanied by crude hieroglyphs. This village imperialism is seen at a fairly advanced stage in the Tjehnu Palette, in the Cairo Museum, where a coalition of nomarch-chieftains – the lions, the falcon and the scorpion – are depicted capturing fortified centres by destroying their walls with levers; the reverse of the palette shows the cattle taken as booty.

However, the consolidation of the Valley and Delta into larger units was not necessarily an aggressive process. The tradition of the regions, as reflected in later tomb-biographies of nomarchs, was that the highest honour was accorded to chieftains who steered their localities safely through periods of low Niles by efficient storage and distribution, and who expanded the fertile land by draining swamps and creating irrigation works. One of the earliest titles was 'Canal Digger'. The leadership-emphasis was on organizational ability and the capacity to inspire collective effort. Thus districts undoubtedly coalesced and expanded by a process of voluntary amalgamation, and it was only in the closing stages of the development in predynastic times that force seems to have been employed to group medium-sized units into two large ones, and eventually into a united country. In this process gods fought alongside men, in the sense that village and district totem-figures cannibalized subject deities and absorbed their power. These obscure struggles formed the basis of later myths and emerged in historic times to constitute the structure of Egypt's polytheology. The most important, because it underlay the Egyptian theory of life and death, was the murder and dismemberment of Osiris by his brother Seth, and the perpetual struggle waged against Seth by Osiris's son, Horus. Horus, the falcon-deity, came from the Delta-North, Seth, associated with deserts and storms, from the south. The identification of Horus with good and royalty, and Seth to some extent with evil, demons and foreigners, suggests that at some stage the Delta-North dominated the south, though during the crucial period of final unification, it was the south which absorbed the north.

Egypt's progress towards state-unity, and the evolution of its religious thought, not only proceeded simultaneously but interacted at every stage. Herodotus described the Egyptians as the most religious

people on earth, and he was writing of an age when the dynamism of the Egyptian faith had run down and the forms, rather than the substance, were in control. At an earlier period, and particularly during the second half of the fourth millennium BC, when the Egyptian theocracy was evolving, the intensity of faith was such as to exclude purely secular considerations altogether. It is not clear why this should have been so but one possibility is that the Egyptians were the first men to conceive of continuing life after death. They early observed that, in the Nile Valley, bodies buried on the edge of the desert were often almost indefinitely preserved from corruption. This physical fact may have first led them to conceive the notion of eternity, and so to stress the transcendent importance of religion in the brief span of human life on earth. Throughout the fourth millennium, they were burying their dead in ever more elaborate graves and tombs, and with an ever-increasing variety and richness of goods with which to reproduce a comfortable existence in eternity. The murdered and dismembered Osiris was reconstituted and revivified as a paradigm of human salvation. Then, too, as a matter of universal observation within both daily and annual cycles, there was the miracle of the sun and the Nile, the two inescapable features of the Egyptian scene. The sun rose without fail in the east and set in the west; in no other land was its motion so visibly reliable. In contrapuntal distinction to this daily birth and rebirth was the annual renewal of the river: 'Thou makest the Nile in the lower world', ran a hymn, 'and bringest it whither thou wilt, in order to sustain mankind, even as thou hast made them.' The conjunction of these two evidently miraculous and god-ordained processes made Egypt a rich country and its prosperity dependable; the preservation of bodies in the sand indicated that such felicity could be prolonged indefinitely. Hence the Egyptians inevitably concluded that the divine powers were beneficent, and the intensity of their religious emotions arose not from fear but from a profound sense of gratitude.

This is in a sense conjectural. But what is beyond argument is that every single aspect of Egyptian life, as it manifests itself by its survival, was enclosed in a pervasive religious context. The outstanding cultural achievement of the Naqada periods, that is virtually the whole of the fourth millennium BC, was a growing skill in the working of stone. These included not only soft stones like limestone, sandstone and alabaster, but basalt, granite, diorite, dolerite, schist, serpentine and breccia, all of which are found in abundance in Egypt. The Egyptians, having discovered eternity, associated it in their minds with their native hardstones, which seemed to last for ever, and so prepared bodies for burial with stone implements and equipment. Long before they built in stone, the Egyptians created splendid stone jars and vessels, hollowing them out and shaping them – often as fanciful animals – with infinite labour, using drills, which only towards the end of the millennium were equipped with copper bits. Most of these vessels, and all of the finest, were intended for religious purposes, not for earthly use.

Thus right at the very beginning of their cultural efflorescence the Egyptians manifested an unbending will to devote their creative skills to the gods. It is probably true to say that, from first to last, there was no such thing as secular high art in Egypt. Both the subject matter and the structure of art were derived from purely religious ideas. Of course at this point we must project ourselves forward into the dynastic age for evidence, but there is no ground for thinking there was ever a secular element in art even before Egyptian theology and myth had taken shape. The Egyptian craftsman did not perform for the human eye but the divine. His splendid vases were transferred direct from workshop to tomb and buried in eternal darkness. Later, the great

Opposite page: Falcon headdress from a statue of Horus, god of Hierakonpolis.

Above: *Details of the horoscope from the Zodiac tomb at Athribis.*

Opposite page: *An alabaster sphinx of Eighteenth to Nineteenth Dynasty age at Memphis, excavated by Sir Flinders Petrie.*

sculptures were usually walled up in stygian rooms to which human access was totally forbidden. These works were perfected to satisfy the gods and if they gave delight to human eyes it was coincidental.

Language, too, sprang in written form from the needs of the religious cult and the desire to communicate more effectively with the deities; hieroglyphs – 'priestly writing' as the name implies – formed the vernacular of the gods. The early votive palettes, with their primitive inscriptions, were messages to god not man; and it was the need to express myth and elaborate ritual which slowly gave the written language flexibility. The *Pyramid Texts* of the Old Kingdom are some of the first texts in Egyptian literature. Their purpose is wholly religious. In fact it would be hard to point to any Egyptian text of any period, however profane in appearance – annals, love poems, song, drama, legend – whose origins were not obviously rooted in a religious genre and which did not retain religious overtones until the very end of Egyptian civilization.

Equally, exact knowledge of any kind remained embedded in the religious mould for which it was originally fashioned. The earliest Egyptian maps, though dealing with the Nile area, are in fact guides to the geography of the underworld and designed to help the dead on their journey to eternity. History, in so far as it was written at all, was a dogmatic assertion of the workings-out of divine purposes through a sacred community (the Egyptian nation) personified by a god-king; by comparison, the Jewish Old Testament would have appeared to Egyptians as replete with secular irrelevancies. Philosophy was wholly committed to theological concerns. Medicine had a religious basis, and its practice was associated closely with the priesthood – as was inevitable since illness and death were judged to be messages from the gods. The diagnosis was magical and prescriptions were applied with magical forms of words. Astrology and chronology seem to have been prompted by the need to compile exact timetables for religious rites, and the original Egyptian calendar, which provides the basis for the one we still use, was set down to reconcile the fixtures and variables in the ecclesiastical year. Observational astronomy, which kept the calendar up to date, was, like medicine, a priestly profession. Egyptian physics merely reflected theological assumptions: the earth arose from out of the primeval ocean. The vault of heaven was above, resting on four pillars, with a counter-heaven below. The controlling influences of this cosmos were personified in various gods and goddesses who kept the structure erect and gave it dynamism by their tensions and quarrels. So long as they were left alone by the outside world to work out their own destinies, the Egyptians never saw any reason to modify this cosmology or, indeed, to secularize any part of their encyclopaedia.

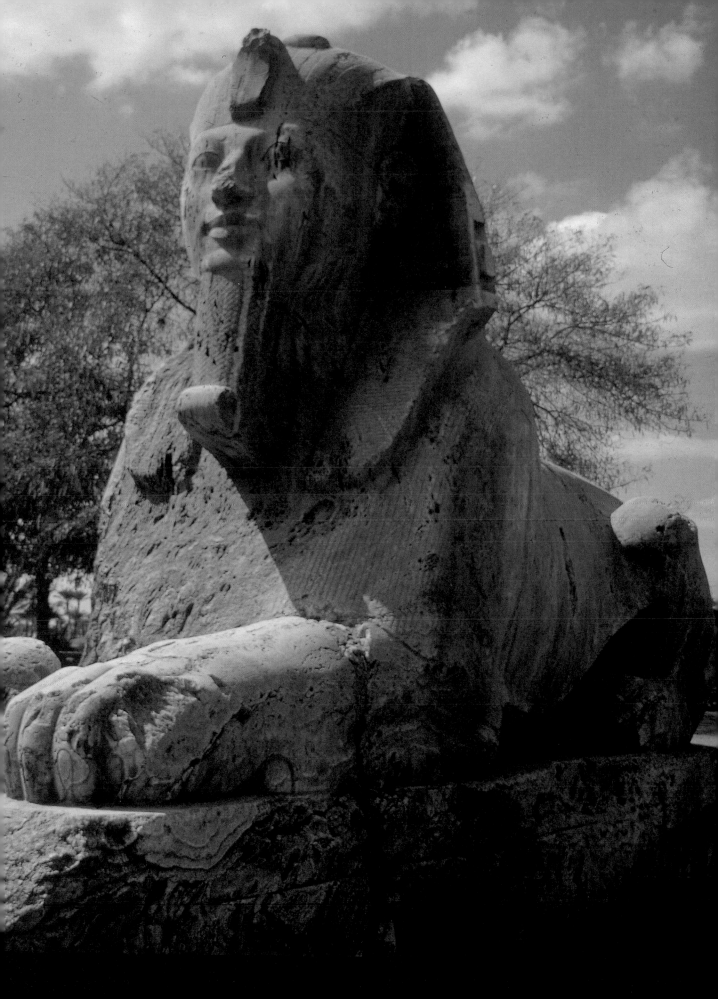

On the other hand, it should not be supposed that religion was a retarding factor in the evolution of Egyptian civilization. On the contrary, it was and remained the chief cultural impulse. The emergence of Egypt as a civilized power at the end of the fourth millennium BC – its 'take-off' as a culture embodied in a State and an economy – was in all essentials a religious process and achievement; and, as we shall see, it was precisely the decline of religious vitality which led to the collapse of Egyptian culture in the first centuries of the Christian era. As in other societies, in its origin the religious impulse in Egypt sprang from the consciousness of 'power', expressing itself in myriad ways in creatures and natural phenomena, and needing to be appeased by pious cult. The concepts of gods evolved alongside village organizations, these gods being multi-purpose originally and only gradually developing the specialized functions implied by their emblems as society became itself more complex and specialized, and the size of the self-sustaining social unit grew. So gods developed personalities and personal histories, all of which were woven by myths into an interlocking series of explanations of what the world was about. The emergence of a unified pantheon of gods, each originally from a local habitation and each still locally powerful, but now working together in a coherent divine scheme of things, corresponded to and inspired a growing human consciousness of the economic and social unity of the Nile valley and its delta. All communities which have to build interdependent dykes and canals develop a strong communal drive. In the Nile area, where the gods seemed to work so openly and obviously, this communal sense received from early times a special divine sanction. Canals, dykes, irrigation channels and barriers were divine, as were the Nile itself and its flood; constructing and maintaining them was an act of conspicuous piety in the spirit of the divine scheme; those who managed such works were divinely selected and their leadership sanctified; even the humble labourer was playing a meritorious part in the celestial plan.

So much is obvious. What is less clear is the manner in which Egyptian theology, and the basic cosmogony on which it rested, overshadowed the creation of the Egyptian State. Certainly the cosmogony was modified as the social unit grew. As gods emerged from mere centres of 'power' into definite personalities, they were anthropomorphized. They were active creatures, usually making things (although sometimes destroying also). Some were potters, others stonemasons or metalworkers; others were procreators. Ancient gods created other gods. One of the first centres

Below: The town of Memphis from a detail of the mosaic floor in the church of St John in Khirbet El-Samra, Jordan.

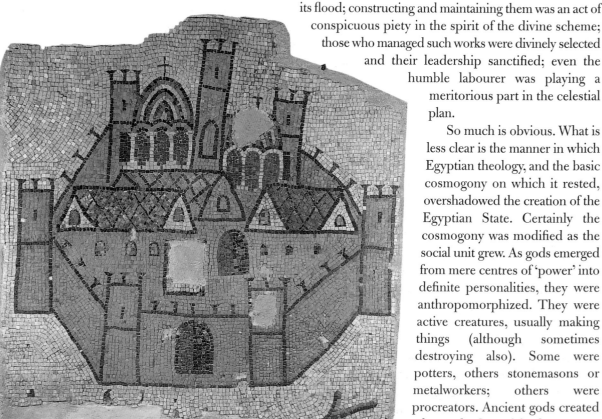

Archaeological finds are much rarer in the Delta, since the Nile has destroyed th... evidence or buried it under alluvium. But it is possible to conclude that Lower Egyp... too, achieved unity, based around a capital at Buto. Then, towards the end of the four... millennium, we find in the Delta the sudden appearance of objects from the La... Naqada culture of Upper Egypt, on a scale to suggest a conquest or a decisi... penetration. This was the moment of unity. And if there was, indeed, a foreign rulir... class of Horus-worshippers in the Delta, it was at this point that they were ousted ar... their cultural apparatus taken over by the rulers from the south.

Secondly, we have some literary evidence, inarticulate though it may be. Tomb 10... at Hierakonpolis contains a frieze devoted to the subject of leadership. There is no tra... of foreign influence here, but evidence that a State bureaucracy, under a dominant kin... was growing up in the south in the Late Naqada period. This king wore the bulbou... pointed White Crown of the south. A jar in the Ashmolean Museum, Oxford, datir... from about 3500 BC, shows the smaller Red Crown of the north, or Lower Egypt. Th... collision between these two evolving States first seems to have occurred under... southern king called Scorpio. He features on a fragment of a ceremonial mace-hea... also in the Ashmolean, which shows him wearing the white crown, and conquerir... and hanging various people in the border regions and the Delta itself – but he does n... yet claim the red crown. This final act was evidently the work of a southern king call... Narmer, who is the hero of the finest and most important of all the votive palettes, four... in 1897 at Hierakonpolis – where according to tradition the kings of Egypt came fro... – and now in the Cairo Museum. The Narmer Palette shows the king not on... completing the conquest but wearing, separately, the red crown of Lower Egypt ar... the white crown of the south. Pictograms, ideograms and fragmentary phonetic sig... tell the story. Sir Alan Gardiner, the great authority on hieroglyphs, argued that at th... time of the Narmer palette the State priests and the artists they employed could not y... write complete sentences; they produced a series of pictures, ideas and sounds whic... the spectator then had to translate into words. He deduced that the palette was clear... composed to commemorate the triumph of unification. The scale of Narmer's conque... is confirmed by another Ashmolean mace-head, which shows him with his boot... apparently 120,000 men, 400,000 oxen, 1,422,000 goats, and the standards of th... northern nomes.

Unification was an act of religious statesmanship as well as military conquest, ar... the organizational and economic benefits became quickly apparent. Southern kin... married northern princesses, so fusing the royal lines. There was a syncretization... the rival gods and goddesses, so that all the deities of the kingdoms and the nomes too... their places in one harmonious pantheon. Either Narmer, or his immediate success... Aha, built Memphis as a joint capital, equipping it with the Palace of the White Wal... which gave it its Egyptian name. Thenceforth the coronations of all the pharaoh... included a commemorative ceremony in which the king symbolically reunited the 'tw... lands' by running round the White Walls in a solemn and solitary race – an act repeate... to display continuing vitality at his periodic jubilees. Egyptian syncretic skill was visu... as well as notional: the two crowns were brilliantly combined into an impressive pie... of headgear which became and remained to the end the most honoured item in th... pharaoh's regalia.

Unity finally ended death feuds between villages and nomes, border raids betwee... the old kingdoms, and banditry by marauding nomads, whose activities in the Nile ar...

in Egypt to acquire a definite religious personality and act as a politic focus was Heliopolis, with its sun-god Re. Its cosmogony, which may have been elaborated about 3500 BC but first attains written form in the *Pyramid Texts* of the late Old Kingdom, is primitive and physical. Thus the primeval god effected the first act of creation without sexual intercourse since he had no partner: 'Atun masturbated in Heliopolis. He took his phallus in his grasp that he might create orgasm by means of it, and so were born the twins Shu and Tefnut.' The first couple were born out of Atun's mouth.

The Egyptians never discarded this unsophisticated explanation. They never discarded any idea they had conceived, preferring, whatever the cost in logic or consistency, to attach to it, in blissful confusion, any additional ideas or explanations as they occurred. Gods multiplied, mutated among themselves, blended, separated, intermarried and procreated. The most the Egyptian theologians felt able to do was to sort them out into congruous triads (groups of three), enneads (groups of nine), and so forth, just as Egyptian villages and townships cooperated together, while retaining their distinctive personalities, in the communal unity of the Nile. It was the same with theological explanations. In the British Museum is the Shabaka Stone, bearing the name of a pharaoh who lived about 700 BC; its theological text is thus late, but its origins are manifestly very early indeed. It reads in parts: 'Whereas the Ennead of Atun came into being by his semen and his fingers, the Ennead of Ptah, however, are the teeth and lips in his mouth, which pronounced the name of everything, from which Shu and Tefnut came forth, and which was the fashioner of the Ennead.' We have here something approaching the elegant and sophisticated doctrine of the *logos*, which was to perpetuate itself into the Greek world and provide an astonishing start for St John's *Gospel*. 'Thus it happened', continued the text, 'that the heart [by which the Egyptians meant the mind] and tongue gained control over every other member of the body, by teaching that he is in every body and in every mouth of all gods, all men, all cattle, all creeping things, and everything that lives, by thinking and commanding everything that he wishes …'

This deliberative and self-conscious creative process by the operation of mind and voice is an analogy of the social and political process which led to the emergence of the Egyptian unified state. Ptah was the god of Memphis, and Memphis was built or acquired heightened importance at the time of unification: it stood at the junction of Upper and Lower Egypt and was deliberately turned into a national capital. It has been suggested that Egypt had to acquire a 'Memphite Theology' in consequence, which allocated a prime cosmogonical rule to the new capital's special god. Hence the Ptah-*logos* was a retrospective rationalization of the unification process. It seems to me far more likely that the Memphite Theology preceded and indeed promoted the political fact, being linked to the earliest writings and pictograms which began to generate magic and excitement shortly before political unity occurred. The idea of conscious statesmanship in founding the cosmos – as opposed to the crude 'happening' of the earlier explanation – would have served, by analogy, to promote and inspire the political aim (which was also of course a religious aim) of founding a unified State by conscious leadership and negotiation as well as by force.

So far we have been assuming that the religious and political developments which led to the creation of the Egyptian State and the cultural take-off took place in total isolation from the world beyond. Certainly, the most minute examination of Egypt's early religious beliefs does not reveal any sign of foreign influence; her political

evolution proceeded on quite different lines to that of
buildings which reflected it – forts and tombs – cont
temples. But Egypt was accessible, if with difficulty, espe
from Asia. Mesopotamia had passed through the 'Ne
Egypt, for her farmers were tilling the plain 2,000 years
Nile valley, and Eridu, for example, was a town of sorts,
the Egyptians were still gathered in small villages. So M
and Egypt to learn, in the fourth millennium.

The likelihood that Egypt benefited from a traff
definite archaeological evidence. There may, in fact,
movement of population, an actual conquest by a Sem
broader, larger skulls than the native Egyptians. It has
the original 'followers of Horus', who formed a region
the fourth millennium, and whose activities account fe
cultural development from about 3400 BC. Another vie
a conquest but an infiltration by Asian merchants,
phenomenon which was to recur throughout antiquity.
remain: early visual representations of boats of Mesopot
especially composite or fabulous animals, or animals
appear about this time especially on the votive palettes
panels; above all, writing.

Egyptian hieroglyphics were from the start entire
system which controlled them. The earliest signs are
looks as though the principle of writing was an import
the whole evolutionary process of literacy from su
pictograms, ideograms and phonetic signs, and then the
or stylus on wet clay, leading to the rapid developmen
missing. But in Egypt no traces at all have been found o
sign of a pre-phonetic script. What seems to have hap
saw specimens of Sumerian writing, grasped the intellec
and promptly devised their own system. They had one
papyrus plant which grew in abundance in Egypt, and f
and writing was made in the second half of the fourt
paper, which made the writing of a simplified cursive so
easy and elegant, there was no reason for Egyptian inte
all. They seem, in fact, to have seized eagerly on the pr
signs, and then rejected the rest of the practice and ap
their own written language, which combined ideograms
Egyptian design.

The acquisition of writing, with the organizational p
as its added magical power, clearly hastened the proces
the most important single factor in it. The other Asian i
particularly since the final drive to unity came from the
All the same, Asian cultural penetration did coincide
development from which unity emerged. What precisely
of evidence. Archaeology suggests that Upper Egyp
Hierakonpolis, in late predynastic times a town app

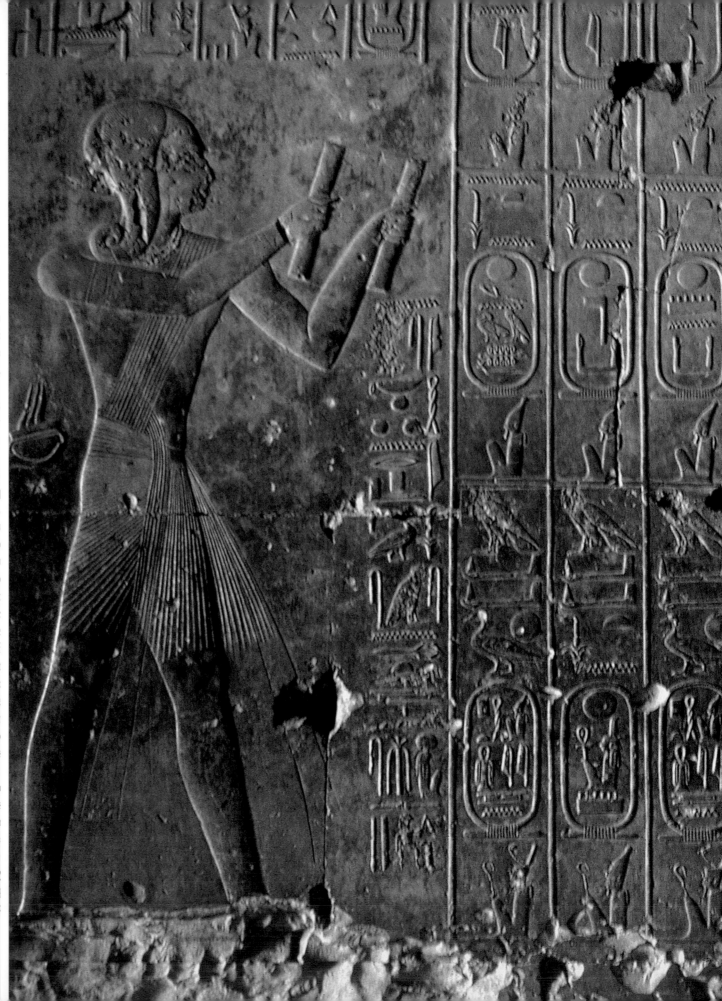

Previous page: A wall relief showing the Abydos list of kings from Menes to Seti I; a prince with a papyrus roll reciting a hymn. From the temple of Seti I, New Kingdom, Nineteenth Dynasty.

compiled primitive calendars of the three seasons, 'Inundation', 'Going down of the Inundation' and 'Drought'. Royal astronomers noticed that when the dog-star Sothis, after disappearing for seventy days, appeared again for the first time in the early morning before the sun rose, the flood was almost invariably imminent or had even begun. The date was accordingly used to mark the start of the Egyptian New Year, and the royal observatory now gave the calendar a firm anchor. The Nile, as it were, was brought under intellectual, as well as a degree of physical, control, and the combination effected a striking increase not only in the total area of land under regular cultivation but in the efficiency with which the soil was worked. This in turn increased royal (and other) food surpluses and reserves, the number of specialized craftsmen and workmen who could be supported, and the scale and variety of tasks the State could accomplish. So the subsistence economy was rapidly left behind, and the Egyptians, from being late starters in the race towards civilization, steadily overhauled the Sumerians.

We now pass from the predynastic (or Naqada) period to the long series of dynasties which cover the history of ancient Egyptian civilization. From this point, much later documentary sources become of increasing relevance, at any rate in fixing the sequence and chronology of dynastic history. What are these sources? They are all, for one reason or another, unsatisfactory; but married together and in conjunction with use of the Sothic dates of the Egyptian calendar, they permit the erection of a surprisingly reliable chronological structure (set out on page 39). The most important source is the Egyptian priest Manetho of Sebennytus, who lived in the reigns of the first two Ptolemaic pharaohs, in the earlier part of the third century BC. Manetho was affronted by Herodotus's wildly credulous and inaccurate account of Egypt, which had become famous by his day. Of course, unlike Herodotus, he spoke and read Egyptian as well as Greek, and had access to a range of historical works which have long since disappeared. He not only produced a pamphlet refuting Herodotus's errors, which has disappeared entirely, but compiled a systematic history of dynastic Egypt, the original of which has also disappeared, but survives in the form of epitomes embedded in the historical works of Julius Africanus, Josephus and Bishop Eusebius.

Manetho's account has been described as a series of folk-tales, and so in a sense it is. He produces fantastic reign-lengths for the earlier dynasties – the equivalent of the Methuselah-type datings of the earlier sections of the Old Testament – which in total would set back the foundation of the Egyptian State to well before 10000 BC. Not even the earliest Egyptologists would accept Manetho-based dating, and in the course of archaeological research in the nineteenth and early twentieth centuries, the 'long chronologies', as they are called, were gradually chopped down. The use of Carbon-14 dating fixes the Naqada periods in the first and second halves of the fourth millennium BC, and the unification under Narmer (or Menes as Manetho calls him) towards its close; after that we are in the carbon-dating margin of error. Manetho is thus no use for earlier chronology. Nevertheless, his structural device of dividing the Egyptian kings into thirty-one dynasties – the last being the Greek dynasty founded by Alexander and his Ptolemaic successors – has never been successfully overthrown by modern Egyptologists. We use it today. These dynasties consist (roughly) of related kings and queens, since Manetho marks a new dynasty when a change in ruling house occurs. Most of the pharaohs he lists were undoubtedly historical personages; in fact, where his information can be checked by modern research he has been found to be right, or nearly right, on a surprising number of occasions.

But Manetho must be supplemented by other documents. We have the Fifth Dynasty 'Palermo Stone' which lists the early kings; and a papyrus canonical list, now in Turin, which gives the names and length of reign of kings from the earliest times to almost the middle of the second millennium BC. But both these documents survive only in fragments. There is a tablet from Karnak (now in Paris) with a list of rulers from early times to the Eighteenth Dynasty; the Royal List of Abydos, which has seventy-six royal names; and a tomb-tablet from Sakkara, now in Cairo, which lists fifty-eight kings up to Ramesses II, in the Nineteenth Dynasty. Cross-checking all this information, merging it together, and bearing in mind that Manetho becomes more reliable as he

Below: Detail of the Abydos list of kings.

proceeds, we can construct a sequence of kings which is dependable for most of the time, and reliable relative dating for the information listed above is supplemented by innumerable individual dates in royal tomb-inscriptions, stelae and papyri.

Unfortunately, the Egyptians dated events solely in terms of each reign: they did not have a cumulative chronology. How, then, to anchor Egyptian dates to our own absolute chronology? This is where the Sothic dating comes in. We have several ancient Egyptian records of the Heliacal rising of Sothis. Since we can work out when these occurred in our own BC dating, we can say, for instance, that the seventh year of Sesostris III of the Twelfth Dynasty was in 1872 BC. From this we can work backwards to date the beginning of the Twelfth Dynasty to 1991 and of the Eleventh Dynasty to (approximately) 2133–4. The Turin Canon gives a seemingly accurate total of 955 years for the first eight dynasties; and this, together with fragments of knowledge about the Ninth, Tenth and Eleventh Dynasties, allows us to give an approximate figure of 3100 for the unification of the kingdom and the beginning of Egypt's dynastic history. This is roughly confirmed by much archaeological evidence and tentative carbon-dating, and is now generally accepted by Egyptologists as a starting point. For dates later than the Twelfth Dynasty we have a number of Sothic anchors – we can, for instance, be sure that the ninth year of Amenophis I of the Eighteenth Dynasty was between 1544 and 1519 BC (and very likely 1537) – and, in due course, a growing number of cross-dates from other cultures.

I have explained in some detail how we can reconstruct Egyptian chronology because it gives some indication of the fragmentary nature of our own sources, particularly for the earlier dynasties. But then, it is not to be expected that we should be able to provide a detailed historical account of such a remote period of time. Our first considerable written treatise is the *Pyramid Texts*, found in the tomb of Unas, the last pharaoh of the Fifth Dynasty, who died around 2345 BC. By that time, dynastic Egypt was already approximately 750 years old. We date the First Dynasty from 3100 to 2890 BC; the Second Dynasty ended in 2686; the beginning of the Third Dynasty inaugurated what is termed the Old Kingdom (dynasties 3–6), the first great peak of Egyptian civilization and in all essentials the matrix of the entire culture.

Of the first two dynasties we know little. Cultural development and economic expansion continued steadily throughout them but the pharaohs did not find it easy to hold the new nation together: the emergence of Seth in symbolic conflict with Horus indicates civil war between the South and the Delta, or parts of it. The last Dynasty ended in anarchy and the breakdown of the united kingdom: the Second Dynasty came to power as part of the process of reunification, its first king being called Hotepsekhemwy, signifying 'the Two Powers are Pacified'. There was a further political upheaval in the Second Dynasty, under King Peribsen, and the union was again restored by his successor, Khasekhem. To mark the event, the latter may have changed his regnal name to Khasekhemwy, 'the Appearance of the Two Powers', and there are two commemorative statues of Khasekhemwy at Hierakonpolis. But both names figure on king-lists and they may have been different men. The memory of these obscure struggles was retained in later traditions of thousands of slaughtered men from Lower Egypt.

As the kingdom consolidated its unity and survived these crises, internal changes no less obscure but equally certain were taking place. The power of the monarch grew at equal pace with unity, for local aristocrats were the only elements who stood to gain

from breakdown, and their transformation, as nomarchs, into mere officials was a consequence of the growth of a homogenous, centralized State, in which the pharaoh and his court were all-powerful. The evidence of burial arrangements is about the only kind we have to go upon. In predynastic times, local notables had been buried in their places of birth and standing. With unification, their tombs begin to cluster around the royal necropolis like iron filings round a magnet.

The Egyptian theory of death and eternity, which was now beginning to mature, presupposed that the exact reproduction, on the funerary plane, of life on earth, was the guarantee that it would be perpetuated into eternity. So tomb patterns are mirror-images of what went on in real life. The royal tomb emerged from the ground, first in the shape of a house or *mastaba*, to use the modern Egyptian term, then a many-roomed palace building with doorways and recessed walls; finally a pyramid, symbol of majesty and divinity. The tomb reproduced the royal earthly household, not only in terms of goods and supplies, but people. A First Dynasty queen, Merneith, was buried with 41 male and 77 female retainers; King Wadji, also of the First Dynasty, took 335 household souls with him. Where such bodies can be found, they show no signs of violence. Were they poisoned? Had they died anyway, in the normal course of events, and were simply used as surrogates of royal retainers? Ritual human sacrifice certainly took place in contemporary Asia, as the great death-pits of Early Dynastic Ur testify. The story of Abraham shows it was still conceivable at the beginning of the second millennium BC. The servants lay in small separate tombs clustered round the monarch. And, as the centralized pharaonic State consolidated itself, and the royal tombs grew accordingly in size and grandeur, so the tombs of great officials and chieftains were pulled into orbit, to constitute a kind of court or State of the dead in hierarchical proximity. The king by conquest and magic power had consumed the totems or emblems, and so the souls, of the original clans and their chiefs. He could restore these souls by enabling favoured officials and courtiers to qualify, through their tombs, for immortality. So the satellite tomb became a religious necessity as well as a social privilege. The excavation of the early dynastic royal tombs, not all of which have yet been identified, suggests that all the kings had two: the actual burial place at the necropolis of Sakkara, near the new capital Memphis, and cenotaphs in the ancient necropolis of Abydos. During the first two dynasties, the evolution of the royal necropolis reflects an irresistible movement towards political centralization and royal theocracy.

The take-off itself, when the splendours of the new civilization became manifest and unmistakable, may be precisely dated to the reign of King Djoser at the beginning of the Third Dynasty in the twenty-seventh century BC. Here is one of those occasions when the customary glacial pace of the ancient world mysteriously accelerates, when enormous innovations occur in a single lifetime and when, for once, a solitary individual of genius stands out from the slow impersonal forces of change. Djoser was a son of the victorious Khasekhemwy, though he may not have been the first king of the Third Dynasty. His reign is specially emphasized in the Turin Canon, 1,300 years later, by the use of red ink – so long was his glory commemorated. He seems to have pushed Egypt's southern boundary to the First Cataract, and sent a royal expedition to Sinai in search of turquoise and copper. By finally subduing the Bedouin he opened up the deserts, especially to the east, to systematic exploitation of their stone and metals. He thus added immeasurably to the range and quantity of resources available to royal

Above: *The Step Pyramid of Sakkara, a gigantic pyramid of stone steps which was built by Imhotep for Djoser.*

The Principal Pharaohs of Egypt

First Dynasty
c. 3100–2890 BC
Narmer (Menes)
Aha
Djer
Djet (Wadji)
Den
Anedjib
Semerkhet
Qaa

Second Dynasty
c. 2890–2686 BC
Hotepsekhemwy
Raneb
Nynetjer
Peribsen
Khasekhem
Khasekhemwy

Third Dynasty
c. 2686–2613 BC
Sanakhte
Djoser
Sckhcmkhct
Khaba
Huni

Fourth Dynasty
c. 2613–2494 BC
Sneferu
Cheops (Khufu)
Redjedef
Chephren (Khafre)
Mycerinus (Menkaure)
Shepseskaf

Fifth Dynasty
c. 2494–2345 BC
Userkaf
Sahure
Neferirkare Kakai
Shepseskare Isi
Neferefre
Nyuserre
Menkauhor Akauhor
Djedkare Isesi
Unas

Sixth Dynasty
c. 2345–2181 BC
Teti

Userkare
Meryre Phiops I (Pepi I)
Merenre Antyemsaf
Neferkare Phiops II
 (Pepi II)

Seventh Dynasty
'70 Kings for 70 days'

Eighth Dynasty
A fragile dynasty
 of Memphis

**Ninth and Tenth
Dynasties**
Heraclopolitan feudal
 dynasties founded
 by Achthoes.

Eleventh Dynasty
c. 2133–1991 BC
Mentuhotpe I
Inyotef I
Inyotef II
Inyotef III
Mentuhotpe II
Mentuhotpe III
Mentuhotpe IV

Twelfth Dynasty
c. 1991–1786 BC
Ammenemes I
Sesostris I
Ammenemes II
Sesostris II
Sesostris III
Ammenemes III
Ammenemes IV
Sobkneferu

Thirteenth Dynasty
c. 1786–1633 BC
Sobkhotpe III
Khasekhemre Neferhotep
Meryankhre Mentuhotpe

Fourteenth Dynasty
Various

**Fifteenth Dynasty
(Hyksos)**
Mayebre Sheshi

Meruserre Yakubher
Seuserenre Khyan
Auserre Apophis I
Aqenenre Apophis II

Sixteenth Dynasty
Various

Seventeenth Dynasty
c. 1650–1567 BC
Nubkheperre Inyotef VII
Seqenenre Tao I
 ('The Elder')
Seqenenre Tao II
 ('The Brave')
Wadjkheperre Kamose

Eighteenth Dynasty
c. 1567–1320 BC
Amosis
Amenophis I
Tuthmosis I
Tuthmosis II
Hatshepsut
Tuthmosis III
Amenophis II
Tuthmosis IV
Amenophis III
Amenophis IV
 (Akhenaten)
Smenkhkare
Tutankhamun
Ay
Horemheb

Nineteenth Dynasty
c. 1320–1200 BC
Ramesses I
Sethos I
Ramesses II
Merneptah
Menmire Amenmesses
Sethos II

Twentieth Dynasty
c. 1200–1085 BC
Userkhaure Sethnakhte
Ramesses III
Ramesses IV
Ramesses V
Ramesses VI
Ramesses VII

Ramesses VIII
Ramesses IX
Ramesses X
Ramesses XI

Twenty-First Dynasty
c. 1085–935 BC
TANIS
Nesbanebded
Psusennes I
Amenemope
Siamun
Psusennes II
THEBES
Herihor
Pinudjem I
Masaherta
Menkheperre
Pinudjem II

Twenty-Second Dynasty
c. 935–730 BC
Sheshonq I
Osorkon I
Takelothis I
Osorkon II
Takelothis II
Sheshonq II
Pami
Sheshonq IV

Twenty-Third Dynasty
c. 817–730 BC
Petubastis

Twenty-Fourth Dynasty
c. 730–709 BC
Tefnakhte
Bakenrenef (Bocchoris)

Twenty-Fifth Dynasty
c. 750–656 BC
Piankhi
Shabaka
Shebitku
Tahrqa
Tanutamun

**Twenty-Sixth Dynasty
(Saite) 664–525 BC**
Psammetichus I
Necho II

Psammetichus II
Apries
Amasis (Amosis II)
Psammetichus III

**Twenty-Seventh Dynasty
(Persian)**
525–404 BC
Cambyses
Darius I
Xerxes
Artaxerxes
Darius II

**Twenty-Eighth and
Twenty-Ninth Dynasties**
404–378 BC
Amyrteos
Nepherites
Achoris

Thirtieth Dynasty
380–343 BC
Nectanebo I
Teos
Nectanebos

Macedonian Kings
332–302 BC
Alexander the Great
Philip Arrhidaeus
Alexander IV

The Ptolemies
304–30 BC
Ptolemy I Soter
Ptolemy II Philadelphus
Ptolemy III Euergetes
Ptolemy IV Philopator
Ptolemy V Epiphanes
Ptolemy VI Philometor
Ptolemy VII Neos
 Philopator
Ptolemy VIII Euergetes II
Ptolemy IX Soter II
Ptolemy X Alexander II
Ptolemy IX Soter II
 (restored)
Ptolemy XI Alexander II
Ptolemy XII Neos
 Dionysos
Cleopatra VII Philopator

THE TOTALITARIAN THEOCRACY

The Old Kingdom, which lasted for 500 years around the middle of the third millennium BC, did not encompass all the accomplishments of ancient Egyptian civilization. But in all essentials it was the matrix of the entire culture. In statecraft, religion, science, architecture, sculpture, low-relief and painting, in writing and thinking, the innovators of the Old Kingdom developed characteristic ideas and patterns which were later modified over 2,000 years, but never fundamentally changed. It would be too much to say that the Old Kingdom was an age of creation and achievement, and that thereafter nothing but decadence followed; but the more one examines Egyptian forms, the more one understands why such assertions are made.

The essence of a culture is style. No culture in world history was so thoroughly penetrated by a quintessential style as the Egyptian; and this style was eternally set during the Old Kingdom, in most respects at the very beginning of it. One could say that under Imhotep the style was already in its noble adolescence, and the full maturity was reached in the Fourth Dynasty. The essence of Egyptian style can be defined in two words: majesty, and self-confidence. The Egyptians were perhaps the most self-confident people the world has known: the cultural egocentricity of the later 'Celestial Empire' of China was less exclusive by comparison. The Egyptians did not regard themselves as a chosen people; they were, quite simply, people. Other humans fell into another category. The Egyptian word for 'man', as distinct from gods and animals (or, in another sense, women) originally applied only to Egyptians. A text called the *Admonitions of Ipuwer*, which dates from the breakdown of the Old Kingdom, complains: 'Strangers from outside have come into Egypt … foreigners have become people everywhere.'

This exclusiveness was not primarily racial, for the Egyptians were of mixed race and seem to have accepted everyone who adopted their culture wholeheartedly, but geographical. The Egyptians were people because they lived in Egypt. In fact they continued to call their united country 'the two lands' (our term 'Egypt' comes from the Greek rendering of Memphis). But 'land' as a concept was identified with Egypt. The world had begun in Egypt, by analogy with the Nile flood, as a primeval mound arose, when the floodwaters of chaos receded. Hermopolis was often considered 'the mound', and thus the oldest place, though other Egyptian cities eventually claimed to be the oldest in the world. A sarcophagus in the New York Metropolitan Museum shows the earth as a circle, with the nomes of Egypt forming an inner circle in the middle; this is a late artefact, but the concept was as old as Egyptian unity. During the king's coronation ceremony, which goes back to the founding of the capital at Memphis, the new king fired arrows towards the four cardinal points of the compass, and released birds to travel there to announce his rule. Egypt was the centre of the earth, and its people the only legitimate inhabitants. All lands belonged to Egypt by divine right, and if she found it necessary to enter territory not, strictly speaking, administered by her, she was merely said to be 'punishing rebels'. Not until late in the second millennium BC do the Egyptians appear to have equated other peoples with themselves, and to the end their language contained many expressions which reflected their Egypt-centred view of the world. Thus the Nile was 'the river'; and the fact that it flowed south to north was affixed as a characteristic of rivers as such – the Euphrates was 'that inverted water which goes downstream in going upstream'. Again, as Egyptian crops were watered by a river rather than rain, the Syrians were said to have been provided with 'A Nile in the sky' – that is, regular rainfall.

The notion that everything in Egypt was 'normal' was fostered by its isolation, and the cultures with which Egypt did have contact, Libya, Nubia, Palestine, were so manifestly poverty-stricken by comparison with her own as to confirm the theory of Egyptian superiority, indeed uniqueness. There were no direct contacts with Sumer in the remote period when it was Egypt's cultural precursor, and the cultural imports of the immediate predynastic period left no traces on Egyptian historiography. By the time Egypt began to trade on any scale, it was a united country and its cultural pre-eminence had already been established. These early commercial ventures, which date from the first two dynasties, were not so much individual voyages as royal expeditions

managed on the king's behalf. In early dynastic and Old Kingdom times there was no private sector in the national economy and trade was a royal monopoly. This was one respect in which Egypt differed decisively from the Mesopotamian city-states. To trade was an act of State, and as part of their theory of cosmic superiority the Egyptians did not draw a clear distinction between trade and tribute, or even colonization. Foreigners who traded peaceably with Egypt were in some sense her servants; those who showed hostility were invariably categorized as 'vile'. Contacts of both kinds became very extensive in the Old Kingdom. Elephantine, so called from its trade in central African ivory, had been the most southerly trading post in predynastic times. Sneferu, first king of the Fourth Dynasty, sent punitive expeditions against the Libyans, and pushed further up the Nile Valley against the Nubians. He, and other Fourth Dynasty kings, as we know from their inscriptions, sent royal expeditions to obtain hardstones, jewels and minerals from Sinai, the Nubian desert and tropical products from a land known as 'Punt' and tentatively identified with Somaliland. Egyptian influence even penetrated as far as the Second Cataract under the Old Kingdom, since copper was being smelted at its north end.

The most important trade was with Byblos, in modern Lebanon, because this not only supplied Egypt with the timber she conspicuously lacked (the pine and cedar forests around the Lebanese Mountains were then still vast), but linked Egypt to the main trade route of the Fertile Crescent. 'Byblos Ship' was the Egyptian expression for a big, ocean-going vessel, built of cedarwood and owned by the pharaoh; one such, over 100 feet long and dated about 2700 BC, was found in 1953 near the south side of the Great Pyramid of Cheops – though most Byblos Ships buried with the monarch were naturally in stone. Byblos was not an Egyptian colony or settlement. Egyptians avoided living abroad since they feared burial there, which would jeopardize their chance of eternity. But it had an Egyptian temple as early as the Old Kingdom and remained an enclave of predominantly Egyptian culture for over 2,000 years. The *Tale of Wenamun*, dating from towards the end of the second millennium BC, when Egyptian influence in Byblos was beginning to wane, reflects the Egyptian belief, which underlay their self-confidence, that Egypt's was the original civilization from which all others sprang. It has the Prince of Byblos say to the sailor Wenamun: 'Amun founded all lands. He founded them, but first he founded the land of Egypt, from which thou hast come. For skilled work came forth from it to reach this place where I am, and teaching came from it to reach this place where I am.' New inventions which did not spring from Egypt, a phenomenon which confronted the Egyptians increasingly in the second millennium BC, were conveniently said to be gifts from the gods.

Cultural self-confidence was closely linked to the magisterial tone of

Below: Weapons, jewellery and vessels probably imported from the incense country, Punt.

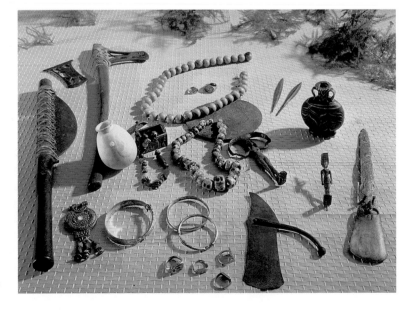

Egyptian style, which itself derived from the majestic character of Egypt's sacrosanct monarchy, an institution so powerful and pervasive that it embraced all others in Egyptian society. Rulers were probably regarded as sanctified if not actually divine in late predynastic times, since they seem to have been identified with their emblematic gods. As unification proceeded, the beneficiary-king became more and more powerful, in divine as well as earthly terms, since he had cannibalized, and so become, the gods of the conquered regions. Divine kingship seems to have been an exclusively Egyptian idea, though it was eventually copied elsewhere. It probably owed something to the fact that the beginning of literacy coincided with unification, sharply raising the status and authority of the royal household priests, who worked out the theology of their master's divinity.

Pharaonic power was not a static concept. It grew steadily throughout early dynastic times and reached its peak under the Fourth Dynasty; thereafter it declined, though very slowly at first. At its apogee, the theory of sacrosanct monarchy presented the king as god made manifest. He was the land's representative among the gods, the only official intermediary between people and gods, and therefore the only official priest of all the gods. Strictly speaking, the teeming hierarchies of priests were only pharaoh's vicars. If pharaoh was present, he alone performed the daily ceremony of 'cultivating' the image of the god, being locked into the inner sanctuary while he did it. It is confusing to us, but apparently not to the Egyptians, that he prostrated himself in such ceremonies, though a god. Indeed he was not merely a god but all the gods, becoming

Below: *A relief from the Temple of Hatshepsut at Deir el-Bahari, showing a column of soldiers on the expedition to the Land of Punt, on the horn of Africa.*

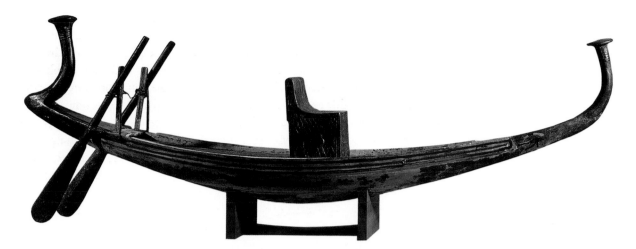

each as occasion demanded. As the protector of the realm he was Son of Bastet, as the punisher of wrongdoers Beloved of Sekhmet, as the prince of understanding Sia, as the augmentor of the population Khnum, who created new bodies on his potter's wheel. Pre-eminently, pharaoh was Re, the supreme ruler – that was why he was buried with boats so that, like Re, he could sail across the sky. But the pharaoh was also the son of Re, the issue of Re's actual body, albeit using a woman as carrier; Egypt was Re's daughter and pharaoh's sister. It did not matter to Egyptians that the king's different titles or capacities overlapped or even contradicted one another. If necessary they fell back on the dualism which was one of their favourite devices. Thus the king had two bodies and a distinction was drawn between the divine character of the office and the human nature of the person holding it. Thus *hm* or 'majesty' really meant the king's body; *niswt* meant the 'bearer of office' and implied divinity. As *niswt* the king was all the gods; as *hm* he was in a sense all men too, since the king was the only entirely complete human being and Egyptians could not conceive for themselves an existence independent of him – something which had important implications for the theory of eternity.

The king acquired *niswt*, and became divine, at his coronation, a ceremony the Egyptians invented, along with jubilees and other royal cult occasions. (A later teaching was that the ruler was predestined for divine kingship from birth.) In the Old Kingdom, the understanding was that the coronation allowed the man-king to enter the world of the divine, and after his death he was wholly divine. Hence the coronation regalia was of immense actual (as well as symbolic) importance. The crowns, especially the double crown of the 'two lands', were conceived of as assimilated by the king, who 'swallowed' them. The *Pyramid Texts* include an archaic 'Cannibal Hymn' showing the pharaoh eating the crown of Lower Egypt. The actual crowns were venerated, kept in special sanctuaries and 'cultivated'; hymns were sung to them. In addition to the double crown, the supreme headgear of Egyptian royalty, the pharaoh gradually acquired other hats: a blue military helmet, with linen tapes at the back, a stiff white linen headcloth, or *nems*, usually with red stripes, a *nems* with two stiff feathers, and a *nems* plus the crown of Upper Egypt and two feathers, resting on rams' horns enclosing a solar disk and two *uraei*, or cobras. This was an enormous contraption. The pharaoh also retained gear of primitive, possibly Libyan, origin: a false beard (Egyptians of dynastic times were often clean shaven), tied on with a strap, and a bull's tail tied on to his belt.

A queen-regnant, like Hatshepsut of the Eighteenth Dynasty, wore a beard and tail like a man.

It is not easy for us to imagine how the Egyptians regarded their god-king. They saw him often enough. Easy travel by royal barge up and down the Nile, and the fact that the great majority of Egyptians lived within a few miles of the river, meant that the pharaoh was seen more often by more of his subjects than any other monarch of antiquity. That was one reason why the institution was so strong and popular. He was expected to be active – which meant visibly present – in the cult of all important gods in their local cult-centres. A Berlin manuscript has the Middle Kingdom monarch Sesostris I saying, at the founding of a temple, that its god had 'formed him in order to do for him what should be done for him'. We have pictorial accounts of pharaohs laying the first stones of important new cult-buildings, and depositing sets of model tools in the foundations. They also cut the first sods of new canals and river-works. The chief events of the liturgical year demanded their presence; and their palaces seem to have been provided with 'Appearance Windows' from which they showed themselves to the populace.

Below: Small limestone pyramid showing a relief of the sun-god Re as a falcon.

Yet men even of the highest ranks had to keep their distance from the pharaoh. Rekhmire, a vizier of the Eighteenth Dynasty, called him 'the god by whose actions we live, the father and mother of all men, alone by himself without an equal.' An Old Kingdom poem says: 'His lifespan is eternity, the borders of his power are infinity.' The uraeus which sat on the king's brow in all his crowns was believed to spit poisonous fire at anyone who approached too near. Indeed, the king's own divinity, embodying the Sun-god Re, was fiery and scorched anyone guilty of unauthorized physical contact. Three incidents in the reign of Neferirkare of the Fifth Dynasty suggest an atmosphere of majesty which we would find inconceivable. The first occurred when an official was accidentally touched or struck by the king's sceptre during a ceremony. The blow meant death. The inexorable consequences to the man were only averted by the king himself apologizing, and the episode was considered important enough to be noted down. On two other occasions, Neferirkare allowed two senior officials, as a special mark of favour, to kiss his actual foot, as opposed to the ground in front of it. These acts of condescension were also recorded, and the title bestowed on the two officials: 'Sole Companion'. Priests were often employed to enable the king to avoid physical contact with people or objects. They had to undergo constant lustration (washing) ceremonies, as indeed did anyone in the king's vicinity: 'pure of hands' is the phrase constantly used about royal priests and attendants.

The king was also the possessor of a royal mystery or secret. We are not clear what it was, but its discovery could precipitate the overthrow of the dynasty: 'Behold,' wrote the author of the *Admonitions* after the fall of the Old Kingdom, 'the secret of

the land, whose limits are unknown, is divulged, so that the palace is overthrown in an hour.' Under the Fourth Dynasty the secrecy theme appears in titles of senior officials close to the king: 'Master of the Secrets of the Things that Only One Man Sees'. There were many taboo words connected with royalty, including the king's name. No one spoke 'to' the king but 'in the presence of His Majesty'. The king himself did not say 'I' as a rule but 'My Majesty'. The third person indefinite was also employed: 'One gave command', not 'the King commanded'. Another circumlocution was to refer to 'the palace', in the same way as 'the Porte' was used to represent the Turkish Sultan, or 'the White House' the United States President. Thus, under the Eighteenth Dynasty the king was spoken of as 'the Great House', *per-aa*, hence 'pharaoh'.

It was the ubiquitous dominance of the pharaonic institution which helped to give the style of Egyptian art its second great characteristic: its supremely magisterial quality. Or one could put it the other way round: it was the sheer skill of the Egyptian craftsmen, especially in statuary, which gave religion, and so the pharaoh, its tremendous impact on the Egyptian consciousness. Doubtless both ways of putting it are true. Certainly Egyptian art acquired its salient character at the same time as the monarchy grew in power and strength, that is during the first three dynasties. In this sense, the great Narmer palette is pre-Egyptian. At one time, indeed, several of the fine early palettes, and other artefacts of the late predynastic or early dynastic period, were classified as 'Middle Eastern', and regarded as imports by Egyptologists. They are in fact purely Egyptian, but the true Egyptian style is missing or embryonic.

Above: A *bronze seated cat depicting the goddess Bastet.*

The key lies in the treatment and evolution of forms. Not enough survive from the early and transitional period to study this change in detail; but there are pointers. Thus, under Djer, the third king of the First Dynasty, the horus-falcon, one of the central images in Egyptian art, ceases to lean forward as a bird, and becomes erect like a king, with magisterial gaze. What the great German art-historian, Heinrich Schäfer, calls 'the ruler-posture' thus established itself. The same transformation overcame the sculpted lion, another recurrent image. Archaic art customarily portrays the lion with jaws open, visibly roaring, snapping or about to rend. This stress on the savagery of the lion is found in predynastic Egyptian art; and in Mesopotamian and Assyrian work the lion continued to the end as a restless, mobile, arching, roaring monster – the quintessential display of brute force. The Egyptian artists, by contrast, ceased during the early dynasties to present lions in these postures (except in some hunting scenes). Instead the jaws close, the tail no longer threshes but curves round the body, the legs and trunk combine to form a firm horizontal base, and the lion's gaze acquires serenity, dignity, authority and permanence. The Egyptian lion is not preparing for a spring; he does not need to roar or flex his muscles to advertise his power. He sits, utterly confident in his own authority, in regnal pose, gazing with benevolent majesty on a world he knows he controls: the ruler-posture again. A third example is the Egyptian portrayal of the cat-goddess, Bastet: Egyptian cats are seated upright, again utterly at rest, confident of their power and beauty, radiating instinctive but still watchful command, a pose

fact – gave this necessary assurance to the Egyptian mind, as it contemplated art. Their word for right order was *maat*, which also stood for justice and morality. The pharaoh embodied *maat*, and also dispensed it. His divinity enabled him to determine what was *maat* and what was not. Thus Egypt, unlike the Mesopotamian city-states and later the Israelites, had so far as we know no written code of law, but (it seems) an unwritten customary law derived from pharaonic judgments, and altered by the pharaoh as he saw fit. *Maat* was also the form of justice dispensed when a man died and appeared at the last judgment: his soul was then weighed in a pair of scales against *maat*. There was, in short, a very close association in the Egyptian's mind between moral goodness, mundane justice, and artistic order. To break an artistic canon, to infringe pharaoh's law or to sin against god were similar activities; all were a denial of *maat*. Since art was ordered by a geometrical sense, it is therefore not surprising – almost inevitable – that its supreme expression, to the Egyptians, should have been that purest of solid

Below: *A Karnak wall relief showing depictions of the human form. Egyptian artists arranged men's feet in profile as baselines.*

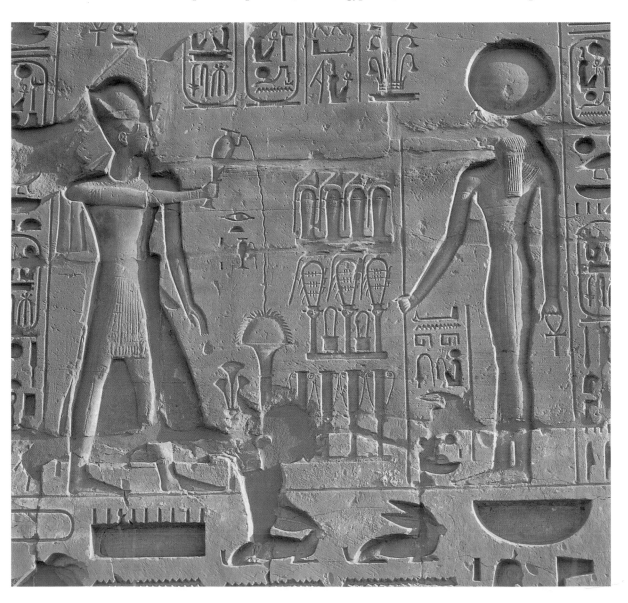

Left: *Detail from* The Book of the Dead *showing judgment in the next world; the deceased, Neferis, is led before the tribunal. Her heart is weighed against the truth and she makes offerings to the gods Osiris, Isis and Nephthys.*

geometrical forms, the pyramid, a symbol for them at one and the same time of *maat* or order, of pharaonic status and of eternity.

Nothing gave more powerful and profound expression to the magisterial self-confidence of Egyptian art than the pyramid. Moreover, it shows that art in its most essential mood: emphasizing pharaonic divinity. The pyramids of the Old Kingdom chart the rise and fall of the monarchy with some precision. They grew in size as the pharaoh's earthly power and divine attributes accumulated; and when both were eroded, the pyramids shrank and finally disappeared. The idea of the pyramid seems to have been based upon the primeval mound which features in Egyptian cosmogony. It thus had a natural inspiration, and it may be that the batter or slope of the pyramid was modelled on the cliffs of the Nile valley. Most pyramids were placed on the west bank of the Nile, in accordance with the theory that the west, where the sun set, was the land of the dead. All the monumental pyramids were built during the Old Kingdom, in a zone stretching for fifty miles or so south of modern Cairo, in a series of royal necropolises, at Sakkara, Giza, Dahshur, Abusir and elsewhere.

The pyramid proper was only part of the burial complex. In addition, there was a mortuary chapel in front of the east face of the pyramid, a chapel in front of the main pyramid entrance in the north face, a small ritual pyramid outside the southern enclosure wall of the parent pyramid, buried boats in wood, or rock-cut boat-shaped pits, and a long causeway linking the complex to a 'valley temple' nearer the Nile, which could be reached by water during the flood. It was by this means that the body of the dead pharaoh was first brought to the complex, and it was in the valley temple that the process of purification and, from the Third Dynasty onwards, mummification took place. The process took a long time – 272 days in the case of a Fourth Dynasty queen buried at Giza – and it was completed by a ritual called 'The Opening of the Mouth', at which point the now mummified pharaoh came to life again. He was then taken along the causeway and put into the burial chamber inside or underneath the pyramid.

The art and practice of pyramid-building was in a state of constant flux, as architects coped with the problems of stress and construction involved, and set themselves increasingly ambitious targets. In his *Natural History*, Pliny the Elder condemned pyramids as 'an idle and foolish exhibition of royal wealth', but even he could not resist wondering 'how the stones were raised to so great a height'. It was not true, as Herodotus had claimed five centuries earlier, that the Egyptians had cranes or lifting

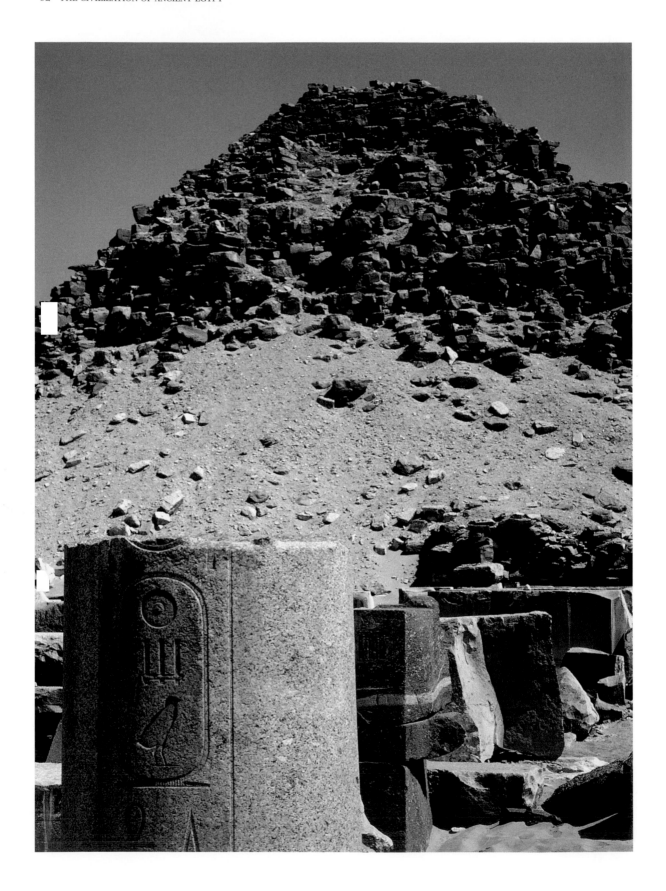

machines; or if such things existed, they have left no traces in the records. We do have visual records of Egyptians shifting huge weights: a picture of 172 men, for instance, dragging an alabaster colossus of a Twelfth Dynasty monarch weighing about sixty tons, from a quarry at Hatnub to El Bersheh in Middle Egypt. We also have pictures of royal barges transporting Queen Hatshepsut's huge obelisks from Elephantine to Thebes. Water-transport posed no great problems, and the flood season was used to cut down the distance travelled on dry land. But for land travel the Egyptians had nothing but sledges, occasionally rollers, pulled by the brute strength of oxen and men, usually the latter, with water poured down to reduce friction. Lifting weights was merely an extension of horizontal carriage. The Egyptians had levers but no pulleys or other mechanical aids. They simply built sloping ramps of earth and rubble, with brick retaining walls, to get the stone blocks up to the higher registers. When the pyramid was done, the ramps were removed. In the case of the Step Pyramid built by Sekhemkhet at Sakkara, which was never finished, the ramps are still there.

Pyramids are more complicated than they look. The Step Pyramid Imhotep built for Djoser is surprisingly sophisticated in design. It suggests some understanding of

Opposite page: The pyramid had a natural inspiration, and it may be that the batter or slope of the pyramid was modelled on the cliffs of the Nile Valley.

Below: Depiction of a brickworks from the tomb of Rekhmen, court official under Tuthmosis III and Amenophis II, Thebes.

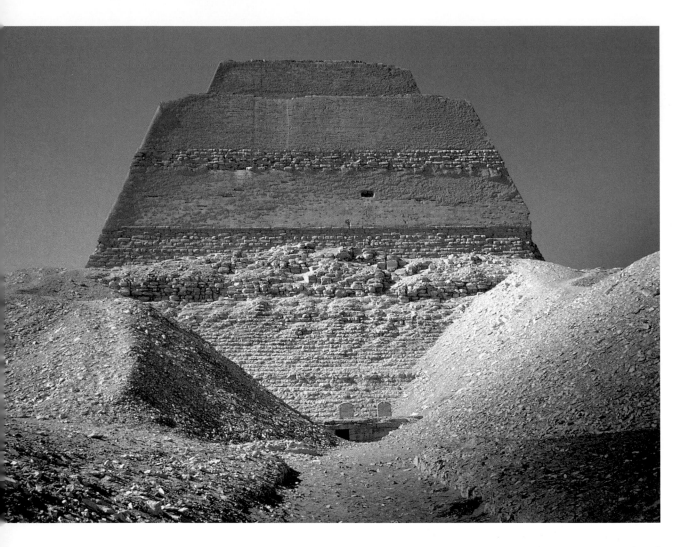

Above: The enormous pyramid at Meidum, begun by Huni, the last king of the Third Dynasty, was constructed in seven steps and faced with limestone.

the concepts underlying the laws of stability. Imhotep was already building on a colossal scale: his Step Pyramid is 411 by 358 feet at base. Surprise is often expressed at the fact that the major pyramids combine huge size with very high standards of workmanship. The answer is that the greater the size the higher the quality of workmanship demanded. The blocks had to be beautifully squared to ensure that they touched evenly, distributed the weight equally, and prevented crumbling; accurate stone-dressing was also required to ensure that the internal weight-forces were properly distributed. Otherwise the pyramid might explode outwards and enormous quantities of stone crash down the sides. To combat the outward-acting lateral forces produced by the sheer bulk and weight of the building, Imhotep had to invent inward-inclining buttress walls, which provided compensating inward-acting lateral forces. These walls, invisible from the outside, are an essential feature in ensuring the stability of big pyramids. Djoser's successor, Sekhemkhet, did not finish his Step Pyramid at Sakkara, almost as big as Djoser's, possibly because it was realized that the design was unsafe. His successor, Khaba, built the so-called Layer Pyramid at Zawiet el Aryan, but this is much smaller – 276 feet square at base. Huni, the last king of the Third Dynasty, built an enormous pyramid, 590 by 656 feet, at Meidum. This had interior buttress walls

but they were spaced at every ten cubits, as opposed to every five in the case of Imhotep's design. There may not have been enough of them to keep the pyramid stable, and the theory has been put forward that the ruinous state of the Meidum Pyramid is due not to stone-robbing but to a catastrophe – detonated perhaps by a heavy rainstorm of a type which occasionally occurs in this part of Egypt – during the final stage of construction.

Huni seems to have died without sons, and the throne passed, through his daughter, to her husband Sneferu, who founded the Fourth Dynasty. He was a man of great ambitions and capacity, who left a good campaigning record and a popular reputation. He finished Huni's work at Meidum and then, at Dahshur, built two immense pyramids of his own: the South Stone or 'Bent' Pyramid, 619 feet square at base, and the North Stone Pyramid, 722 feet square. These involved advances in design and workmanship, and the principle of filling in the steps to present, at a distance, a smooth linear appearance. Sneferu also worked out the full implications of the complex, including the valley chapel and the causeway. His building operations were on a colossal scale and were supplemented by many huge mastaba-tombs built by his nobles and courtiers and grouped at the foot of his pyramids.

It was Sneferu's son, Cheops, who carried the process to its ultimate conclusion by erecting the Great Pyramid. This is 756 feet square at base and is the most ponderous building ever set up by man, consisting of about 2,300,000 stone blocks, averaging $2 \frac{1}{2}$ tons each. The inner blocks were once covered by a smooth casing of fine-quality polished Tura limestone, which must have glittered in the sun. The detail of the Great Pyramid was as impressive as its bulk. The casing was later covered in hieroglyphic graffiti; over the centuries it was stolen, but even at the end of the twelfth century AD, an Arab writer, Abd el Latif, declared that the remaining inscription on the outside of the Great Pyramid would fill 10,000 pages. Even more striking was the precision of the stone-cutting and polishing. In order to ensure stability, the stones were made to fit with impressive exactness: on the north side, they do not 'gap' (as the builders say) more than one-fiftieth of an inch at any point on their surface. Sir Flinders Petrie, the painstaking archaeologist who first thoroughly investigated and measured this pyramid, wrote that mistakes in the lengths and angles of this enormous pile can be 'covered with one's thumb'; and 'neither needle nor hair' can be inserted into the joints. To put it another way, on the north and south sides, the margin of error in squareness is only 0.09 per cent; and on east and west, 0.03 per cent; the whole construct was on a pavement which from opposite corners has a deviation from the true plane of a mere 0.004 per cent.

The quality of the stonemason's skills lavished on Cheops' Great Pyramid was never again equalled in Egypt's history; indeed, it is hard to point to any building in subsequent civilizations, including our own, which exhibits consistent workmanship of this order. This awesome fact itself provides a clue to the spirit in which the pyramid was built, and to the religious fervour of Old Kingdom society, especially during the Fourth Dynasty. Slave labour might pile up pyramids but it cannot endow them with superlative artistry. In fact there were comparatively few slaves in the Old Kingdom, and certainly not enough to provide the workforce for an operation on this scale. Herodotus says that 100,000 men worked for twenty years on the task, and this is plausible, assuming the peasants of the region were employed on it during the four-month pause while the fields were under flood. It is not clear whether this labour was

Following page:
The pyramids of Cheops, Chephren and Mycerinus at Giza. The Great Pyramid of Cheops is the heaviest building ever set up by man.

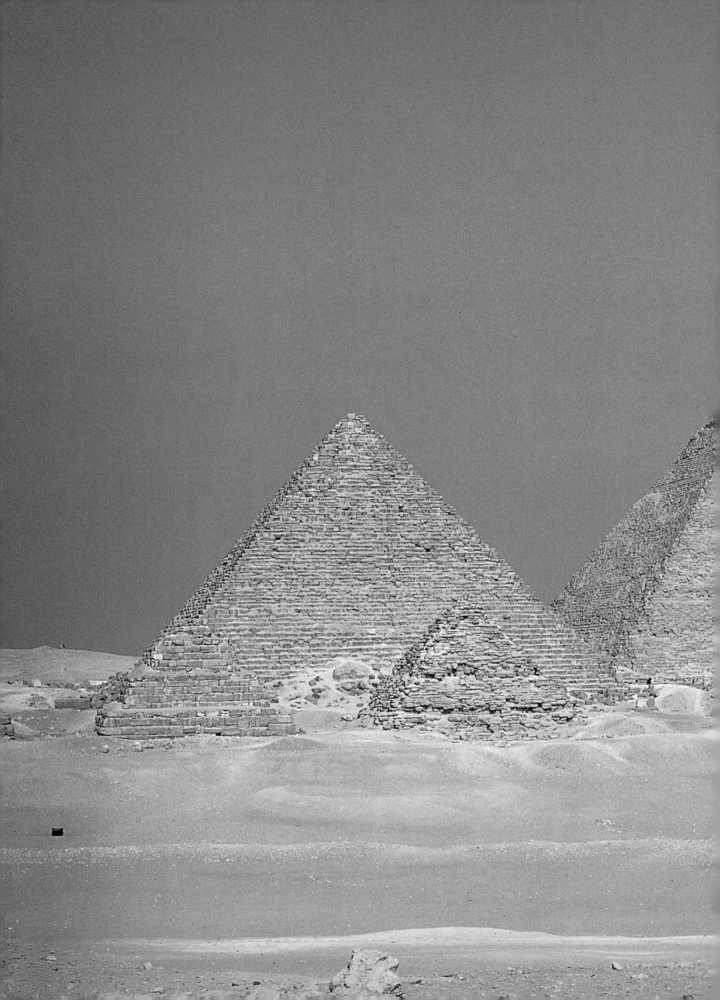

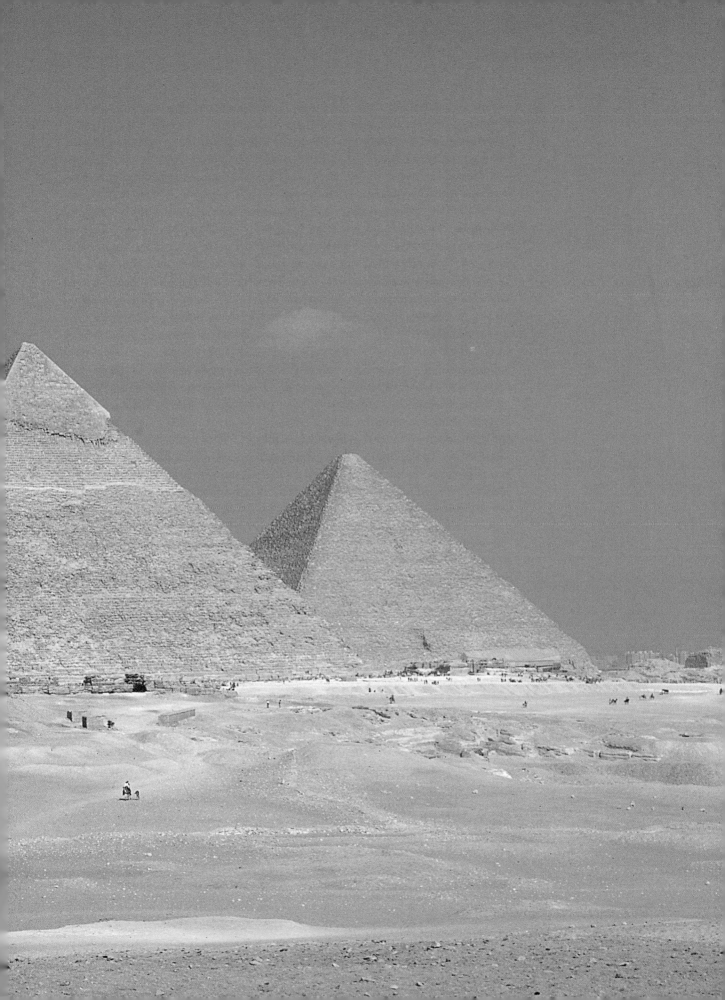

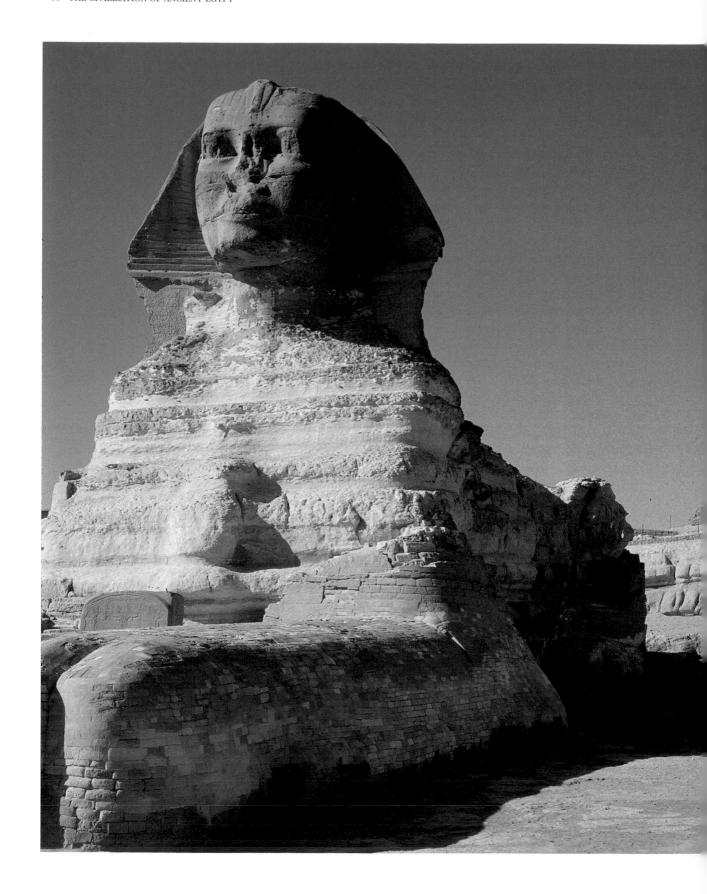

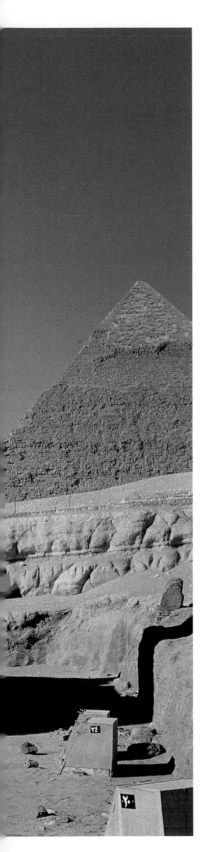

found in the 1920s, a recovery of royal funerary goods second only to the great hoard of Tutankhamun.

We must face the possibility, difficult though it is for us to comprehend, that the gigantism of the pyramids was the product of religious fervour, rather than of royal egomania conscripting a servile multitude. The Egyptian nation evidently did not regard these funeral works of their Horus-king as expressions of a private whim but as public works of compelling importance, which had a direct bearing on the future well-being of all. In this sense Egypt was a collectivist society of a very rigorous kind. The King personified the collective. If he passed safely into eternity as a fully-fledged god, then the immortal status of his entire people – serving him in the next world as they had served him in this – was somehow also guaranteed. It was therefore vital to all that the funerary arrangements of their Horus should be on the most ambitious scale and satisfy any possible celestial requirements. We must assume, then, that the craftsmen and labourers of Egypt worked on the pyramids as though their eternal lives depended on it. Tombs of the kings they may be but we should also see them as collective cenotaphs of the people.

The prodigious structures of the Fourth Dynasty plainly coincided with the point at which the theory and practice of divine kingship were most confidently asserted, and most generally believed. This was reflected in the selection of senior royal officials. Whereas in the first two dynasties, and often in the Third, even the greatest officials, such as Imhotep, rose from obscurity in the royal service, under the Fourth Dynasty political-religious theory seems to have dictated that they be selected almost exclusively from the royal family. Thus Sneferu's son, Kanufer, was the Master of Works and chief architect, the leader of expeditions to obtain raw materials for building, and later vizier. Rahotpe, also a son of Sneferu, was Leader of the Shipping. Another prince, Meryib, was Chief Architect and General of the Workmen. Such men, and others with royal blood or who married into the dynasty, dominated the priesthoods, especially those of Ptah at Memphis and Re at Heliopolis. There was, to our way of thinking, complete confusion between religious and secular: the Temple of Ptah controlled the 'House of Gold' where all the treasures were made, and the sculpture studios, on the grounds that work in 'everlasting' materials like gold and stone belonged exclusively to the gods and the god-king. In the Fourth Dynasty, only sons of the kings became High Priests, and it was therefore inevitable that they should run public works programmes, and royal expeditions. In turn, royal offspring became High Priests of Re, since Heliopolis was the starting point for many important royal expeditions, especially in Sinai.

But the policy of appointing royalty to the Temple of Re was dangerous, for their status reinforced the claims of this ancient and powerful cult-centre, and its priesthood. As always in antiquity, offices tended to become hereditary so the priesthood was liable to become a challenging *Doppelgänger* to the royal line itself. Sacrosanct monarchy always faces this problem, for the priests who administer the cult of divine kingship confer the godhead at the coronation ceremony, and are therefore in a sense the king's benefactors – this was at the root, for instance, of the conflict between Pope and Holy Roman Emperor in the early Middle Ages, and in particular of the 'Investiture Contest' of the twelfth century AD. The Horus-kings of the Fourth Dynasty met the challenge

Left: *Near his pyramid at Giza, Chephren carved a giant sphinx – a lion with a human head (probably like his own) – a symbol of majesty.*

Opposite page: A statuette of Cheops, Fourth Dynasty.

Below: Bas-relief found in Amarna depicting Akhenaten and the royal family shown sacrificing to the sun-god Aten.

by insisting on their divinity from birth and their personification of the entire pantheon. But towards the end of the dynasty the doctrine of a royal 'incarnation' crept in and, in turn – partly as a result of the invasion of the Re priesthood by the royal family – the use of the title 'Son of Re'. From full divinity to mere incarnation, and then to divine sonship shows a definite deterioration.

The identification of the pharaoh with the 'son of Re' became politically important when the Fourth Dynasty failed for lack of male heirs in the main branch. Radjedef, a king of the Fourth Dynasty, had a daughter Neferhetepes, and it was through her, either as wife or mother, that Userkaf, first king of the Fifth Dynasty, got the throne. But a document known as the Westcar Papyrus insists that the wife of a priest of Re was the mother of Userkaf and his two successors.

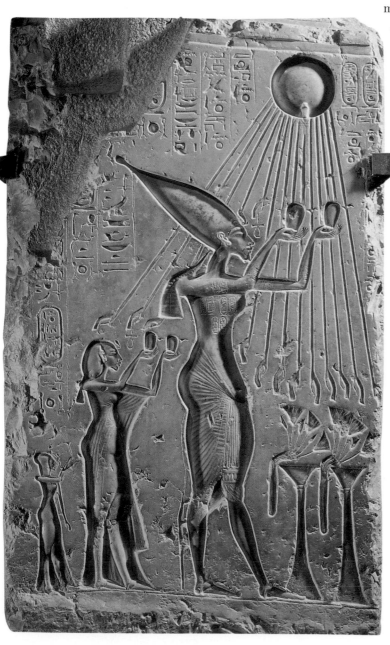

If Userkaf was connected with the Re priesthood, possibly through a junior line of the Fourth Dynasty, springing from Cheops, this would help to explain the dominant role played by the Re cult in the Fifth Dynasty. For the first time since the creation of the united kingdom, there is a hint that the monarch is in some way inferior or subordinate to the gods. The Fifth Dynasty kings no longer built pyramids at Giza, which by their sheer bulk testified to their importance in the cosmos: instead they built sun-temples to Re, chiefly at Abusir. These temples were part of pyramid complexes, but the royal pyramids were very much smaller than under the Fourth Dynasty, and the temples larger. In fact, the sun-obelisk of Nyuserre, sixth king of the dynasty, was actually five feet higher than his 165-foot temple. These obelisks, which now first make their appearance, were based on the sacred stone of Re which stood in the forecourt of the principal temple at Heliopolis. At sunrise, when its rays touched the gilded top of the stone, the sun-god took his seat. At the foot of the stone was an altar, where sacrifices of sheep, goats and cattle to the sun-god were carried out on a prodigious scale. Much of this sacrificial meat, and offerings of bread, beer and cakes, were distributed to the masses at feasts: under the Fifth Dynasty, 100,600 meals were provided on New Year's Day. The Re ceremonies were

conducted in the open, as was natural. When the king conducted them, therefore, there was no question of his locking himself up in the innermost sanctuary and communing with the god in secret and on terms of equality. He could be seen by vast crowds, prostrating himself, and his subordinate status as son and priest of Re was made manifest. The bounties of the Temple appeared to come rather from Re than him.

Hence Herodotus's tale of a quarrel between Cheops and Chephren, the two Old Kingdom monarchs who made the most audacious claims on behalf of their godhead, and the temples, may represent a tradition of conflict between the secular and the clerical power – a conflict which broke out again in the Eighteenth Dynasty under Akhenaten (Amenophis IV) and led to a dual monarchy in the Twenty-first Dynasty. The clergy controlled the historical records in distant antiquity, as in the Dark and Middle Ages, and monarchs who were seen as anti-clerical at the time were always liable to be presented to future generations and to us as 'unpopular'. The government of Egypt might be a theocracy, but it always contained the elements of a Church–State conflict. The Church tended to undermine monarchical power in quite another way, by eroding its economic base. Pyramids were not only immensely expensive to build, at any rate on the scale of the Giza series, but it was of the essence of Egyptian religion that they had to be 'served' for all eternity. Kings like Cheops who built hugely made provision for the cult of their tombs on a similarly generous scale. This meant alienating royal estates in perpetuity: we know, for instance, that the cults of the Fourth Dynasty monarchs at Giza were still flourishing during the Eighteenth Dynasty, well over 1,000 years later. Some of these religious estates were partly self-supporting. When a pyramid city was finished, a small community of priests, workmen and craftsmen remained to look after it for ever. The desert plateau was thus the home of many small settlements, with their farms and gardens stretching down to the edge of the cultivated area in the valley below. They were the prototypes of the later Christian monasteries, first created on the verge of the desert in the third century AD. But other religious institutions, notably the temples in the cities, were wholly supported by royal endowments, often very generous ones. There was thus a continuous and cumulative drift of royal land into mortmain, the 'dead hand' of the Church.

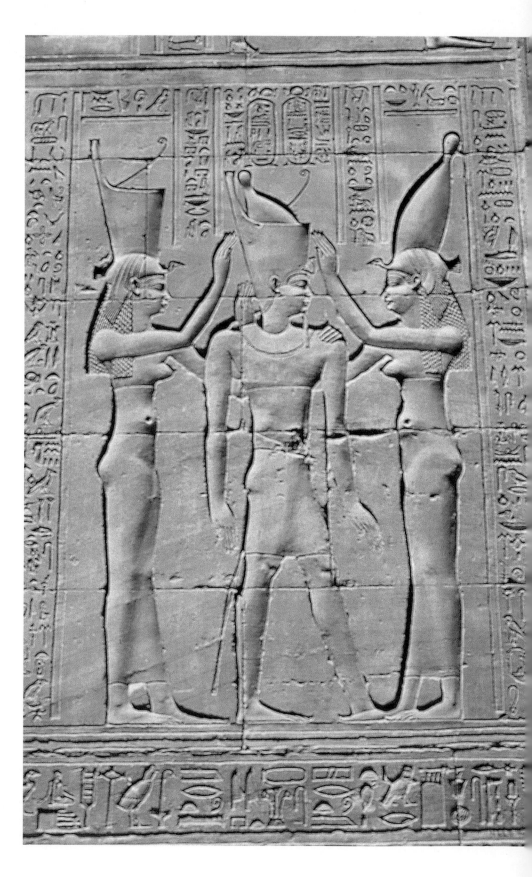

Right: *Relief from the Horus temple showing the coronation ceremony of kings.*

This might not have been so significant had the monarchy maintained its position of absolute dominance in secular society. In the early Old Kingdom, all land, indeed all property whatever, was held to belong to the king. This regal socialism remained the theory. In practice the transfer of land to the Church, endowments being recorded in solemn documents and inscriptions, created the notion of privately held real property, on which secular lords eagerly seized – more particularly since it called back traditional memories of regional baronies before the united kingdom. Under the Fourth Dynasty royal land was undoubtedly alienated to secular nobles; but the king could and did take it back. From the Fifth Dynasty onwards, some nobles seem to have disposed of their property freely, and the number so privileged, 'honoured before the god', grew.

Hereditary tenure of office developed alongside the establishment of private property. Under the Fourth Dynasty all the top jobs being kept within the royal family, the entire administration was conducted from the royal palace and household – a true patriarchal system. But with the growth of the state, it proved impossible to maintain this primitive state. Under Neferirkare, third king of the Fifth Dynasty, a study of the titles inscribed in tombs reveals for the first time a standardized, bureaucratic system. This was the point at which the civil service split off from the household and became independent. Recruitment of commoners for senior posts was resumed. As a matter of fact, the kings themselves may not have liked the patriarchal system. In all ages, monarchs have tended to prefer able men promoted from the ranks to ambitious relatives. No pharaoh is a god to his valet – or his family. The serpent in the patriarchal paradise, as it were, was the harem conspiracy. The bored and restless harem women, and still more their private officials, tended to engage in ceaseless intrigues to promote the interests of favourite sons and nephews; so much the worse if these were already endowed with high office. From Abydos there is the revealing life-history of Weni inscribed in his tomb. He was a noble who became a great general in the reign of Pepi I of the Sixth Dynasty. He first achieved official prominence by investigating and putting down a harem plot. The kings raised such creatures to counter the power of the central bureaucracy and priesthood. They attempted administrative reorganization, as shifts in the names, ranking and ordering of titles in tombs indicate. Viziers now came to be chosen from among the provincial magnates, and kings built up the authority of the nomarchs to counter civil service power in Memphis.

But the cure was worse than the disease. Under the Fifth and Sixth Dynasties we note the steady development of a kind of feudalism. High-placed men, who would not have dared publicly to record their names under Sneferu or Cheops, now set up boastful stele at the scene of their exploits. The royal burial grounds no longer served as magnets for noble tombs, or to a much lesser extent. The many splendid private mastabas of the period, richly decorated with limestone reliefs and elaborate biographical inscriptions, include the famous tombs of Ti, Ptahhotpe and Akhtihotpe from the Fifth Dynasty, and from the beginning of the Sixth Dynasty the tombs of the viziers Kagemni and Mereruka. Many nobles were now buried in their localities. 'I made this,' says the tomb of Djau, 'in Abydos of Thinis … through love of the district in which I was born.' Under the totalitarian monarchy of the Fourth Dynasty, the right to record a personal inscription, which was of course a private message to the gods, was a rare privilege; so was a portrait sculpture, and its transport and installation in a tomb. Under the Sixth Dynasty, such privileges were usurped, and the private tombs of the rich were equipped with religious devices hitherto the monopoly of the ruler.

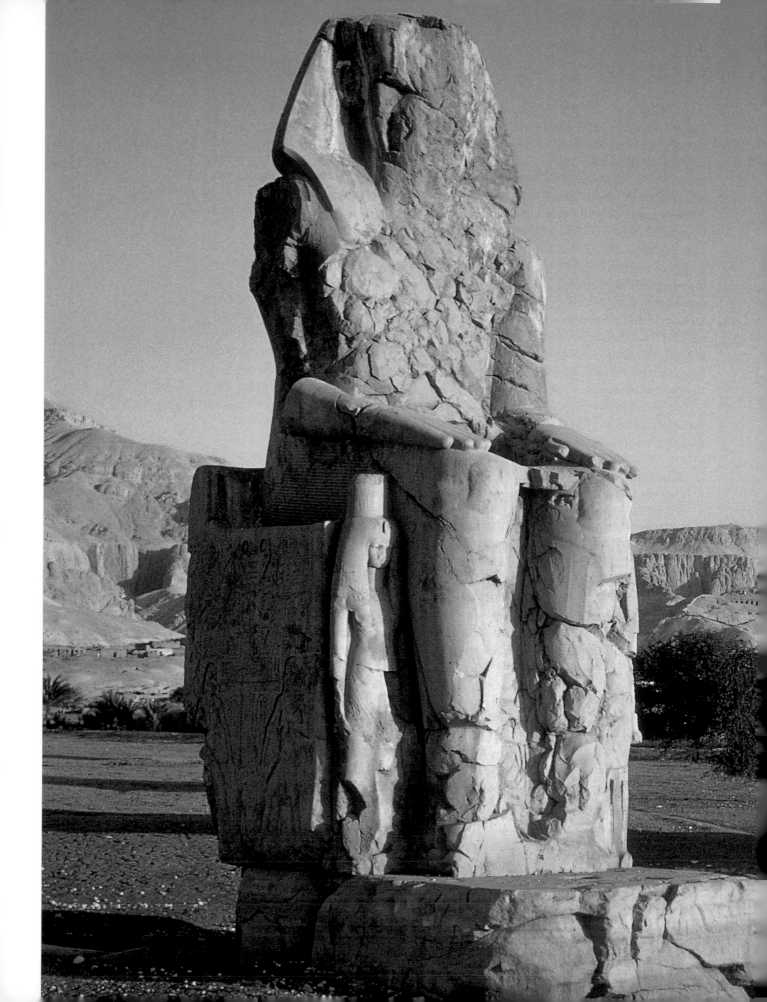

THE EMPIRE OF THE NILE

The collapse of civilized living and the rule of law which followed the end of the Old Kingdom indicated Egypt's perilous dependence on the single politico-religious institution of the pharaoh. And the fact that pharaonic rule was successfully re-established shows that the Egyptians were well aware of their historic needs. Continuity, conservatism, tradition, hierarchy and the subordination of the individual will to the demands of order were the great conceptual custodians of Egyptian culture. And yet, even when the foundation of the Middle Kingdom ended the feudal provincialism and near-anarchy of the First Intermediate Period, things were never the same again. The patriarchal rule of a god-king, governing by sheer divine authority from a palace which was also the seat of government, was a phenomenon of the Early Bronze Age of the third millennium BC, and could not be resurrected in the second – except, of course, in the semi-barbarous petty states of Minoan Crete and Mycenaean Greece.

Above: The Occupations of the dead in the fields of Ialu from the Papyrus of Ani.

Previous page: The two gigantic statues, the Colossi of Memnon, built by Amenophis III.

From the Fifth Dynasty, around 2400 BC, we have a document called the *Instructions* of the Vizier Ptah-Hotep, laying down the rules of wisdom and decorum. It was copied many times in later periods but its spirit is essentially that of the Old Kingdom: be obedient to established authority, submit to your superiors in all things, defer to your elders and keep a humble and subordinate heart – 'An obedient son is a follower of Horus', a phrase which might have served as a motto for the entire early period. The texts which originate from the Intermediate Period and the Middle Kingdom seem to come from a different age, almost a different moral universe. A recurrent phrase, 'He spoke with his own mouth and acted with his own arm', testifies to a new, self-conscious individualism. The willingness of men to act out their own thoughts and opinions was less pronounced at the height of the Middle and New Kingdoms, when pharaonic rule was firm and respected. But it never again entirely disappeared. How could it? Men no longer believed they were part of a collective personality, subsumed in the pharaoh. An ever-growing circle of people were now convinced that each of them had an individual soul in eternity, which implied a separate personality on earth. Towards the end of the Old Kingdom, powerful nobles had usurped the religious devices and magical spells written down in Unas's *Pyramid Texts* and which were then the absolute monopoly of the god-king. In the Middle Kingdom these sacred writings appear increasingly in the coffins of private individuals, and so are known as the *Coffin Texts*. In the New Kingdom they are used far more widely, written on papyrus scrolls placed with the bodies of the dead in their tombs, and known to us, in compilation form, as the *Book of the Dead*. This process of spiritual democratization, which gave the dignity of a separate soul, and the right to an individual judgment in eternity, first to the rich and then to masses of ordinary people, is one of

the most important phenomena in world history. To use a phrase of the great American Egyptologist J.H. Breasted, it is 'the dawn of conscience'.

Once the idea of individual conscience has become established, mankind can never be the same again, even though its rights are subsequently denied and suppressed. Indeed, the development is political as much as spiritual. In the *Coffin Texts* there is a striking passage which stresses the common humanity of man in the eyes of God. The 'All-Lord' is made to say, commenting on his creation:

> *I did four good deeds within the portal of the horizon. I made the four winds that every man might breathe thereof like his fellow-men. I made the great flood that the poor man might have rights therein like the great man. I made every man like his fellow. I did not command that they do evil – it is their own hearts which tell them to break my commandments. I made them remember the dead and make offerings to the gods of their local nomes.*

The last 'good deed' is more important than it seems at first glance: it was a recognition that eternity, once the sole prerogative of kings, might be secured by a good man locally, away from the religious magnet of the royal court and tomb. It is a text of spiritual feudalism (as opposed to spiritual anarchy) and a comment on the practice of nobles being buried in their homes instead of clustering round the totalitarian pyramid of the king.

The inevitable consequence was a shrinking of the pharaonic myth, and its personified reality. Indeed, confidence in all the old certitudes was shaken; the age of innocence and trust was over. One text consists of a dialogue of the soul about suicide – which illuminates Ipuwer's sinister statement: 'Men go to the crocodiles of their own accord.' Another, termed *The Song of the Harper*, preaches a thoughtless hedonism:

> *Make holiday, have a good time without wearying.*
> *For it is not given to man to take his property with him.*
> *No one who leaves this life ever comes back.*

The song sneers at the wisdom of Imhotep and Hordedef, whose tombs are forgotten. Evidently, the ransacking of the royal tombs in the anarchy made a deep impression on the Egyptians, suggesting to many that preparing for the future was futile – even a pharaoh could become a pitiful heap of bones thrown on the floor of a violated sepulchre. In the alabaster quarries of Hatnub, between Memphis and Thebes, where the Hare nomarchs flourished, graffiti treat them as though they were pharaoh – the marginal role played by pharaoh or his total absence, is a characteristic of many of the documents of these times.

Even when the anarchy subsided, pharaoh re-emerges in the documents as a politician not a god, a cautious, apprehensive and pessimistic manipulator, obliged to work hard in order to stay in power. Merikare, who ruled from Heracleopolis, and was a member of the obscure Tenth Dynasty, left a set of political instructions by his father, which throw a lurid light on the faction-politics of the day:

> *[if a man] is gracious in the sight of his partisans … and he is a demagogue, a talker, remove him, kill him, wipe out his name, destroy his faction, banish the memory of him and of his followers who love him … The contentious man is a disturbance to the citizens: he*

provokes two factions amongst the youth. If you find he is attracting a following … denounce him in front of the court and remove him. He is also a traitor. A talker is an exciter of the city. Divert the multitude and calm it down … Be a craftsman in speech, so that you may be strong. The tongue is a sword and speech is more effective than fighting.

This is a thoroughly feudal document. A king must remain on good terms with the nobility, especially the young scions of fighting age:

Advance your great men, so that they may carry out your laws … powerful is he who is rich in his nobles … Never deprive a man of his father's property and let officials keep their hereditary posts … Look after the younger generation so that your Residence City will love you. Recruit new followers. Behold your citizenry is full of growing boys … Make your officials great, advance your soldiers, recruit friends among the younger generation and provide them with property, lands and cattle.

Another illuminating set of royal instructions purports to have been written by Ammenemes I, the first king of the Twelfth Dynasty, to his son. The king had evidently been let down by his bodyguard and killed in a conspiracy or a sudden rush of malcontents on his palace. The king told his son he should trust absolutely no one. The very men he had raised from nothing had plotted against him. Subordinates, even if not actively treacherous, were liable to be careless. He himself had been surprised while asleep at night: '… I had not prepared for it. I had not even thought of it. My heart [mind] had not accepted the possibility of the slackness of servants …' No one was dependable: a king must look after himself. We have here a very mortal and apprehensive monarch, rather than a divinely self-confident Horus-king.

It was against this background that the Middle Kingdom was established. After the collapse of the Sixth Dynasty there seems to have been a gap when no pharaoh ruled the whole of Egypt, or perhaps at all. Manetho's 'Seventy kings who reigned seventy days' may have been an ephemeral coalition of barons. We know little more about the Eighth Dynasty, though inscriptions bearing the names of some of them have been found at Coptos in Upper Egypt. Effective government devolved on the hereditary families of the nomes. Gradually, stronger nomes, or groups of nomes, emerged, as in the pre-unification period. The first of these, Heracleopolis, produced the family of the Achthoes, who claimed royal status, produced eighteen kings of the Ninth and Tenth Dynasties, succeeded in re-establishing themselves at Sakkara. Manetho, reflecting the tradition of their ruthless road to power, says that Achthoes was 'terrible beyond all before him and wrought evil for all Egypt, but afterwards went mad and was destroyed by a crocodile.' But a much earlier Middle Kingdom document is a short story, set in their court, which gives a different picture. This *Story of the Eloquent Peasant* tells of a peasant on a journey who was robbed of his donkey and goods by a rapacious Chief Steward. His complaints that the law had been broken, and that those charged to uphold it were the principal malefactors, were so noisy, protracted and well-argued that eventually the king gave him justice. Like Ipuwer's lament, it provides the unthinkable spectacle of the pharaoh being upbraided – a sign of the times – but it also suggests that the Egyptians had grasped the concept of equality before the law, and thus possessed one of the marks of civilization even in this dark period.

Ruthless or not, the Achthoes could never establish their power either in the Delta or in the real south. There the noble family of Inyotef, which came from Thebes, centre of a rich plain to the east of the river, seized the leadership of a rival group of nomes, and the battles that followed are glimpsed in one of the Achthoes tombs. The first Inyotef, founder of the Eleventh Dynasty, was described as 'Great Chief of the Theban Nome', 'Hereditary Prince' and finally 'Great Chieftain of Upper Egypt'. His second successor was termed 'Pacifier of the Two Lands' and his name was placed within a cartouche, signifying his royal status: by the end of his reign Heracleopolitan power had been crushed. The last Inyotef, third of the line, claimed to be king of Upper and Lower Egypt, and his successor, the second of four monarchs called Mentuhotpe, completed the reunification by taking Heracleopolis and subduing the Delta.

The kingdom thus reconstituted was still essentially a feudal one; the shift from the Eleventh to the Twelfth Dynasty was a feudal move. By the time of Mentuhotpe III, the royal practice of mounting great desert expeditions to obtain precious stones, gold and blocks of fine stone for monuments had been resumed. One such, in quest of material for a splendid sarcophagus for the king, was led by a vizier called Ammenemes, and gloriously attained its object with the help of a miraculous well and a magic gazelle, or so his inscriptions tell us. As he is described as 'son of Somebody', he must have been a feudal noble but not royalty. When Mentuhotpe IV died, presumably without male heirs, Ammenemes was powerful enough, doubtless aided by marriage to an Eleventh Dynasty princess, to seize the throne and found the Twelfth Dynasty, an act subsequently justified – as a biographical papyrus now in Leningrad tells us – by discovery of an ancient prophecy. But he was not much more than 'the first among equals', and had to be very active all over the country – settling disputes, fixing boundaries, administering justice – to ensure that the royal will counted at all. A characteristically feudal document is an inscription in the tomb of Khnemhotpe, nomarch of the Oryx nome in Upper Egypt. It says that Ammenemes had appointed him to be:

> … hereditary prince, count and governor of the eastern deserts … He fixed his southern boundary-stone and secured his northern one like heaven … His Majesty had come that he might crush iniquity, arisen as Atum himself, and that he might repair what he had found ruined, what one town had seized from another, and that he might enable the towns to know their boundaries with each other, their boundary-stones being secured like heaven, and their water-rights, according to what was in the documents and verified according to antiquity, through the greatness of his love of maat.

Ammenemes I, in short, was a very active, ubiquitous feudal monarch and one of Egypt's greatest pharaohs, but he was murdered in his own palace. The finest of all ancient Egypt's literary documents, the *Story of Sinuhe*, begins when news of the king's death reaches his eldest son, who was on campaign in Libya, and Sinuhe, a young courtier who fears he may be implicated in the conspiracy, flies abroad – his travels and subsequent return forming the gist of the tale. The work of Ammenemes I did not, then, bring back the monumental stability of the Old Kingdom.

The kings of the Twelfth Dynasty, called either after their founder, or his father Sesostris, strove hard to convert their feudal state into a totalitarian one. As a precaution, they brought their designated heirs into government as co-rulers, a practice called 'the staff of old age'. Their object was to make the nomarchs non-hereditary, and

Above: *An Egyptian painting of a Nubian and an Asiatic prisoner, bound at the elbows and at the feet.*

towards the end of the dynasty they may have succeeded. At any rate, the tombs of nobles ceased to be found in provincial cemeteries. But much of their time was spent reinforcing Egypt's geographical isolation by artificial means. Ammenemes I built defensive lines and forts to keep out Asiatic infiltrators. He boasted: 'I made the Asiatics do the dog-walk.' We have a stele belonging to a general, Nesmont, telling how he was sent to destroy the castles of dangerous Asiatic princes, and Sesostris III led a punitive expedition into Palestine. Egyptian objects from the Twelfth Dynasty have been discovered in plenty in Syria, and for the first time Asian slaves became common in Egypt. The Twelfth Dynasty kings also invaded and pacified Nubia, where the pressure of population and the emergence of ferocious warrior tribes presented Egypt with a much more serious problem than any of the Old Kingdom monarchs had had to face. They built a series of huge fortresses between the First and Second Cataracts and policed the area with great thoroughness. The British Museum has a series of papyrus letters in which the fortress commander at Semna, at the southern end of the Second Cataract, reported almost daily to the authorities at Thebes on the movement of tribes to the south.

They were also active in the Fayum, where they reclaimed many thousands of acres from marsh, dug canals and basins, created a giant lake known in classical times as Lake Moeris, and built a multi-room structure – actually the funerary temple of Ammenemes III – which later gave its name to the famous Cretan Labyrinth at Knossos, and was hailed by Herodotus, who inspected it, as an even more spectacular creation than the pyramids. Nothing of it now remains. Indeed, to a surprising degree the physical legacies of the Twelfth Dynasty have been erased by time. A number of royal statues and buildings were simply appropriated by New Kingdom monarchs by replacing the original cartouches with their own, or demolished to provide building materials for new monuments. But several very fine royal portrait-statues survive: sombre, thoughtful, introspective works, which have all the magisterial authority of the Old Kingdom, but seem less confident, almost worried. These monarchs are weighed with responsibility and display manifest concern for the people whose welfare they must safeguard. The symbol of the shepherd's staff was adopted by royalty, and the idea of a king as the shepherd of his flock permeated the Middle Kingdom, to be adopted later in Old Testament and Christian imagery. The literature of the period emphasizes the moralistic notion that power has its duties as well as pleasures. Middle Kingdom literature, in fact, is very rich: most of the finest texts which have come down to us date from this time, at least in their original form. The language had by now acquired considerable flexibility and expressiveness and was in its 'classic' period. During the New Kingdom and the Late Dynastic periods, tradition-minded scribes customarily went back to Middle Kingdom examples for perfection of form and the chief texts became copybook models in the schools.

The Middle Kingdom also produced its supergod, Amun. In origin he was not a local Theban deity, but he was a very old, indeed primeval god, and he seems to have been set up deliberately as a Theban counterpart to Ptah of Memphis and Atum of Heliopolis. The cult of Amun thus became the official state religion of the royal family. But he was more than this. His great merit was that he was unseen and could be declared to be immanent everywhere. He was protean and syncretistic and could be

united conveniently with other important gods such as Re. He could travel and was thus potentially an imperial god. In many respects, then, he was an ideal deity for political purposes and his career was one of the great theological success stories of antiquity. It was Sesostris I who inspired and first began to create the magnificent Temple of Amun at Karnak, near Thebes; virtually all the subsequent kings of Egypt embellished and added to it, tearing down their predecessors' work to make room. It grew over 2,000 years, a longer lifespan than any Christian cathedral.

The Theban kings also made use of the superb natural amphitheatre of Deir el-Bahari in the western sandstone cliffs on the opposite side of the river. The experience of the Old Kingdom had finally persuaded Egyptian royalty that pyramids built in the open, however massive and ingenious, could not be made thief-proof. They therefore adopted the device of the rock-cut tomb. About 2040 BC, Mentuhotpe III, of the Eleventh Dynasty, built his mortuary temple at the southern end of Deir el-Bahari where the rocky cliffs under the peak of El Qurn are steepest. In this magnificent setting, the work combined a pyramid as a memorial, and a temple built on a terrace, part of which was cut out of the cliff face. Beneath it, at the end of a long passage cut through the rock far below the cliff, was the burial chamber. The base of the pyramid above was in a square pillared hall and the terrace was partly enclosed in colonnades. The idea was ingenious and its execution embodied new and elegant concepts in architecture, above all the use of columns in the open, enclosing light as well as space. But it was no more proof against Egypt's criminal classes than any of its predecessors; indeed, the Theban area, which over the next thousand years became the greatest and richest necropolis of antiquity, bred criminal village clans of unparalleled cunning and ferocity.

Below: *The single remaining column of the colonnade of Taharka in the Great Court of the Temple of Amun, Karnak.*

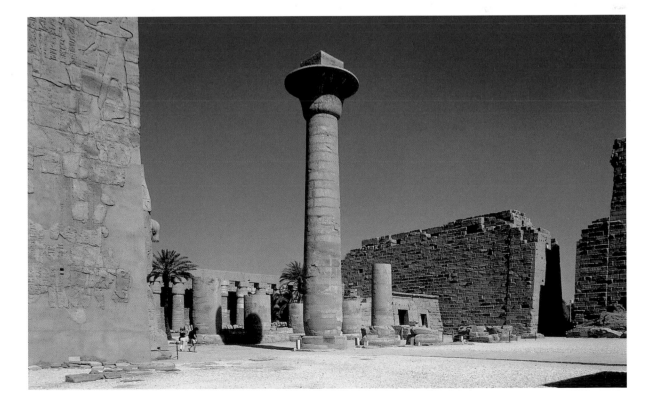

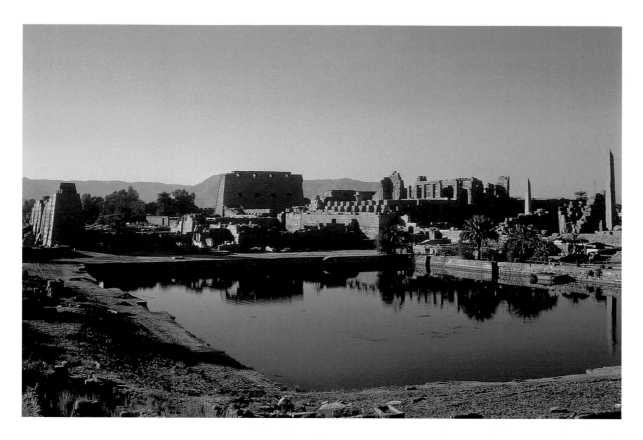

Above: *View across the Sacred Lake looking at the Temple of Amun, Karnak.*

The dynasty itself proved no more durable than its burial arrangements. In seeking to suppress feudal provincialism entirely it overreached itself, and nemesis came about in 1790 BC, with a failure of male heirs and a female sovereign, Sobkneferu. It was succeeded by the Thirteenth Dynasty but it is unlikely that its later kings controlled the whole country, and the next 200 years, until the creation of the New Kingdom under the Eighteenth Dynasty in about 1570 BC, is known as the Second Intermediate Period. Later Egyptian propaganda presented this Dark Age as a shameful and cruel foreign conquest by the *hekaukhasut*, 'princes of foreign countries' – a term Manetho misleadingly presents as *Hyksos* or 'shepherd kings'. The reality may have been different: it is possible that many Egyptian provincial nobles, in reaction to the centralizing policy of the later Twelfth Dynasty kings, joined forces with Asian elements to drive out the legitimate royal line and set up petty kingdoms. In the Berlin Museum there are fragments of pottery bowls, dating from this period, which were covered with the names of State enemies and then smashed to pieces in solemn cursing rituals. Like many early peoples, the Egyptians made no absolute distinction between name, image and the real person, and believed that to destroy or erase a man's name was to inflict physical injury upon him – hence the striking phrase in *Merikare*, 'Wipe out his name!' These *Execration Texts* list a number of Asian princes by name, 'and all the retainers who are with them … their strong men, their swift runners, their allies, their associates … who may rebel, who may plot, who may fight, who may talk of fighting or talk of rebelling, in this entire land.' But they also include curses against rebellious Egyptians, 'all men, all people, all folk, all males, all eunuchs, all women and all officials who may rebel, who may plot, who may fight, who may talk of fighting' – and so forth. The

execrations are childishly all-inclusive, and end by cursing all evil of any kind everywhere, but they conjure up the picture of an impotent Egyptian court fulminating in senile fashion against a combination of foreign and domestic enemies.

A tradition later reported by the Roman-Jewish historian Josephus says the Hyksos won Egypt without a battle. Though regarded by the Egyptians, at any rate in official propaganda, as barbarians – Queen Hatshepsut of the Eighteenth Dynasty called them 'vagabonds' – they in fact had a superior military culture, which included fighting-chariots drawn by horses, and composite bows, made of wood and horn, and sinews. They had body armour and very sharp, rapier-like bronze swords, of a type which now began to dominate the warfare of the second millennium. One of their rectangular fortified camps, big enough to enclose 10,000 men and their chariots, has been found at Tell el-Yahudiyeh in the Delta (there are others in Palestine and Syria), but they did not try to impose their civil culture on Egypt. On the contrary: like later occupants, they tried to assume at least the outward form and ideology of the Egyptian Crown, already by far the oldest and most august institution in the known world. So far as we can judge, the Hyksos kings of the Fifteenth Dynasty, and the lesser Asian chiefs who formed the Sixteenth, had mainly Egyptian civil servants. A Nineteenth Dynasty folk-tale tells of the Hyksos king, Apophis, living in Avaris in the Delta, complaining that he was disturbed by the noise of the Hippo pool in Thebes, hundreds of miles away; this and other evidence indicates that they had adopted Seth – the ambiguous god-devil who occurs again and again in Egyptian political history – as their chief deity. Apophis II resorted to the old Egyptian regal trick of appropriating fine effigies of his predecessors: he put his own cartouche on sphinxes belonging to Ammenemes II and colossal statues of a Thirteenth Dynasty king. But Hyksos kings also built temples of their own to the Egyptian gods, and patronized Egyptian art and literature. The capital they embellished, Avaris, was an Egyptian-style town, and New Kingdom pharaohs took credit for it.

Nevertheless, the supremacy of a small ruling class of foreigners was a deeply-resented affront to Egyptian pride, at any rate in Upper Egypt, always in Egyptian history the source of national unity. It was the Upper Egyptians who had first created the kingdom, and restored it under the Eleventh Dynasty; now, again, it was a Theban noble family which rebuilt united Egypt. While the people of the Delta accepted the Hyksos, the Thebans hated them, not least because they were in alliance with their traditional enemies, Nubians and Kushites, to the south. We have the mummy of a Seventeenth Dynasty Theban ruler, Seqenenre Tao II, known as 'the Brave', who seems to have had his head crushed fighting the Hyksos. His son and heir, Wadjkheperre Kamose, carried on the struggle with great determination. A surviving papyrus fragment, evidently a schoolboy's copy of a well-known New Kingdom Text, shows Kamose debating with his 'council of nobles' whether he should break the truce which carved up Egypt between himself and the Hyksos rulers. They advise maintaining the *status quo*; but he was for a patriotic war of liberation:

> *Let me understand what this strength of mine is for! One ruler in Avaris and another in Kush, and I sit on a level with an Asiatic and a Black. Each one of them has his slice of our Egypt, dividing it up with me … No man can rest in peace while he is racked by the taxes of the Asiatics! I will seize the Asiatic and cut open his belly. My policy is to save Egypt and smite the Asiatics!*

The business of expelling the Hyksos, which took two generations, was finally accomplished under Kamose's brother, Amosis, founder of the immense Eighteenth Dynasty and the New Kingdom who effected a profound change in Egypt's attitude to the external world. It was the end of 'splendid isolation'. The Old Kingdom had been content within its frontiers, limiting its foreign contacts to trade and punitive raids. The Middle Kingdom had resumed this policy in all essentials. True, it had annexed Nubia and penetrated deep into Kush and Palestine to punish intrusive foreigners. But it had rested its security in the powerful fixed lines and massive forts it had built on the eastern frontier and in the cataract region. The shameful catastrophe of the Hyksos takeover proved that such a conservative policy would no longer suffice. The development of sea-power and chariot-warfare made the Sinai desert an inadequate *cordon sanitaire*. Egypt, it seemed, had no alternative but to push its frontiers deep into hostile territory and turn 'the Princes of Retenu', as they called western Asia, into satellites or reliable allies. One of the themes of the New Kingdom was 'No security except on the Euphrates'. Thus the expulsion of the Hyksos developed into an Asian adventure and the search for peace into Nilotic imperialism. One important document from the beginning of the Eighteenth Dynasty, a tomb-inscription from Upper Egypt, indicates that the operation which finally drove the Hyksos army off Egyptian soil led to a war of conquest in Palestine. The tomb's occupant, who began life as a sea-captain, tells us he was awarded seven gold medals by the pharaoh for his part in a series of Asian

Below: A wall painting from the tomb of Rakhmere, court official under Tuthmosis III and Amenophis II at Thebes showing goldsmiths at work. Egypt was the greatest gold-mining and gold-exporting power.

campaigns. The motive initially was revenge against the foreigners, an emotion which seems to have stirred Egyptian breasts for at least 100 years after the Hyksos vanished from the stage of history, but it was gradually absorbed by the new political gospel of imperialism.

Yet the Egyptians were at no stage a colonizing or conquering people. From first to last they hated living, and still more dying, outside Egypt. Burial in Egypt was a privilege and pious folk refused to go abroad at all, let alone as occupying troops or colonists, thus risking burial in lands where there were no ancestral gods. The Egyptians never developed either the military ferocity or the administrative skills of the Hittites, Assyrians and Persians. Their empire was based not on satrapies but on buffer-states and client-princes, trade and gold. International trade was expanding anyway around the middle of the second millennium BC: it was the first great cosmopolitan age in world history. Egypt exported linen, papyrus, salted fish and corn; it imported wine, olive oil and massive quantities of timber – not only Lebanese cedar and fir but oak, ash, beech and birch from Asia Minor. These trading expeditions were led by Egyptian royal commissioners, 'Treasurers of the Gods', and the pharaoh was a gigantic wholesale merchant, using Byblos as an entrepôt. Most of the overseas trade went through there, but the Egyptians also sailed direct to Cyprus, which supplied them with copper, and Crete, whose artistic influence on Egypt has left distinct traces from the Middle Kingdom onwards. Egyptian ships and traders may also have sailed into the Aegean and along the southern coast of Turkey. We have, too, pictorial records of Cretan voyages to Egypt. The Egyptians liked to treat these expeditions as embassies and their goods as 'tribute'. In reality, trade was a matter of barter, adjustments in payment being made in corn, copper bars or sheets, or precious metals like silver (now more plentiful), gold or electrum, which combined the two. Egypt was the greatest gold-mining and gold-exporting power: in fact it was gold rather than military success which sustained her 'empire' and which made her the principal world power throughout the third quarter of the second millennium BC.

We can indeed follow the influence of Egyptian gold in the inter-state correspondence which became a feature of the period, written on clay tablets in Akkadian cuneiform, the language of cosmopolitan diplomacy, but sometimes annotated in hieratic script by Egyptian officials. The Syrian state of the Mitanni, violent foes of the Egyptians in the first decades of the New Kingdom, was transformed by Egyptian subsidies into a buffer-state against the expanding Hittites further north. Thus we have King Tushratta of Mitanni writing to Amenophis III: 'My brother, pray send gold in very great quantities such as cannot be counted. My brother please send me that. And my brother please send me more gold than my father got from you. For in the land of my brother, is not gold as plentiful as the dust upon the ground?' This exigent prince, it should be added, was Amenophis III's father-in-law, for another feature of the new cosmopolitanism was royal intermarriage. Hitherto, Egyptian pharaohs had never married outside their country, and even during the New Kingdom period it was considered demeaning for an Egyptian princess to give herself to a foreigner, however exalted, for in Egypt (as among the Jews and certain other Semites)

Above: *Gold dish belonging to Pharaoh Sheshonq from the royal tomb at Tanis, Twenty-second Dynasty.*

the birthright of blood was thought to pass through the mother. But now pharaohs married foreign brides – Amenophis had three – and such matters as dowries took up much of the diplomatic correspondence.

The costly presents thus exchanged account, in part, for the development of a rich 'international style' in artefacts which flourished between about 1500 and 1200 BC. But there were also quite substantial movements of population. It was the first great age of slavery. Egypt, as the richest and for a long time the most successful power in the Middle East, was a major recipient of slaves. It was the Egyptian custom to turn prisoners of war, if they were not slaughtered on the spot, into conscript soldiers. She was also beginning to recruit foreign mercenaries. They first make their appearance during the campaigns against the Hyksos; gradually, as we can tell from pictorial evidence, they formed whole regiments and often supplied pharaoh's household troops. Nubians had been recruited as policemen since Old Kingdom times; now they were joined by Libyans, Palestinians, Greeks, from 'the islands of the Great Green', men from 'Keftiu' (Crete) and 'Ity' (Cyprus) and such 'Peoples of the Sea' as the Sherdan, who wore horned helmets. As an imperial power, Egypt had no alternative but to strengthen her army with foreigners, since Egyptians were incorrigibly reluctant to risk death and burial abroad or even to serve in Asian garrisons. But the mercenaries were often resettled by the State, when they retired, on Egyptian Crown land, usually reclaimed marshland in the Delta or the Fayum, and thus became a permanent part of the population.

There were other immigrants. Despite its low Niles and lean years, Egypt was the most reliable food-producing centre of antiquity, and a famine refuge from earliest times, or at least since the twentieth century BC: 'There came a famine in the land so severe that Abram went down to Egypt to live there for a while' (Genesis 12:9). The presence of a large Jewish community in the Egypt of the thirteenth century BC, on which the Old Testament casts an illuminating light, is largely confirmed by Egyptian sources. From the fifteenth to the twelfth centuries BC, Egypt occasionally harboured starving groups or issued them with grain from her stores. There is a mid-fifteenth century papyrus in Leningrad which mentions leaders from Megiddo, Taanach, Hazor and Ashkelon appearing before the pharaoh for supplies, just like Jacob's sons. In another document, an official on the Sinai frontier reports: 'We have completed the transfer of the tribes from Edom by way of the Merneptah Fortress ... to provide sustenance for them and their herds.'

A number of Egyptian documents of the period refer to Apiru (from the Akkadian tongue *Hapiru* or *Habiru*, hence Hebrew). To Egyptians this did not mean a special racial or ethnic group but a social concept – inferior people who were employed on forced labour. A letter from the time of Ramesses II, very likely the archetypal pharaoh of the Bible, commands: 'Distribute grain rations to the soldiers and to the Apiru who transport stones to the great pylon of

Below: *Hatshepsut, although a woman, called herself king and was depicted wearing masculine regalia and a false beard.*

Ramesses'. This matches Exodus I:II, where we are told the Jews 'built for pharaoh store-cities, Pithom and Ramesses'. Ramesses II came from the Delta, and the second of these towns was his new palace-capital; Pithom was the other city he founded, Per-Atum, in the land of 'Goshen'. The Egyptian frontier defences, much strengthened by a line of forts built by Ramesses II's father, Sethos, around 1300 BC, were designed to prevent the departure of conscript labour, as well as the infiltration of undesirable tribes. Hence Moses, having failed to secure official permission for his people to leave, slipped out with them at night and took the southerly route to avoid the forts which straddled the direct route to Palestine along the coast. Of course the Biblical writers heightened and dramatized a story which, to the Egyptian officials who administered an increasingly cosmopolitan country, was a routine affair which has left no trace in their records.

The Egyptians were always ambivalent about these cosmopolitan contacts and the foreigners in their midst. By the mid-second millennium, Egypt was no longer an innovatory culture, and was a mere recipient of new ideas, techniques and products. But cultural imports, though welcome in one sense, were an affront to a civilization which believed itself self-sufficient and rated all change as vice. However, Egyptian establishment opinion was at least united on policy towards the south. All agreed the south had to be held and exploited. The great achievement of the Twelfth Dynasty kings was to conquer and thoroughly 'Egyptianize' the stretch between the First and Second Cataract. This had its own kings during the Second Intermediate period, but the Eighteenth Dynasty kings took up the burden quickly, re-established the fort of Buhen, below the Second Cataract, and the town of Iken, near Wadi Halfa, which served as an obligatory 'staple' market for the whole area, and then gradually pushed further south. They never pushed their power below the Fifth Cataract, but all the area to the north of it was Egyptianized, dotted with forts and trading posts, and in part administered and exploited by temple-monasteries, founded by the kings and endowed with valuable commercial and mineral rights.

In the south, the Egyptians prefigured the colonial patterns of the distant future. They valued it for its exotic produce (especially skins) which they paid for in cheap glass beads and trinkets, for its big game hunting, and for its quarries and mines. Aswan produced monolithic granite obelisks which made possible Egypt's finest achievements in the working of stone. As long ago as the Twelfth Dynasty, Sesostris I, who first conquered Nubia, had excavated a 67-foot obelisk at Aswan, which he set up in Heliopolis. Some 400 years later, Tuthmosis I of the Eighteenth Dynasty quarried a pair of similar size for his works at Karnak. Queen Hatshepsut's obelisk at Karnak rose to 96 feet, and her step-son and successor, Tuthmosis III, worked on a 137-foot monster, weighing an estimated 1,168 tons, in the Aswan quarry. It was later scaled down to 105 feet but it was still unfinished at the king's death and remains in the quarry to this day.

Tuthmosis III also extracted a gold-tribute from Kush and Nubia. In his day, the target set for Lower Nubia was between 475 and 510 pounds of gold a year. The mines at the head of the Wadi Alaki were the most important. Gold from the south was central to the Egyptian economy, and to its international trade and imperial diplomacy. Hence Ramesses II's anxiety to dig wells to make the mines workable, if possible, all year round. Water was needed to pan the gold as well as to keep the miners alive. If wells could not be dug near the mines, water had to be carried in jars and skins from the river:

south of Aswan, the ancient tracks of the water-donkeys can still be seen. Eventually, the gold mines ran out and all modern attempts to re-exploit them have failed. The failure of the southern gold mines was one potent factor in the decline of Egypt as a great power.

So long as the mines were productive, however, it was possible for Egypt to pursue an expansionist policy in Asia. This was where the argument started at court. The earlier kings of the Eighteenth Dynasty were preoccupied with making the south secure and setting the stamp of Egyptian culture on it. Tuthmosis I pushed right into Asia in the sixteenth century BC and reached the Euphrates. The question was: should the frontier be held there, and Egypt become an Asian power? The king's successor, Tuthmosis II, was a youth; after his reign and during the long minority of his son, Tuthmosis III, power fell into the hands of the old king's masterful daughter Hatshepsut, who held it for twenty years. There was hostility towards reigning queens in Egypt, reflected in later traditions that the great dynasties had often ended with a woman. Hatshepsut, however, seems to have been the first actually to call herself king, to wear masculine regalia (including the false beard) and to claim full authority. Her inscription proclaims: 'The king of the gods, Amun-Re, came forth from his temple saying: "Welcome my sweet daughter, my favourite, the King of Upper and Lower Egypt, the *maat*-lover, Hatshepsut – thou art the king, take possession of the Two Lands."' As a court official put it in his tomb: 'She governed the land, and the Two Lands were under her control. The people worked for her, and Egypt bowed the head.'

But Hatshepsut, as a woman, could not campaign in person and therefore chose not to campaign at all. She took the conservative and traditionalist Egyptian view that, while a pharaoh must preserve the territorial integrity of Egypt, it was not his duty to rampage abroad but to raise monuments to the gods at home and embellish the land with trade. At Thebes, her father and grandfather had finally abandoned the pyramid-tomb as too vulnerable. Their tomb-architect, Enene, began the practice, about 1525 BC, of siting the tombs deep in the western mountains of Thebes, in what is now called the Valley of the Kings. In his own inscription, Enene said he was chosen because he had 'a discrete mouth in speaking of the affairs of the King's house' and he adds: 'I witnessed the hewing-out of the rock-tomb of His Majesty in the solitary place where nobody could look on and nobody could listen.' Hatshepsut's architect, Senenmut, was also a discrete confidential servant whom she raised up to become a great power in the land, guardian of the heiress to the throne, Princess Neferure, and the Queen's chief adviser on policy. He was of humble birth and came to prominence as an army scribe. He had, he said, a long record of building triumphs before he came into Hatshepsut's service, but for her he erected his masterpiece, a funerary temple in the great circular cliff-bay of Deir el-Bahari. It is alongside the earlier temple of Mentuhotpe, and also in the form of a terrace with projecting columned halls, but conceived on a much grander scale and executed with tremendous

Opposite page: Some of the most famous pharaohs of the New Kingdom were buried here in the Valley of the Kings at Thebes.

Below: Relief from Hatshepsut's temple of the Dead in Deir el-Bahari showing the expedition to Punt.

elegance and purity of line, in fine limestone, unlike the yellow sandstone used in most of the other Theban temples. Within, the magnificent low-reliefs depict on a monumental scale the two events which she evidently considered the high points of her reign: the transporting by barge of the two enormous obelisks she quarried at Aswan and set up at Karnak, and a great expedition to Punt in East Africa.

It is notable that, in depicting the royal Council of State which planned the Punt voyage, Senenmut is the only official named, apart from its leader. He seems to have occupied a position in the state similar to Imhotep – already revered as a god as well as the prince of architects – and to have helped to determine the policy of limited foreign commitments. Having completed one tomb for himself, he began work on another larger one. But it was never finished. His ward, Princess Neferure, died and it proved increasingly difficult to deny Tuthmosis III, now a man, his rights to the throne. Senenmut seems to have fallen from power even before the death of his royal mistress and on his earlier tomb his name and likenesses were savagely hammered out. Hatshepsut, too, disappears from view, possibly put to death, and in her turn cartouches and images were mutilated.

If Tuthmosis III was obliged to claim his throne by violence, this would explain his policy of revenge against the works and memory of his aunt, but there was also an abrupt change of policy. The king seems to have departed on a campaign of conquest in Asia only seventy-five days after taking over: 'His Majesty', says the inscription he set up in the great Temple of Amun at Karnak, 'allowed no delay in proceeding to the land of Djahi [Palestine and Syria] to kill the treacherous ones who were in it and to give things to those who were loyal to him.' The campaign, conducted in haste in response perhaps to a sudden deterioration in the Egyptian position in Asia, produced the greatest of all Asian victories, at Megiddo in Palestine, which made the Egyptians the dominant power in western Asia for three generations. Tuthmosis, his son Amenophis II, his grandson Tuthmosis IV and his great-grandson Amenophis III, were all men of conspicuous virility, athletes who took pride in their skill at rowing, swimming and running, ferocious warriors, experts with the bow and the chariot, and notable big-game hunters who slaughtered lions and elephants *en masse*.

Yet Tuthmosis III does not seem to have been simply a brutal extrovert. He conducted seventeen campaigns in Asia, but most of these were annual parades of force in which battle was unnecessary. The Egyptians, with the advantage of a spring harvest, could time their parades to arrive in Syria just as the autumn harvest was ripening and most vulnerable. Tuthmosis relied on good organization, naval power, diplomacy, threats, blackmail and gold as much as skill and courage in battle. He was also long-sighted; he not only took princely hostages but had them brought up in Egypt and exposed to Egyptian culture. There they joined Nubian princelings and chieftains who were brought to court and trained in a secret military organization known as the *Kap*, preparatory to careers as staff officers and commanders in the army. He seems to have seen education as an essential part of his imperialist policy – rather as the British, 3,000 years later, set up the School of Princes in India, to instruct the eldest sons of Moslem, Hindu, Persian, Burmese, Arab and Malayan potentates in the political culture of their empire.

The methods of Tuthmosis were directly related to his Amunite theology. Hatshepsut appears to have tried to conciliate the priests of Amun at Karnak, but unsuccessfully; perhaps she was too deeply imbued with traditional Egyptian

pantheism. She was also as an active woman-ruler, something of a heretic in the eyes of the priests. Tuthmosis was said to have been picked by the Amun priesthood, a tradition which probably enshrines the fact that he had their active support in claiming his royal rights. Certainly they became enthusiastic imperialists. Amun, as an unseen and mobile deity – we hear of 'Travelling Amun' – was well-adapted to imperialist purposes; made for export, as it were.

The rise of empire, not only among the Egyptians but among the Hittites and Assyrians too, was linked to the emergence of a form of monotheism which, while allowing a multiplicity of gods, tended to subordinate them to one superdeity. It was a mark of the period to identify nationalism with god. The question was: could god work effectively outside the limits of his territorial origins? The great discovery of the second millennium BC was that he could; or, rather, some gods could. The god of the Israelites, Yahweh, followed them around on their migrations until he settled in the Jerusalem Temple. The god of the Thebans, Amun, went one better: though resident in his great shrine at Karnak, he also moved, invisibly, with the Egyptian host, as the successful campaigns in Asia showed. Merged with Re, the sun-god, as Amun-Re, he was also in orbit round the earth. Tuthmosis III proclaimed: 'He seeth the whole earth hourly.' As R.H. Breasted put it: 'In the ancient east, monotheism was but imperialism in religion.' Tuthmosis, who of course regarded himself as a god, seems quite deliberately to have formed a working partnership in imperialism with his 'brother', Amun. The idea of a theological contract was rooted deep in Egyptian conceptions of religion and justice: you 'cultivated' the gods, and they in return rewarded you. Tuthmosis conceived such a contract on a much larger scale: Amun promoted his imperialist schemes, and (being a travelling god) lent his authority and presence to centres of Egyptian power in Asia and Nubia. In return he received a lavish share of the commercial profits of conquest. These returns took the form of mining concessions, lands, immunities, monopolies, trading rights, slaves, as well as the sheer booty of ransacked cities, all of which were lavished on Amun's temples and on the swarming and increasingly powerful priesthood which served them.

Yet the 'Divine Contract' between pharaoh and Amun was in a sense a piece of political and religious adventurism, ill-suited to a traditionalist country like Egypt, which had flourished on isolating itself from novelty and alien customs. Neither a totalitarian ruler nor a priestly caste is wise to embrace cosmopolitanism and the exchanges of ideas it necessarily implies. Running an empire meant that Egypt became for the first time a member of the international community and had regular contacts with societies roughly on her own cultural level but with different political and religious systems. In consequence she was now exposed to the risk of sudden change – cultural, religious, political, artistic – of a type for which her history and customs had not prepared her. This was the background to the curious and obscure story of Akhenaten (Amenophis IV), the sun-worshipper.

The cult of the supergod and of theological imperialism, in which gods left their localities and crossed frontiers without losing their power, necessarily presupposed the possibility of monotheism, of a universal, all-powerful and solitary deity. A drift in this direction is apparent after the end of Queen Hatshepsut's reign and during the period of strident imperialism introduced by Tuthmosis III. A papyrus in the Cairo Museum contains a hymn to Amun-Re with the following passage:

Twenty years later, the 'Restoration Stele' set up under King Tutankhamun near the Temple of Amun in Karnak, claims that, in Akhenaten's time, 'the temples of the gods and goddesses from Elephantine to the marshes of the Delta had gone to pieces, the shrines were desolate and overgrown with weeds … and the gods turned their backs upon this land.'

In fact it was plain that Akhenaten met with considerable resistance, not only from the clergy, but from most of the members of the Egyptian establishment. Unwilling to rule from a divided city, he transferred his capital from Thebes to a new site down the river, now called Amarna, on a desolate stretch of the Nile about half way between Thebes and Memphis. There he built an entirely new city, Akhetaten, 'Horizon of the Aten'. There is fertile land on the west bank, but on the east bank, where the city stood, the mountains which hem it in, with desert beyond, create a claustrophobic

Below: Akhenaten and Nefertiti shown in domestic bliss, playing with their daughters. The sun is depicted radiating its influence above their heads.

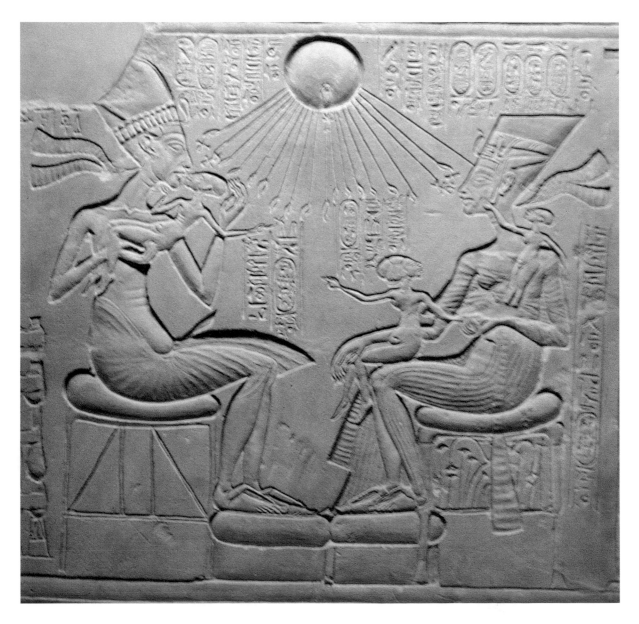

atmosphere, and the whole site has been compared to a concentration camp. Nearby was a famous alabaster quarry, Hatnub, worked by criminals, slaves and prisoners of war, a fearful penitentiary. Akhenaten marked out the new city himself, and on its boundaries he set up stelae which provide precious documentary evidence of his intentions. He says that he was building his new capital on virgin land which 'belonged to no god or goddess and no lord or mistress, and no other person has the right to tread upon it as the owner.' There, he says, he desired to build a city to his father, Aten, 'in the place that he shut in for himself with mountains and in its midst set a plain that I might there make offerings to him.' He adds that he rejected advice to build it elsewhere, even after work had begun and the disadvantages of the site became apparent. But the portion of the text where he explains his reasons for leaving Thebes has been damaged, probably deliberately: he says he had been 'forced to listen to terrible things', worse even than his father and his grandfather had been forced to hear.

After Akhenaten's death, possibly under his immediate, ephemeral, successor, Smenkhkare, or the young prince, Tutankhamun, who married his daughter, the court dismantled and abandoned Amarna, and returned to Thebes to resume the worship of Amun. The new city was only lived in for a few years. One of the problems which faces students of ancient Egyptian history is that, while the stone monuments of the dead have been preserved to a great extent, the brick towns and cities in which ancient Egyptians actually lived have vanished almost without trace. One exception is the pyramid-town of El-Lahun, built in the Fayum during the Middle Kingdom, and excavated by Petrie. The other, far more important, is Amarna. It is the Pompeii of ancient Egypt.

Amarna is thus a mine of information about daily life in the second millennium BC, though it does not actually tell us much about Akhenaten himself, since he was posthumously degraded as 'the Blasphemer' and his mummified body has never been found. At his city, which he took a solemn vow never to leave, he led an isolated existence, closely guarded by Asiatic and Nubian mercenaries. When members of the royal family went in their chariots outside the city limits they were surrounded by running soldiers, and all the countryside around was regularly policed by military patrols. The social structure of Amarna is revealed by the size and layouts of the houses, but tomb inscriptions giving the names and origins of prominent inhabitants make it clear that Akhenaten failed totally to carry with him to Amarna the leading figures in the Theban establishment. The rich of Amarna were self-made men with no pedigrees, or rather men whom the king had raised from nothing: soldiers, scribes, artists, architects – no priests. Most of them admit this in their tombs; in fact they go further and claim that they were 'taught' their professions by the king. In the case of the painters, sculptors and architects, the admission is of some significance.

The 'Amarna Style', already prefigured in Thebes, marks an abrupt departure from the statuesque immobility and eternalism so characteristic of Egyptian art at all periods. Its origins have been traced back to the period following Hatshepsut's death, but it evidently received an enormous impetus as a result of the Akhenaten upheaval. It is hard to escape the conclusion that the king himself laid down the patterns of the new art. Certainly it was Akhenaten-centred. He is shown in domestic bliss, embracing his wife, Nefertiti, and playing with his little daughters, in a style which is at once both highly naturalistic in subject and absurdly mannered in treatment. The grotesque rendering of the human body suggests that the king and his obsequious artists were

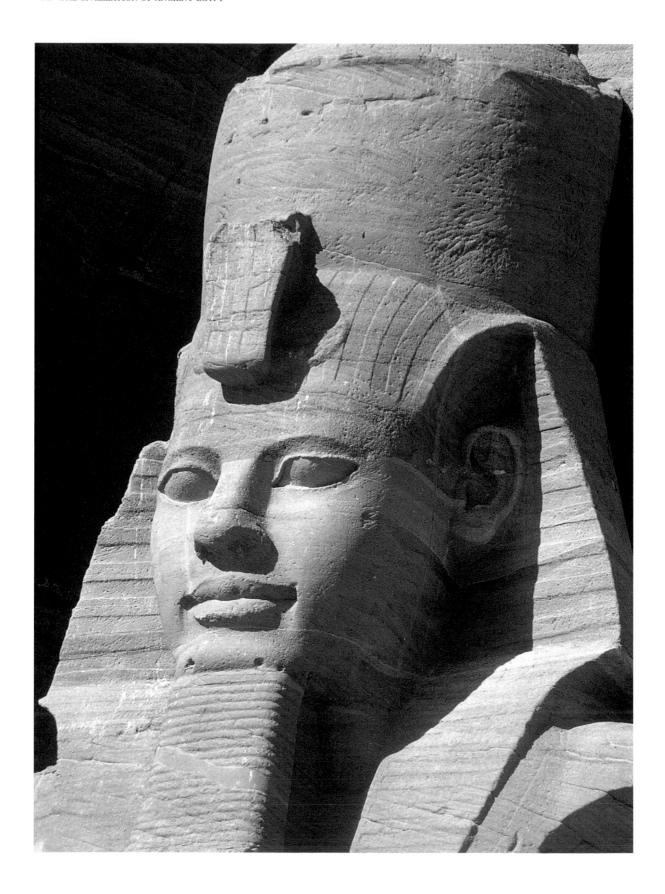

general from the Delta, the Vizier of Lower Egypt, who took the throne as Ramesses I, founder of the Nineteenth Dynasty. It was his son, Sethos I, and grandson, Ramesses II, who rebuilt the Asian empire to something approaching its old splendour. Sethos stabilized the frontier by signing a peace-treaty with the Hittites and he issued an up-to-date version of Horemheb's police-decree. His son, Ramesses II is often termed 'the Great', and certainly in classical times he was the best known of the pharaohs. He reigned sixty-seven years, begetting over 150 children by his Great Wives, lesser wives and concubines and devoting most of his long life and reign to ostentatious self-glorification. To the Greeks and to some extent to us too he personified imperial Egypt.

Opposite page: Head of the colossal statue of Ramesses II at Abu Simbel.

Yet there must be doubts about Egypt's real strength at this time. Egyptian official sources are propaganda, not an objective record of events. In his early days as king, Ramesses II campaigned actively in Asia. In 1286 BC he fought a battle at Kadesh against the Hittites. This was a mismanaged affair, in which Ramesses (according to his account), was cut off from the main body of his troops and saved the army from disaster only by prodigious acts of personal valour. Yet even in his account he did not then take the town of Kadesh, but merely returned with his army to Egypt in good order. We also have a Hittite version of the battle, from which it is clear it was in no sense an Egyptian victory. It was doubtless inconclusive, as were further hostilities. Some years later, Ramesses, like his father, sensibly signed a peace-treaty with the Hittites. This was a non-aggression pact and also an offensive-defensive alliance against unnamed, barbarous enemies; and it provided for the extradition of political refugees. Here again we have the versions of both sides. Ramesses's hieroglyphic treaty from Karnak refers to him as 'the Bull of Rulers, who has made his frontier where he wished in every land'. It claims that the Hittites wrote the treaty 'in order to beg peace'. The Hittite version, in cuneiform, leaves out all propaganda but otherwise corresponds to the Egyptian text.

Below: The pillars of the Great Hypostyle Hall at Karnak, built by Ramesses II.

Ramesses never went campaigning again, but he constantly harked back to his role in the Battle of Kadesh, in which (as he put it in one inscription) 'he repelled all lands through terror of him, and the strength of His Majesty had protected his army, so that all foreign

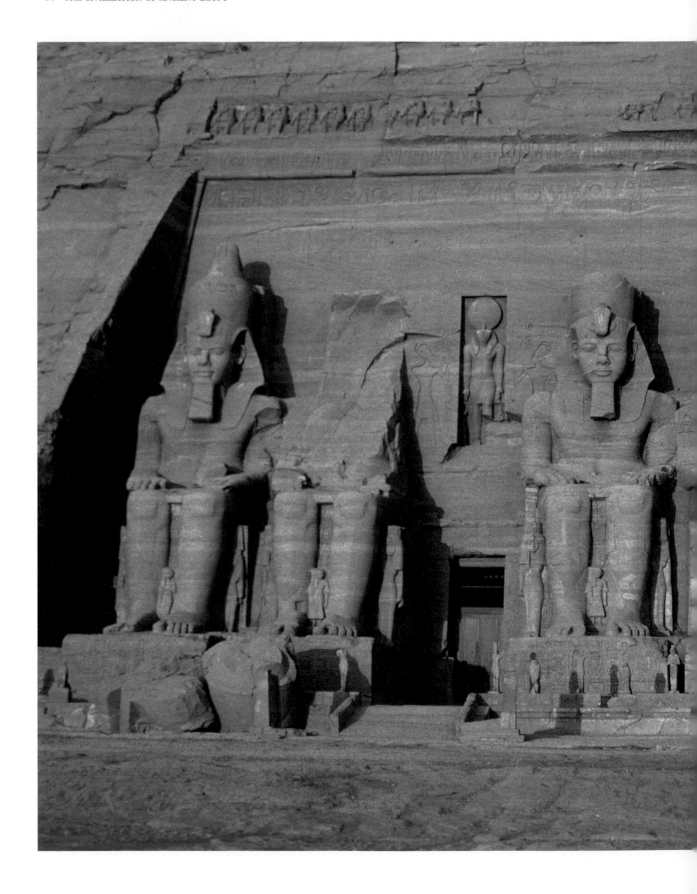

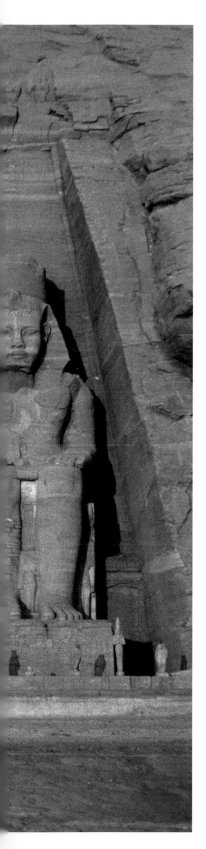

countries were giving praise to his goodly countenance.' He repeated the tale of his exploits often; it gradually came to occupy more wall-space than any other event in Egyptian history. And it grew with the telling – the king, single-handed, dispatching thousands of Hittite charioteers – rather as George IV of England came to believe he had personally led the charge of the Scots Greys at Waterloo, provoking Wellington's laconic comment: 'So Your Majesty has often observed.'

It was almost inevitable that Ramesses II should revive the colossal style. It was a characteristic of Egyptian self-expression at various periods, notably the Fourth Dynasty. Amenophis III had been a greater builder, of massive pillared halls, immense pylons and superhuman statues. His work is now ruinous, but the two gigantic statues he set up, the Colossi of Memnon, survive to testify to his egoism – similar structures of his strange son were smashed during Horemheb's iconoclasm, leaving only the two Cairo fragments. Ramesses II resumed building in the grandiose manner, and on an unparalleled scale. He completed the Hypostyle Hall at Karnak, with its forest of 134 gigantic columns, and set his mark ineffaceably on Upper Egypt with the four monstrous images of himself cut into the rock of the temple at Abu Simbel. He set up colossal statues of himself all over Upper Egypt, especially around Thebes. It was the broken, 60-foot statue of him, in the so-called Ramesseum at Thebes, which inspired Shelley's famous sonnet on tyrannical pride, 'Ozymandias' (the Greek form of Ramesses is derived from Userma'atre). Another of his colossal heads, weighing seven tons, was removed to the British Museum in 1816. There were repairs of Ramesside colossi at Memphis and Tanis. No doubt his most impressive works were in the Delta, where he came from and where he built his two cities, but virtually nothing now remains of those. Ramesses, however, restored, enlarged and rebuilt temples everywhere. He smashed up the work of his predecessors and refashioned it without scruple, and no pharaoh was so ruthless in carving his own cartouche on the other kings' statues (or even those of private persons). Some of his early statues, especially one with his (miniature) wife in the Egyptian Museum at Turin, are of fine quality. But the imperial-colossal style of his middle and later years tends to be crude and repetitive. Much of his building work is shoddy and was unsafe from the beginning. Often, behind the surface ashlar, we find hastily packed rubble, and massive walls depend precariously on half-columns used instead of carefully squared blocks. The Egyptians were magnificent masons – there have been none better in human history – but they rarely used secure foundations, unlike the Romans. In the time of Ramesses II all was sacrificed to quantity and ostentation. Hence much of the desolation of his colossal ruins is due more to corner-cutting than time, and even some of the stone-carving is poor, at any rate compared to the puritanical precision of the Fourth Dynasty.

Despite its evident wealth, the Egypt of Ramesses II gives hints of a civilization in material and spiritual decline. The theatrical 'Ramesses-Hollywood Style' – as one might term it – impressed foreigners then, as it still impresses us now. But Egypt was already technically backward, in a world on the brink of the Iron Age. We are coming to the end of the second great cosmopolitan period in world history – the age of Hittite Turkey, Minoan Crete, Mycenaean Greece, Mittanian Syria – when an intricate series of diplomatic and artistic contacts fostered trade and the 'international style'. Ramesses

Left: *The Great Temple at Abu Simbel; four enormous statues representing Ramesses II dominate the façade.*

II's treaty with the Hittites presupposed an external threat to both, which became steadily more menacing. Huge and irresistible movements of peoples, some of them armed with fine bronze weapons or even iron ones, threatened all the established empires and states. Ramesses's heir, Merneptah, was required to deal with this new threat, which took the form of a tribal incursion into the western Delta. There he won a great victory at Pi-yer; but the barbarian pressure was soon resumed.

Our chief authority for this period is the Twentieth Dynasty Great Harris Papyrus, now in the British Museum, the largest and in some ways the most valuable of all the written documents of ancient Egypt. Its historical summary indicates a complete breakdown at the end of the Nineteenth Dynasty: 'They had no chief spokesman for many years previously up to other times. The land of Egypt was officials and mayors, one slaying his fellow, both exalted and lowly. Other times came afterwards in the empty years, and ... a Syrian with them, made himself prince.' Of course there were Syrian and other foreign officials at the Egyptian court even in the time of Akhenaten (who had a Syrian chamberlain), and a Syrian mercenary general may have taken over when male heirs failed at the end of the Nineteenth Dynasty. The Harris Papyrus was compiled by Ramesses IV in honour of his father, Ramesses III. He says that his father 'cleansed the great throne of Egypt', and though Ramesses III did not exactly found the Twentieth Dynasty he was the first to make it the effective ruler of all Egypt, the empire to the south, and what remained of the Asian territories. He had to meet the full fury of the ferocious movements of population which now threatened international order, and indeed were already smashing up the Hittite Empire and Mycenean Greece. 'The foreign countries,' he recorded, 'had made a conspiracy in their islands', a phrase which ominously prefigures the 'great conspiracy' of Picts, Scots, Saxon Pirates and Franks which smashed its way into the Roman Empire in AD 367. Ramesses III won two splendid victories against the alliance of 'the Peoples of the Sea' and Libyan tribes, one on land to the west of the Delta, one at sea, in the Canopic mouth of the Nile. And on the walls of his magnificent temple of Medinet Habu at Thebes, he inscribed an elaborate pictorial and written record of these two triumphs, a record which represents the culmination of Egyptian wall-design and the supreme example of Egyptian internationalist art.

The Harris Papyrus indicates that Egypt was still a wealthy country in Ramesses III's time, for it lists the magnificent donations in lands, slaves and goods which the king made to the temple-communities, particularly Amun's at Thebes. The 'Divine Contract' was still working. But his temple and palace in Western Thebes had defensive walls, a suggestive sign of the times. At periods towards the end of his reign even the royal necropolis workers, the best-paid and most highly organized of all Egyptian labouring groups, went on strike because, they claimed, they were starving. The reign seems to have ended in a peculiarly virulent harem-conspiracy. Involved in it, according to the record of the subsequent trial, known as the Judicial Papyrus of Turin, were senior palace and harem officials, women, guards and gatekeepers, the head of the Treasury, the commander of the troops in the south, the Commander-in-Chief of the army, the Head of the Religious Library, the High Priest of Sekhmet and other important ecclesiastics. In this great State trial it is notable that prejudgment was carried out by altering the names of the accused. Thus a man called, presumably, 'Re-Loves-Him' appears in the record at Mesed-su-Re, 'Re-Hates-Him'; others charged, found guilty and sentenced appear as Pai-bak-kamen, 'This Blind Slave', Pen-Huy-Bin, 'He of the Wicked Huy', Bin-em-Waset, 'The Wicked One in Thebes' and Pa-Re-Kamenef,

Opposite page: Relief from the mortuary temple of Medinet Habu depicting the defeated sea-people honouring pharaoh Ramesses III.

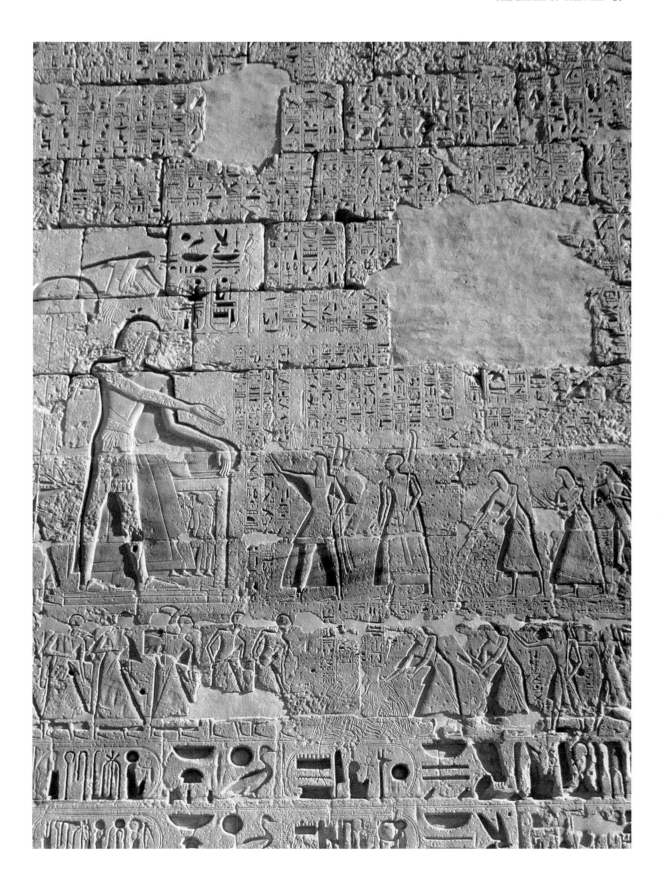

'Re Will Blind Him'. These new or criminal names signified the transformed character of the accused and hinted at their punishments. Thus some were blinded and sent to work as slaves in the quarries; some, according to the record, had their noses and ears cut off. Those whose names signified they hated the gods must have been executed. One was 'left' – possibly walled up – and is said to have committed suicide. Yet one of the accused, given no name at all, was simply 'rebuked severely with wicked words' and 'no penalty was carried out against him.'

Ramesses III was the last great pharaoh of independent Egypt. When he died in the 1160s, Troy was already a memory, Mycenae a ruin and Hattusi, the Hittite capital, levelled. The ramifications of the conspiracy at his court were wide enough to imply that the whole system of Egypt was under considerable strain internally in addition to the external threat. It is time, now, to look closer at this social system, to turn away from the narrative of events, and to examine some of the chief features of Egyptian life.

Below: *Avenue of sphinx in the first courtyard sculpted for pharaoh Amenophis III, Karnak.*

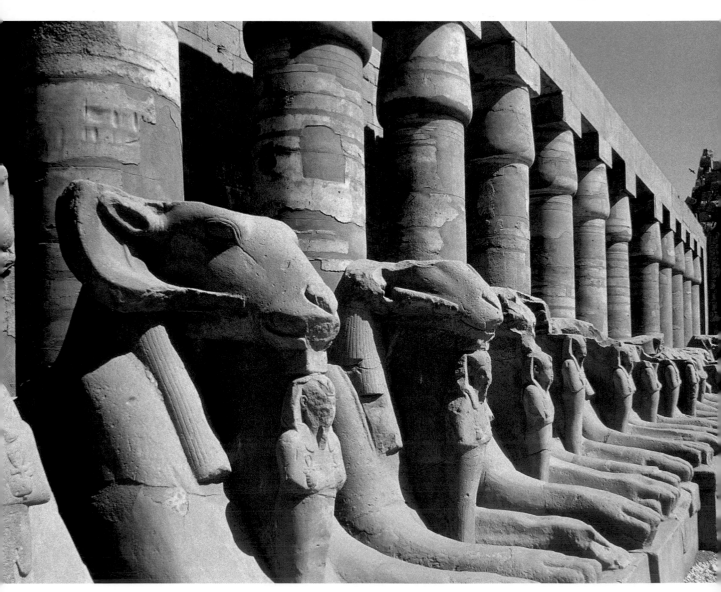

Below: *Sarcophagus of
Ramesses III showing the
goddess Isis.*

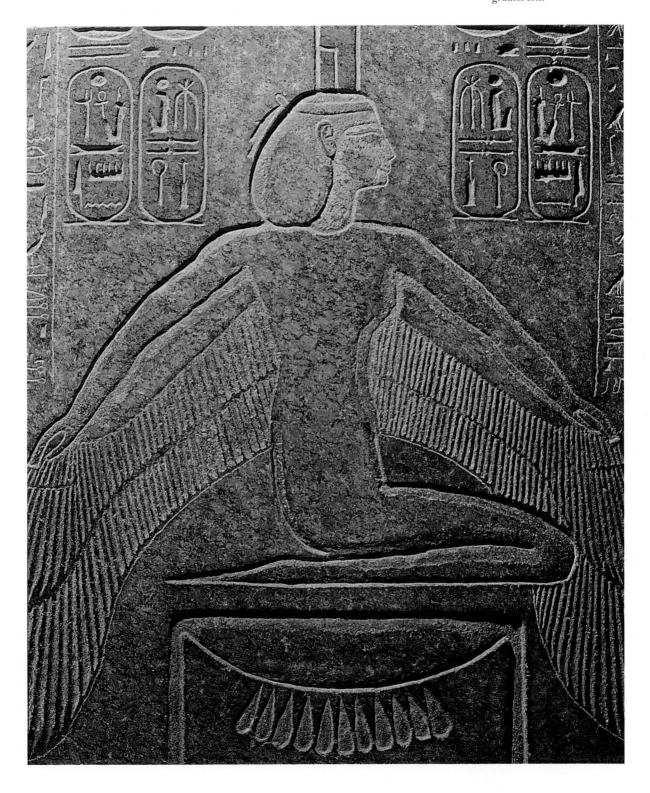

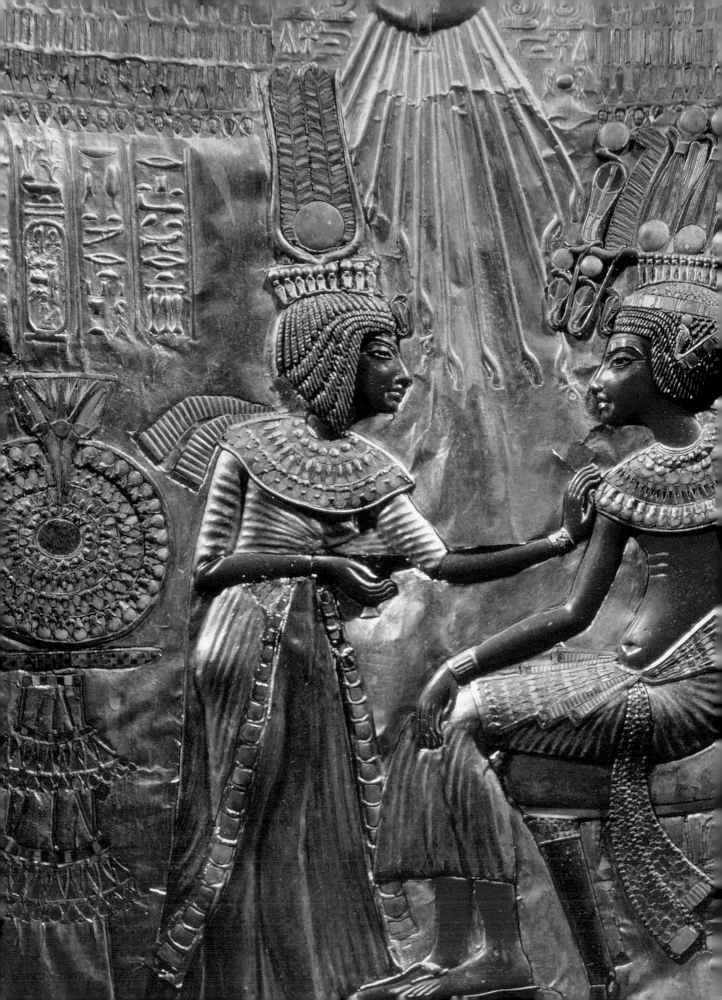

THE STRUCTURE OF DYNASTIC EGYPT

The reconstruction of Egyptian political history which the surviving documents allow us to make docs not shed a great deal of light on the way in which Egyptian society was actually managed. From the period of unification onwards, Egypt was an autocracy of the most absolute kind, all power whatever emanating from the god-king. Although, in periods of pharaonic weakness, nobles or priests, or both together, might in practice severely limit the power of the king, these intrusions were conducted within the theoretical framework of absolutism. There is no document limiting the pharaoh's power or imposing any obligations on him, indeed no constitutional document at all. There is no code of law, as in Israel, implying that the king is subject to it and can do no wrong; not a hint of the popular assemblies or councils of elders which seem to have existed in the early city-states and kingdoms of Mesopotamia. Diodorus, in the Roman period, tells us that the pharaohs were subject to a code which imposed minute restrictions on their behaviour at all times and he says they welcomed this protocol because, if disaster struck, no blame fell on the Crown. But of course he is speaking of the last period, when the institution was in irreversible decline.

Above: Wall painting from the tomb of Tutankhamun depicting monkeys.

Opposite page: A wall relief from Hermopolis showing the growing of olives.

frame. The elegant lines and restrained decorative effects of these pieces have never been surpassed; they are, of course, less sumptuous than the New Kingdom furniture of Tutankhamun. Ordinary people with any wealth at all possessed low chairs, sometimes with leather or basketwork seats, stools, tables, jar-stands, wooden-framed beds, with animals and texts carved on them, and good boxes and trunks with metal hinges – though the Egyptians had no metal locks or keys before Roman times.

These low, cool and spacious houses, though uncluttered with furniture, were splendidly decorated with stucco murals, and wooden pillars in the form of plants, especially palm-trunks, overlaid with coloured plaster and sometimes, in very rich houses or royal palaces, gilded. In these decorative schemes, the dominant theme was nature – birds, especially the birds of the marshes, animals and hunting, plants, flowers and gardens, with trees and pools. In one of his palace rooms, Akhenaten, not normally a monarch one associated with conquest, had a decoration of bound prisoners in the centre of the floor, so that he could stamp on them. But such bombast was rare. Egyptians loved nature more than any other ancient people – portrayed it better too – and they seemed anxious to bring it right into their houses if they could afford it. They loved animals, as their religion bears abundant witness, and kept multitudes of household pets, especially dogs, cats, geese and monkeys. Akhenaten had a zoo in his palace and a large aviary – aviaries, both indoor and outdoor, were common in Egyptian houses. Above all, the Egyptians of all classes were devoted to gardens and went to all lengths to maintain one near their house, transporting earth, digging wells and channels, and excavating artificial pools, stocked with waterfowl. The houses of the rich had highly ornamental gardens, pools on stone bottoms, set with trees, and elaborate stone kiosks furnished with statues. But many of the poor had gardens, too, for growing vegetables: the *shaduf* was the most benevolent of all Egyptian inventions.

It was the existence of gardens which kept men alive in years of low Niles. Egypt was the granary and flesh pot of the antique world. Tribes tried to enter Egypt 'to fill their bellies', as Ramesses III put it, and under Merneptah, Ramesses II's son, grain-surpluses were exported to the Hittite famine areas. But Egypt, too, occasionally knew hunger. A woman witness, questioned during a tomb-robbery investigation during the later Ramesside period about some money she had possessed, answered: 'We got it selling barley during the Year of the Hyenas, when people went hungry.' Gardens produced radishes, leeks, garlic, onions, cucumbers, figs, grapes, dates and perhaps (after the Hyksos introduced them), apples and olives. According to the *Instructions of Ani*, dating from the late Empire and for centuries the most popular of Egyptian moralistic treatises, planting a garden was a commendable virtue, along with preparing your tomb, honouring the gods, being kind to your wife and old people, chastity,

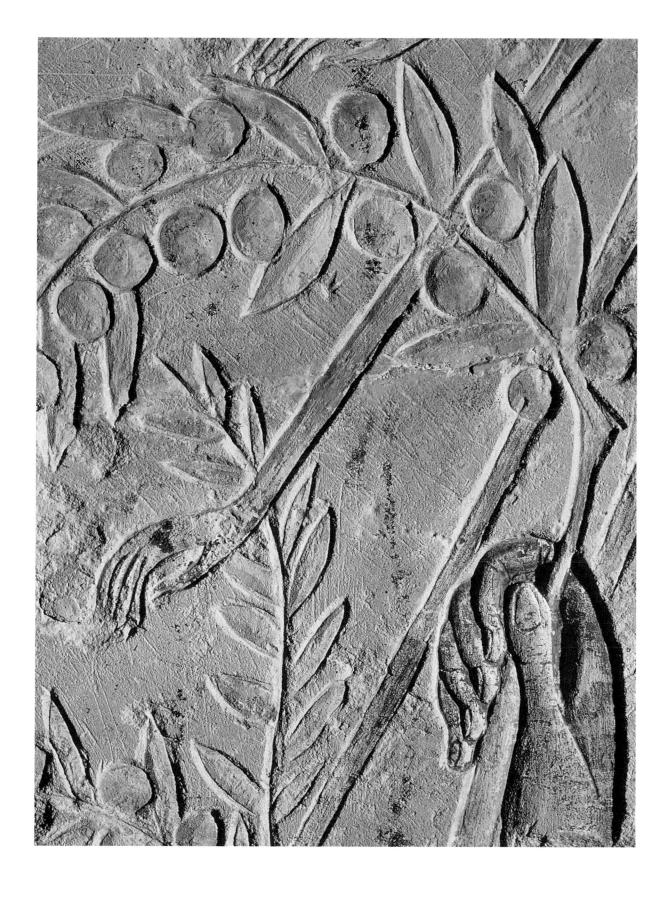

classes oiled their bodies regularly: body oil was one of the basic supplies issued in the form of wages to even the lowliest workers. The black galena and green malachite paint which both sexes used on their eyes were also regarded as essential for medical and magical reasons – the Egyptian name for the eye-palette came from the word 'protect'. Women also wore rouge made from red ochre, henna on their hands and feet and they painted their fingernails. Rich ladies had, in fact, very elaborate toilet articles, such as pins, tweezers and mirrors made of polished metal, and of which there is an elaborate collection in the Louvre.

Both sexes, besides being sensitive about their hair, or lack of it, were uneasily conscious of body-odours. They associated nasty smells with impurity and sin – probably one reason why fish was theoretically forbidden. A good smell was 'the fragrance of the gods'. Each god had, or in time acquired, his or her own smell. All precious smells, from scented ointments and unguents, had particular religious meanings. Hence temples and shrines (and tombs) had to smell good, and smell, often enough, in a particular way. That was why the Egyptians first invented the process of incensing, though it is possible they may have borrowed the idea from the Babylonians. Priests, too, had to smell good, as well as being clean and wearing spotless garments, so the Egyptians used body-scents and incense in enormous quantities. Most of them were imported and the trade in cosmetics was, next to timber, the chief *raison d'être* of Egyptian foreign commerce.

These scents and so forth came from the Middle East – we get a little Biblical vignette of the trade in the Joseph-story: 'they saw an Ishmaelite caravan coming in from Gilead on the way down to Egypt, with camels carrying gum tragacanth and balm and myrrh' – but chiefly from Punt, which also supplied incense. In early times, these expeditions to Punt, which were royal enterprises, went from near Suez, the ships being brought up from the Nile via a network of canals. These were ocean-going or Byblos ships, made of Lebanese cedars, capable of sailing to Byblos from the Delta in about 100 hours, or of travelling down the Red Sea to Punt in East Africa. Later, the Punt expeditions went from Thebes or Coptos across the desert roads to embark at ports on the Red Sea. The elaborate wall-scenes of Queen Hatshepsut in her temple at Medinet Habu provide our most detailed information about the Punt voyages – down to the enormously fat wife of the African king who greeted the voyagers – but we have also a letter, dictated on behalf of the Sixth Dynasty king Pepi II, then a child, ordering the fleet to make all speed to bring to court a dancing pigmy or Deng – 'My Majesty desires to see this Deng more than all the tribute of the mineland and Punt'.

Sailors, watermen and ferrymen formed a significant part of the total population. Virtually all travel, for men and goods, was by water. There were no roads as such. River-navigation was extended by canal-building. An inscription of 1870 BC records the construction of a canal 150 cubits long, 20 wide and 15 deep to make the navigation of the First Cataract possible. There was an ancient canal from the Bubastis arm of the Nile to Sile, near Qantara, and another, from the first millennium BC, which linked this arm to the Great Bitter Lake, the approximate route of the present freshwater canal to Suez. It was the ability to travel up and down the country swiftly and cheaply which gave Egypt its strong cultural unity, and helped to even out the available supplies of

Right: *A wall relief from the temple of Seti I, Abydos depicting the pharaoh offering perfume to a god. All precious smells had particular religious meanings.*

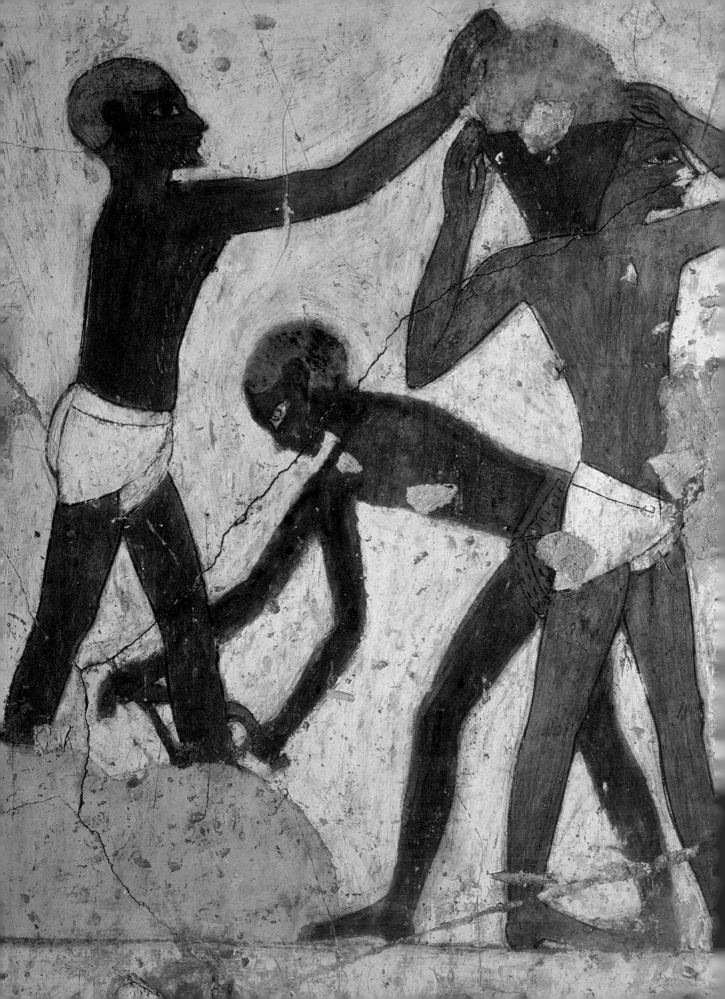

food. Men were able to travel widely in Egypt even during the chaos of the First Intermediate Period. All men of property owned ships. But privately owned ships could be commandeered for the royal service, local mayors acting as agents. This was how royal messengers, or the 'Horus-Service', functioned. The right of the king's men, or mayors acting for them, to pounce on private boats and use them for weeks at a time, was 'the terror of the royal house', and one of the longest-standing grievances in Egyptian history. Of course exemptions could be bought or earned; but they could also be ignored – or suspended as, for instance, by the eager Pepi II, to speed the arrival of the dancing pigmy. One of the objects of Horemheb's fierce decree was to stop illegal requisitions of boats by royal officials and messengers, whereby 'authority in this land was undermined' and the boat-owner was 'deprived of his property and the reward of his labour.' Obviously, this was a very ancient royal prerogative, probably from before the unification, and consistently abused ever since. The Crown was still trying to control the abuses in Ptolemaic and even in Roman times; but they went rolling on like the river, as indeed did abuse of the *corvée* system, which was only finally abolished by the British at the end of the nineteenth century.

Land travel was almost entirely on foot and by donkey. The camel was not domesticated at all until late in the second millennium BC, and was not used in any numbers in Egypt until Ptolemaic times. Even wheeled ox-carts were unknown before the Hyksos came but the Egyptians travelled constantly and widely across the desert, to the western oases, to desert shrines, such as the famous oracle of Siwa in Libya, visited by Alexander, but above all in search of gold, semi-precious stones and fine rock. The Egyptians hated the desert, the realm of Seth, but they could not do without it and they learnt to master it up to a point. One of the earliest maps in the world, from Ramesside times, now in Turin, deals with the route to the gold mines in the Wadi Hammamat, Eastern Desert.

These royal expeditions were huge: we have lists of their participants, running up to 6,000 or 8,000 men – one of Ramesses IV's listed 9,368, divided into their grades. The leader of one at the end of the Old Kingdom, sent to quarry stone in the Wadi Hammamat, says 50 cattle and 200 goats were provided daily to feed the 100 stonemasons, 2,200 labourers and guards under his command. Nearly all high Egyptian officials served in these expeditions as young men; it was an essential part of their training and the best way (short of war) to make a reputation. One successful expedition-leader lived to become a pharaoh and found a dynasty. But high officials who disappeared miraculously and left unfinished tombs may often have succumbed to desert disasters. Cambyses, the Persian conqueror who founded the Twenty-seventh Dynasty, lost his whole army in the Western Desert, swallowed in a sudden sandstorm, an event graphically described by Herodotus. The Egyptians never admitted calamity in their official records, but they do once hint that half a large expedition died of thirst. Hence their frantic efforts to find desert wells, and their elaborate desert caches of water, stored in huge stone jars buried in the sand.

Gold mining in Upper Egypt went back to predynastic times: superior gold supplies were one important factor in giving the southern kings their victory and bringing about unification. Under the Old and Middle Kingdoms, the desert mines

Left: *A painting from the tomb of Rekhmere, court official under Tuthmosis III and Amenhotep II, depicting workmen transporting stone.*

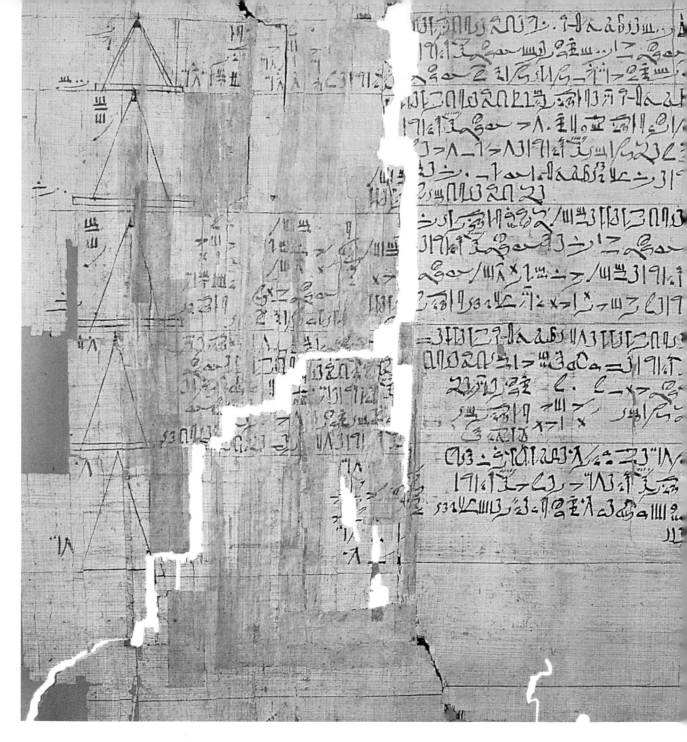

The Egyptians used only unit fractions, probably because they could not conceive
how there could be more than, say, one-fifth: the concept of two-fifths was alien to them.
Egyptian scribes thus had to remember a lot of facts by heart, or use tables, like the
Rhind Papyrus. Such mental blocks were common in their conceptual knowledge and
go right to the heart of their intellectual character as a people. In this respect they were
primitives, unable to think in the abstract, or to remove their minds any distance from
the actual loaves or jars of beer they were calculating. Left to themselves they always
worked empirically, and they often worked very well, for their patience and accuracy
in going through a monstrously tedious sum or measurement were admirable. By such
means they made effective calculations of the volume of a pyramid, or part of it; and by

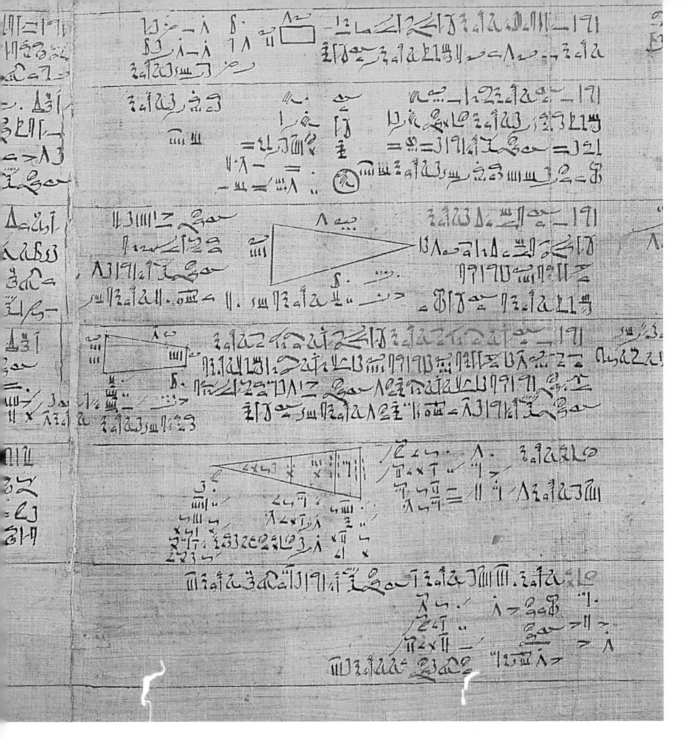

measurement they found the area of a circle fairly accurately – more so than the Babylonians, who were in every respect better mathematicians. It was their long-suffering patience which formed the Egyptian's chief intellectual handicap: they lacked the impatient drive towards the short-cut which animates science, just as they lacked the incentive to save muscle-power which animates technology. On the other hand, it should be added that the exclusive use of unit fractions persisted into the Greek and Roman worlds, and Egyptian-style primitive mathematics are reflected in such archaic ditties as 'As I was going to St Ives I met a man with seven wives', etc. Granted the technology of the ancient world, and certainly granted the technology the Egyptians possessed, there was no demand for mathematical skills more elaborate than they

possessed. Therein, of course, lay the vicious circle of intellectual antiquity, of which Egypt was the outstanding victim.

The Egyptians made a bigger contribution to general knowledge in devising systems of measurement, which appealed to their empirical spirit. They were very observant people. They were the first to note the fact that all the parts of the body are (on average) constant in any individual in terms of their mutual relationships, irrespective of the individual's size relative to others. It was this observation of an invariable canon which lay at the heart of their extraordinary grasp of physical form in their painting and sculpture. But it also led them, very likely at an earlier stage in predynastic times, to an anthropometric system of measurement. The basic unit was the armlength from elbow to thumb-tip, the cubit. This was divided into 6 palms or handbreadths (measured on the back across the knuckles), each made up of 4 fingers. The thumb was 1 $\frac{1}{3}$ fingers, which later became standardized as the Roman *uncia* or inch. A hand of 4 fingers plus thumb was 5 $\frac{1}{3}$ fingers or 1 $\frac{1}{3}$ basic handbreadths. The distance from the elbow to wrist was 4 handbreadths or as it was termed in Egypt the 'two-thirds' (of a cubit); in other Mediterranean systems it was called the *pous*, or foot. Four cubits was one fathom, the height of a standing man up to the hairline. The ordinary or 'short' cubit (6 palms or 24 fingers) was supplemented by the 'royal cubit', equal to 7 palms or 28 fingers – and, in our terms, nearly 21 inches. For longer distances there was the 'River Measure' of 20,000 cubits (10.5 kilometres or 6.8 miles). The basic land measure was the *setjat* or 100 cubits square, approximately two-thirds of an acre.

The same empirical strain led the Egyptians to devise a workable calendar, the only effective one in antiquity. Like all other primitive peoples, they started out with a lunar calendar of 12 months, giving a total of 354 days, 11 short of the natural year. As we have seen, the heliacal rising of the dog-star Sirius or Sothis was used by them as the anchor for their three-seasonal year of *akhet* (flood), *peret* (sowing) and *shomu* (harvest). The rising of Sothis occurred in the fourth month of the third season, that is the last month of the year. Whenever the rising took place in the last eleven days of this month, the following month was regarded as extra, making that year a 'Great Year' of 13 months or 384 days; thus this Sothis-rising was kept safely in its 'proper' month.

This was too clumsy a system for the Egyptians, who liked accuracy even if they could not think in the abstract. By a process of observation – the concept of a Nilometer must have helped – they produced an 'averaged' year of 365 days, divided, as before, into three seasons of four months each, but with the months averaged at 30 days, the extra five days being called 'days upon the year'. The Egyptians hated to drop anything entirely and they characteristically kept their lunar calendar for calculating their religious festivals, adding the solar calendar for administrative purposes and farming. When the two systems diverged too much, a sixth 'extra' day was added every four years. When Alexandria was founded, and the Greeks made it the scientific centre of the ancient world, they seem to have ignored Egyptian mathematics entirely – there is no reference to Egyptian methods in any of their treatises, including the voluminous works of Claudius Ptolemy – but they found the Egyptian solar calendar extremely useful, especially for astronomy. In 45 BC Julius Caesar decided to reform Rome's lunar calendar and called on the Alexandrian astronomer Sosigenes for help. He produced a form of the Egyptian solar calendar which (subject to corrections under Augustus) constituted the famous Julian Calendar, standard in Catholic Europe until the papal reforms of the sixteenth century, and in most of the Protestant world until the 1750s.

The Egyptians divided each month into three weeks of ten days each within which they devised the twenty-four-hour day. The system of hours seems to have been derived from astronomical observations which the Egyptians worked into star-clocks, giving the names of stars rising at ten day intervals at the same time as the sun. They painted these clocks inside the lids of the coffins of important people – the earliest date from the third millennium, but they became much more elaborate under the New Kingdom. There is a fine star-clock on the ceiling in the tomb of Queen Hatshepsut's architect, Senenmut – and in Sethos I's cenotaph-temple at Abydos there is a mass of astronomical material in this form. The star-clocks divided the night into ten hours of unequal length, with an hour at each end for twilight and pre-dawn; then a corresponding number for day. The system was certainly in use by about the end of the Eighteenth Dynasty. It was, of course, an esoteric religious system which completely baffled ordinary people – few of whom were interested in telling the time during the hours of darkness anyway, though it was considered useful for dead people of any consequence. In fact only priests and scribes knew the names of the hours (there were no numbers). But the night star-clock became the basis of the twenty-four-hour system, which was then calibrated on clepsydras (water-clocks) and, for daytime, on gnomons (sun-dials).

The Greek astronomers adopted the system when they came to Egypt and it thus became universal usage. Astronomical tables were constructed on the basis of the twenty-four-hour day, and the 365-day year, and it was this fact, plus Alexandria's unrivalled reputation as an astronomical centre, which led to the tradition in the Greek world that the Egyptians were, or had been, superb theoretical and observational astronomers. True, they were good observers, but only in a strictly empirical way. The pharaoh, as part of his job as a season-predicter and rainmaker, possessed astronomical instruments. The Oriental Institute in Chicago has an ebony bar belonging to Tutankhamun, which may be part of a machine for charting the stars, but they had no theory and never advanced from their primitive cosmology. In this field they were very inferior to the Babylonians who made systematic observations on which they based their celestial theories and their system of astrology. This in turn became the basis for Graeco-Roman horoscopes and much else. Ptolemy's work in Alexandria betrays no sign that he learnt anything from the Egyptians.

On the other hand, in medicine the Egyptians taught the Greeks a good deal. But here again it was their empiricism rather than their theory which proved useful. Their theoretical system of medicine was, of course, religious, and no more use than the Babylonian and Assyrian systems which equated disease with sin and prescribed incantational remedies. But they had a parallel system of empirical medicine which was often very effective. They did not derive this from their experience in mummification, which in fact taught them little about anatomy. They believed, for instance, that the heart, rather than the brain, was responsible for thought; study of their anatomical vocabulary, largely derived from animals, reveals that they knew nothing about the circulation of the blood or the nervous system, and not much about muscles. Like other early peoples, they tended to confuse the disease with its symptoms and treat the latter.

On the other hand, their observational skills enabled them to become the first people to compile a useful pharmacopoeia. We cannot identify all the substances they used as medicine – castor oil, various salts, opium, hartshorn and tortoise-shell, syrup of figs and alum were among them – but it is clear that their empirical treatment was

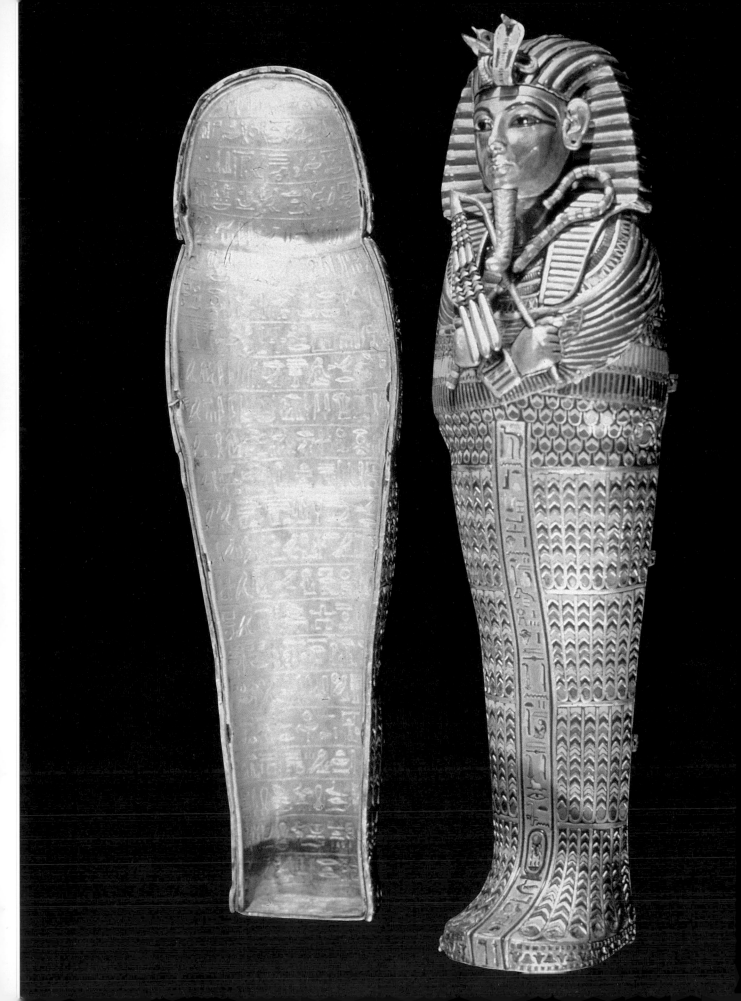

THE DYNASTIC
WAY OF DEATH

Writing about the religion of ancient Egypt demands a powerful effort of imaginative understanding. Even for those of us who possess a strong religious faith, it is hard to conceive of the intensity with which the Egyptians accepted the existence of the supernatural or the extent to which it not only invaded but completely dominated every aspect of their daily existence. A second point to remember is that their religion was in process of constant, if slow, development. The first gods the Egyptians worshipped, as local village or nome-gods, were theriomorphic – that is, in the form of animals. Later, in early dynastic time, and still more under the Old Kingdom, a more sophisticated society made the gods anthropomorphic – of human form – and wove about them a complicated system of myths which constituted their theology, and which reached written form in the *Pyramid Texts* of the late Fifth Dynasty. Later still, in the last millennium, with the decline of the pharaoate and the loss of national independence, the Egyptians returned to theriomorphism.

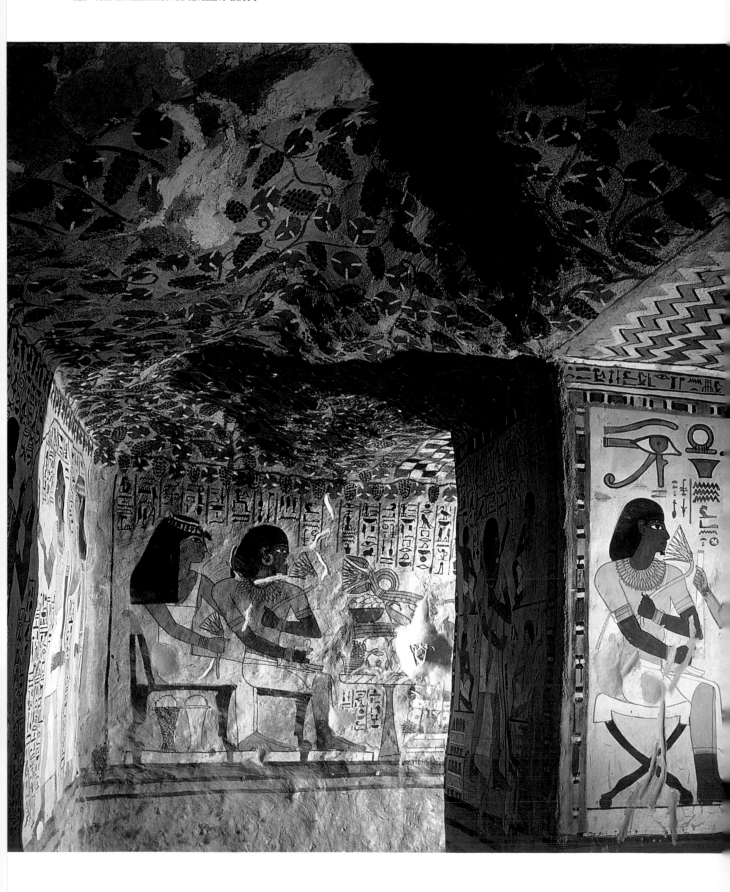

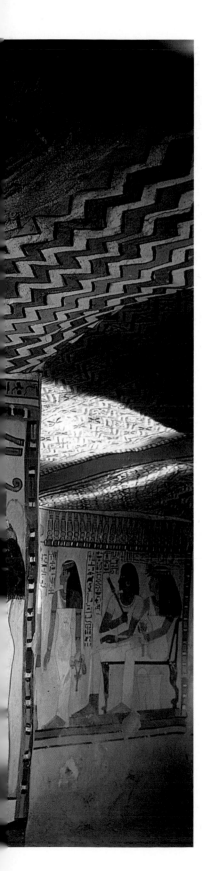

development of the individual conscience, Egypt's greatest spiritual gift to mankind, and to the idea of a last judgment for all, presided over by Osiris.

Originally, however, there was no such thing as 'private' religion in Egypt. Religion was a village, district, State affair. It was also essentially a cult religion, not, like Judaism, Christianity and Islam, a 'religion of the book'. Religious activity expressed itself through the cultivation of images. Originally, like most primitives, the Egyptians did not draw a distinction between the image and reality: the images they created *were* the gods they presented. Early sculptors, having completed their work, engaged in a ceremony of 'opening the mouth', after which the image-god lived. Then Egyptians gradually came to draw a distinction between the god and the image. Ani, the most widely read sage of the Late Period, insisted 'The god of this land is the sun which is on the horizon, and his images are upon the earth'. In this sense the Hebrews were wrong to accuse the Egyptians of idolatry, as they did in the *Wisdom of Solomon* (written probably by an Alexandrine Jew in Ptolemaic Egypt). The Egyptians of the first millennium BC believed that the *ka* of the god – his personality and vitality – only entered the image after the necessary rite or cultivation.

The cult took place daily. Except for Re, the sun-god, who was cultivated in the open, images were placed in the innermost sanctuary of the temple and the rite might even take place in pitch darkness. At dawn or soon after, the officiating priest (pharaoh on state occasions) broke the seal on the shrine containing the image, entered, genuflected or bowed, incensed the shrine, picked up the image, undressed it and washed it thoroughly, dressed it, put on its special perfume and cosmetics, crowned it, and then 'fed' it with sacrificial food. The image was thought to 'eat' the food by gazing at it. After a time, the food was taken away to be eaten by select mortals, the priest exited backwards, dusting away his footprints, shut the door and sealed it. The god then was thought to inhabit the image until it was time for the next cult on the following day. As a rule, no one except the priest saw this process, for the image had to be 'less accessible than that which is in heaven, more secret than the affairs of the nether world, more hidden than the inhabitants of the primeval ocean.'

Cultivation of images was, of course, of great antiquity, and the earliest temples were evidently very simple shrines. With the advent of stone architecture under the Old Kingdom, attention was concentrated on the Horus-king's tomb, with its pyramid and palace of the dead – the valley-temple and pyramid-temple were secondary. With the Fifth Dynasty we get the shift away from the pyramid of the ruler to the temple of the priests, but these were sun-temples and atypical. City temples which survive in a recognizable shape are of much later date – for instance, the New Kingdom Temple of Amun at Karnak, or the best preserved of all, the Graeco-Roman Temples at Edfu and Dendera. These big temples, in addition to an inner shrine for the cult, contained a series of rooms and courtyards along a central axis, which allowed the priests to re-enact in dramatic form the Osiris-Isis-Seth-Horus myth, slowly progressing through the outer pylon entrance to the colonnaded halls and courts to the back wall of the temple where the image-shrine stood.

These performances are pictured in low-reliefs in the Edfu temple, and described in a New Kingdom papyrus which forms a *Book of Rites*. There were set prayers, hymns

Left: *A wall painting from the tomb of Sennefer showing Sennefer and his sister making an offering to a priest.*

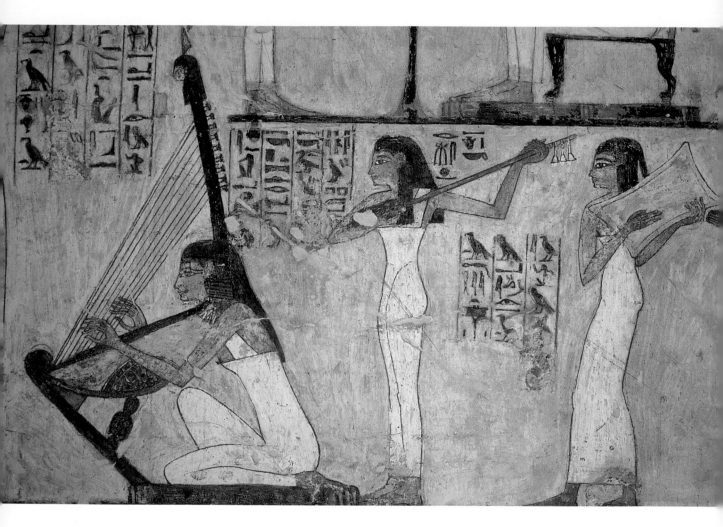

Above: *Female musicians with harp and string instruments from a wall painting from the tomb of Rekhmere, court official under Tuthmosis III and Amenhotep II, Thebes.*

– a number of which we possess – and readings, presumably from mythology, for 'lector-priests' figure in the documents. Big temples had professional choirs, musicians and ritual dancers. We do not know much about Egyptian music, for it is not clear how papyri thought to be musical guides or scores should be read, or whether they are scores at all. Egyptians did not possess the mathematical sense to develop complex music themselves, and it is probable that the music of the Old Kingdom was simple, slow and magisterial, and the accompanying dances stately. With the Second Intermediate Period and the New Kingdom, however, Egypt imported Asian music and dancing, along with much else. The range of instruments expanded, the music became richer, wilder and faster, and some of the dances of which we have pictorial records display terrific acrobatics and chorus-line discipline.

The public did not participate in the daily cult at the temple but all big city temples had an open, colonnaded court, called at Edfu 'The Chamber of the Multitude', designed to accommodate mass-worshippers at the big ceremonies. These were 'festivals', the Egyptian expression meaning 'to appear' and translated by the Greeks as 'great appearance'. There were festivals to mark the beginning or end of the seasons; royal festivals and jubilees, with the pharaoh as the cynosure, and particular anniversaries of the god to whom the temple was dedicated. All involved some kind of

Opposite page: *The Horus Temple, Edfu.*

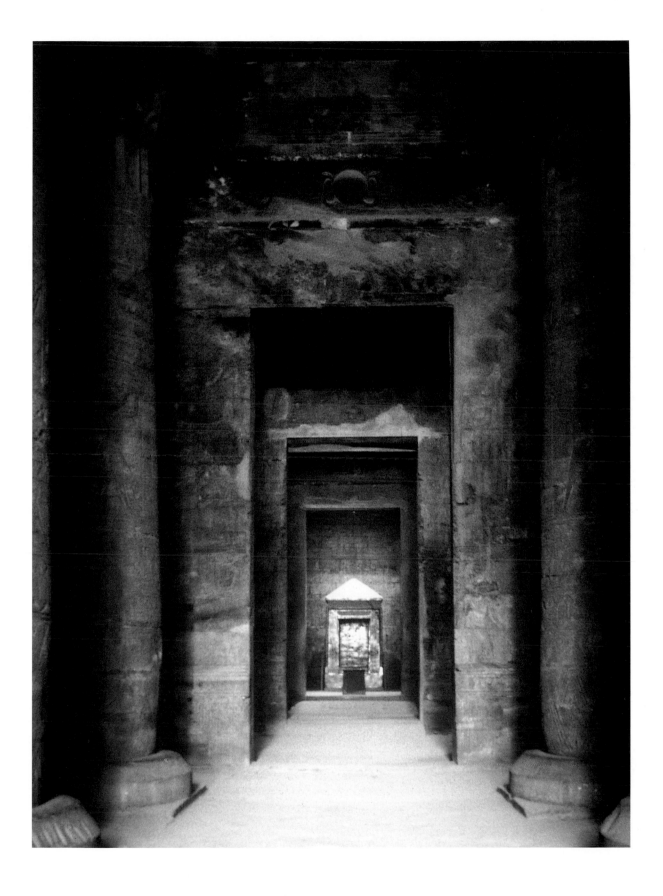

Below: *A view of the necropolis town of Deir el-Medina, Thebes showing workers' houses and tombs.*

public appearance and ritual drama. With god-festivals, the image was actually taken out of the inner shrine and carried in procession round the town or to a symbolic destination. Once a year, for instance, Amun left his temple at Karnak and was carried to his harem at Luxor. Hathor, the cow-goddess of Dendera, paid an annual visit to Horus in his temple at Edfu. These were very emotional occasions, with heavy eating and drinking. As the world became more cosmopolitan in the first millennium BC, and religious cults grew competitive, the festivals became noisier and more exotic – and sometimes more terrifying, especially under the influence of Syrian theology.

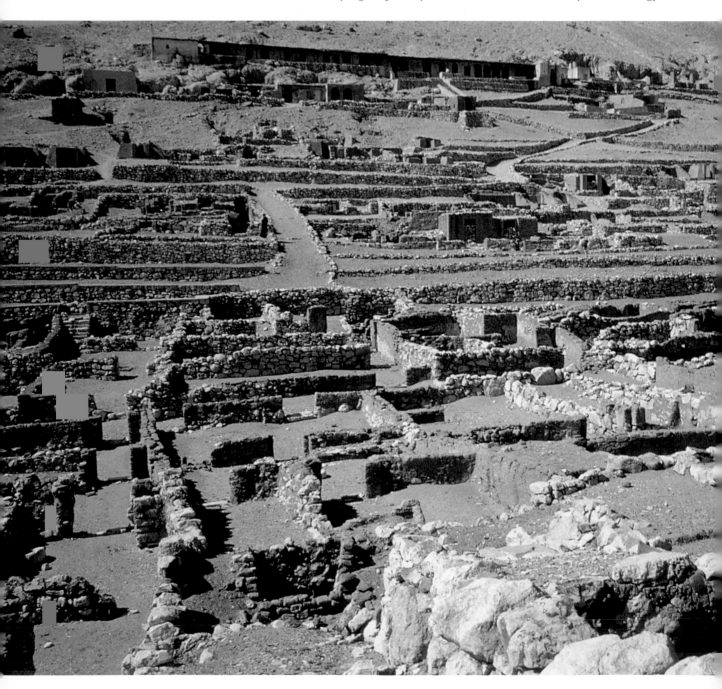

Mechanical gimmickry was introduced, so that gods rolled their eyes, moved hands and feet and appeared to speak oracles.

The development of pious fraud was of course the product of a progressive increase in the size of the professional clergy, the crucial period of expansion beginning with the Empire under the Eighteenth Dynasty. Originally there was no professional priesthood. The priest acted vicariously for the pharaoh, the only true priest, and the priest's person was therefore sacred, as participating albeit remotely in the king's divinity. The words 'sacred' and 'segregated' are hieroglyphically close. Priests had to be fair of face, well-formed, without physical blemish. But the priesthood democratized itself as it expanded, and by the time of the late Empire there were enormous numbers of temple-priests, many of whom must have been illiterate, and who led a parasitical existence on the profits of the huge temple estates. Literate priests also earned their livings by copying out sacred texts (collectively, *The Book of Life*) for private individuals to deposit in their coffins and tombs, the fees depending on the length of the texts, and the quality of the calligraphy and illustrations. Increasingly, during the first millennium, priests hung about temples in swarms, catering for the growing tourist trade of Assyrians, Persians, Greeks and Romans, by giving conducted tours, telling tales, selling charms, scarabs, amulets and other pseudo-sacred artefacts. They already appeared slightly contemptible, prefiguring the 'gypsies' they later became when Christianity usurped their original role.

There is no evidence, however, that the clergy, however exclusively they may have administered the temples – in a manner not essentially different from the cathedral clergy in medieval Latin Europe – ever attempted to suppress private religion. It was late in developing, but it proceeded unopposed, hand in hand with the idea of the individual soul and conscience. In the Old and Middle Kingdoms laymen actually performed many of the priestly tasks while earning their living in an ordinary way. Only in the New Kingdom, when imperial wealth led to the rapid expansion of the professional clergy, was the traditional lay-priest eliminated. But the great mass of ordinary people did not concern themselves with 'official' religion and the temple services, except on great feast days. The complicated theology of the cult was no more accessible to them than were the hieroglyphics in which it was expressed. Some did go to the temples, into parts of which they were allowed to penetrate for private devotions. They formed their own little cults, centring on architectural features or statues. Rich or important men occasionally got permission to install a statue in a temple court. Ani wrote that a man who went to the temple to pray by himself about his private troubles should do so silently: 'Noise is the abomination of the gods. Pray lovingly in your heart but with secret words.' A low relief from Deir el-Medina at Thebes shows one of the workmen kneeling before the great statue of Amun and saying a prayer of thanks to the god for curing his son.

Private worship, however, usually took place outside temple precincts, in small street-corner or countryside shrines, or in private homes. One of the advantages of Amun, for instance, was his mobility; a poem says 'when a man calls him he comes in a second from a great distance'. Excavation of workmen's houses in the little necropolis-town of Deir el-Medina reveals that nearly all had niches for small altars and the busts and statues of gods. Very likely every house had a religious shrine of some kind. Private men created their own gods and theology. Private cults deified Imhotep as a god of healing, and several of the better-known pharaohs were worshipped. Ancestor worship

was common. Under the Empire, soldiers returned with private cults of foreign gods – that is how Astarte and Kadesh were established in an Egyptian setting. Gods which cured and protected were the most popular. Many small and cheaply-made images survive of Thoeris, the beneficent female hippo-goddess, patron of childbirth. She is often shown pregnant, or hollow with tiny holes in her breasts, so she could be filled with milk. The most characteristic of the 'proletarian' deities – who had no cult at all at a higher social or official level – was Bes, the grinning cheerful dwarf or gnome-god, often with a lion's head, who protected the home. Such plebeian deities, usually in animal form, swarmed over the domestic furniture and were worn as amulets.

Below: *A papyrus showing the teachings of the writer Ani.*

The growth of popular magic and gross superstition was only one feature of private religion in the second and first millennia BC. When religion ceased to be collective and began to democratize itself, and as the individual conscience made its own adjustments

to the idea of god, cults inevitably developed on class lines. If Bes was for the illiterate masses, we can also trace the emergence of sophisticated ethical and religious cults among the educated classes. The demand for a contemplative or philosophical cult, with a stress on ethics and the meaning of existence, led to the production of wisdom texts and religious poetry. Such cults had little to do with temple-religion, official festivals or with the visualized, anthropomorphic images of the traditional gods – let alone the crude animal-gods of the poor. They tended towards monotheism and abstraction. High-born men, including pharaohs, practised them in addition to their more formal adherence to the official cults. Thus the Egyptians first set the pattern of the dual faith – a personal faith of choice combined with the public faith of duty and decorum – which remained the norm in antiquity until State Christianity began to crush private cults in the late fourth century AD.

A dual faith demanded an atmosphere of tolerance, and the extraordinary diversity of Egyptian religion in the second millennium BC makes it clear that such tolerance usually existed. That was what made the Akhenaten affair so exceptional, as well as shocking. His sun-disc religion must have begun as an abstract, philosophizing cult, of a highly sophisticated and literate kind. It was the cult of his family but there is evidence it was practised privately outside royal circles, though only among the upper-classes. By trying to turn it into the State religion, and still more by suppressing the traditional observances, Akhenaten abandoned the policy of religious tolerance which was very old indeed – probably as old as the unity of the kingdom, which it had helped to make possible. Moreover, what was tolerable as a private cult among the rich became heresy as an official creed; nor was it popular. Outside the royal circle it was plainly unloved even among the bulk of the aristocracy, who did not follow the king to Amarna. Those who did were new men on the make or Theban 'Vicars of Bray'. The Aten cult had the supposed merit of simplicity but there is no evidence that most Egyptians regarded simplicity as a virtue in religious matters; quite the contrary. Even at Amarna, excavation of the poorer quarters shows that the illiterate section of the population did not adopt Atenism as their religion, or rather that they continued to worship the old deities in private. After Akhenaten's death or fall, a religious reaction of an intolerant kind was inevitable; hence Horemheb's savage decree and his cartouche-smashing. Thus in a short space of time Egypt experienced religious persecutions both against and on behalf of the official creed, a hateful and uncharacteristic business. But gradually tolerance and diversity re-established themselves, and private wisdom cults and popular superstitions again became the warp and woof of Egyptian religious life, beneath the official surface.

It is through wisdom cults, and through the writings attributed to Ptah-hotep, Hordedef, Kagemni, Amenemope, Kheti, Ani and the Ptolemaic *Insinger Papyrus*, that we derive our knowledge of Egyptian ethics. Their approach was in marked contrast to that of the Hebrews, who on the basis of the laws handed down by Yahweh, and the essence of the scriptures, as interpreted by generations of legal scholars, casuists and rabbis, constructed an elaborate code of conduct which enabled a man to go through life in the certainty of doing no wrong provided he was knowledgeable and obedient enough. The Egyptians likewise accepted that knowledge was the key to goodness. But what a man had to know and understand was not the letter but the spirit – their approach was much closer to St Paul and the early Christians than to the Jews. However, unlike the Christians, they made no distinction between what was legal and

what was moral, or between God and Caesar. Indeed, their Caesar *was* God. All revolved round *maat*. The word has its linguistic origin in the concept of 'straightness' and the earliest hieroglyph for it probably derives from the plinth of the pharaoh's throne. But this throne itself was in origin merely a stylized version of the primeval mound, which emerged as the principle of order from the waters of chaos.

Thus order meant the king and the king, in turn, meant order. It was the king's function to maintain and uphold the order established at the creation, and the individual's duty to help him to do so, both in relation to the State and society, and in his private life. The idea of change, then, was hostile to the Egyptian's sense of justice – a prime reason why their society was so conservative. But the opposite of *maat* was not change but covetousness, associated with deceit and violence. Ptah-hotep wrote: 'The man who lives by *maat* will live for ever, but the covetous has no tomb.' Kagemni draws no essential distinction between civic and religious duty: 'Do *maat* for the king, for God loves *maat*. Speak *maat* to the king, for the king loves *maat*.' The detailed application of *maat* derived not from specific texts, whether divine commandments or royal law-codes, or their interpretation, but from an intuitive or charismatic knowledge of *maat*. The king, of course, possessed this quality in superabundance because of his physical relationship with divinity. This link was maintained by food from the principal sacrifices going to the royal table after the divine image had looked at (i.e. eaten) it. Thus it is written in a royal tomb, of the god Amun: 'I have offered the *maat* which he loves, since he lives by it. It is my bread and I drink from its dew. I am of one body with him.' Since there was no written law, pharaoh's personal law-giving had to establish this causal connection between the Egyptians and *maat*. Normally this was done through the blood royal. General Horemheb, who was pharaoh by his marriage and by virtue of his coronation, seems to be referring to the latter in his law-and-order decree when he says: '*Maat* has come after it has united itself with the pharaoh, Horemheb.' Under a goodly ruler, the whole nation was transformed into a mystic unity revolving around justice. Thus Sethos I, another law-giver, was praised because 'thou hast implanted *maat* in Egypt and it has become united with all.' High officials were in theory also identified with *maat*, since they shared the charismatic quality which radiated from the king, sitting on his *maat*-plinth, in concentric circles of diminishing intensity – rather like the *shekinah* (power of God in the temple) emanating from the Jewish Holy of Holies. Hence the vizier was called 'Priest of *Maat*' and judges wore the sign of *maat* round their necks. They did not need a written code to sit in court: they had the interpretative faculty. Egyptians thus associated *maat* with the gift of wisdom and it was this definition which became the basis of the Jewish view of wisdom: 'Council is mine and sound wisdom. I am understanding. I have strength. By me kings reign and princes decree justice. By me princes rule, and nobles, even all the judges of the earth.' (Proverbs 8:14-16.)

Hence Egyptians saw themselves judged not by law but by moral wisdom. They do not seem to have drawn any essential difference between a State court on earth and divine judgment in heaven. We can be pretty sure that Egyptian courts contained the scales of justice, symbolically weighing *maat* against the accused, just as in heaven. The texts which form the *Book of the Dead* contain many 'negative confessions' – that is, assertions by the soul under judgment that he has not committed specific sins. But many of these are not so much sins in the moral sense as crimes against order in the State sense. While the dead deny pederasty and masturbation, they also deny various forms of usury, all kinds of offences against the temples and their property, and a long

list of 'sins' connected with agriculture, rights in land and water, and the payment of taxes ('I have not damaged the grain measure of the tax-officials'). And, curiously enough, the negative as opposed to the positive confession is itself more suited to a terrestrial court – where a man has a right to insist that he is innocent until proved guilty – than judgment before an all-seeing (but also all-forgiving) divinity. In the *Book of the Dead*, the candidate for immortality does not admit sin, repent and ask to be forgiven but tries, as it were, to bluff it out by flatly denying any fault whatever.

This approach may have been shaped by a genuine confusion in the minds of Egyptians as to the reality of the world on earth and in heaven. Very early Egyptian religious texts, in so far as we understand them, do not make absolute distinctions

Below: *A painted shabti-box showing the weighing of the dead man's heart against the Truth in the judgment of Osiris.*

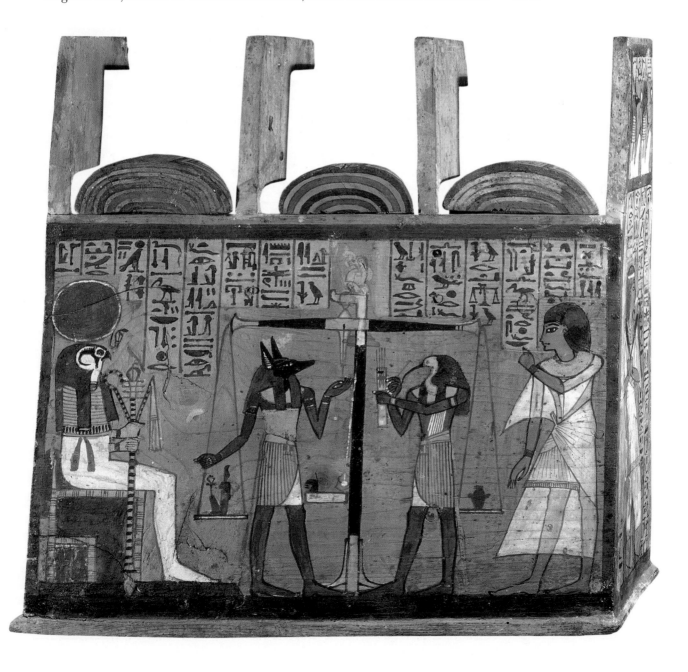

between life and death. At death one 'moved to the West', that is passed from the fertile strip to the edge of the desert on the west bank of the Nile, where the dead were buried. Since the body remained, or could be made to remain, incorruptible, and since the gods and divine activities were all around on earth anyway, the moment of death was not a transcendental change but an episode in a continuum. One could say that the earthly system of jurisprudence was believed to continue among the dead; or, alternatively, that earthly courts merely foreshadowed celestial ones. But however it was put, the Egyptians believed there was continuity. Dead men and women did not remain in a suspended or static relationship with each other. They could sue and be sued and take each other to court, even in heaven, and in respect of terrestrial misdemeanours and torts; but you could also commit crimes in the tomb.

The confusion in Egyptian minds between life and death seems to have been cleared up as the Old Kingdom progressed, or at any rate as and when ordinary people began to claim the same rights to an individual personality, or *ka*, as the king and other gods. The democratization of religion and conscience, the ascent from collectivism to humanism, brought home to ordinary people the momentousness of the fact of death, the need therefore to organize their life on earth with this in view, and to make preparations for death every bit as elaborate (according to their means) as those of the pharaoh. It was a very early principle in Egyptian law that a man could not inherit a legacy until he carried out suitable funerary arrangements for the testator. But the implication there is that the testator died suddenly. A man who lived to ripe years would certainly have built, adorned and equipped his tomb down to the last details – all his heirs had to do was to provide the perishables, and ensure they were replenished and the services kept up. The great majority of fine Egyptian tombs were built in the lifetimes of their occupants, a source of pride and self-satisfaction to them and very likely the most valuable items in their property. Egyptians wrote their own epitaphs and tomb-biographies.

This helps to explain why the overwhelming mass of the surviving evidence of Egyptian art and civilization is connected with death and fashioned for tombs. Egyptologists deny that this in any way indicates that the Egyptians were morbid. They were, so far as we can judge, a lively, extrovert, cheerful people, greedy for the pleasures of the senses and all the good things of this world. It was, it is argued, the very fact that they cared for life so much – and that life in Egypt was so rich – which made them so anxious to prolong it, and therefore so meticulous in the mortuary arrangements needed to win immortality. All this is true. But it is also true, as the instinctive modern Western reaction to the externals of Egyptian civilization indicates, that the Egyptians were, to our minds, obsessed by death. Death always had the first-fruits of Egyptian culture. Imhotep's great building for Djoser at Sakkara was a mirror-image of the king's earthly palace. But the first was built in immortal stone, which remains, and the second in perishable brick, which has vanished in dust. Writing to his son, King Ammenemes I did not boast about his palace but his tomb, made in far more magnificent materials: 'I made for myself a house adorned with gold, its ceiling of lapis-lazuli, the floors of [word missing], the doors of copper and the bolts of bronze, made for eternity and prepared for the everlasting.' No man would expect to have in his house articles of the same quality and workmanship as those he commissioned for his tomb – and which, as a rule, he would live to admire and enjoy even in his lifetime. An Egyptian spent his adult years planning for eternity just as, today, the insurance companies tell us we should plan for retirement.

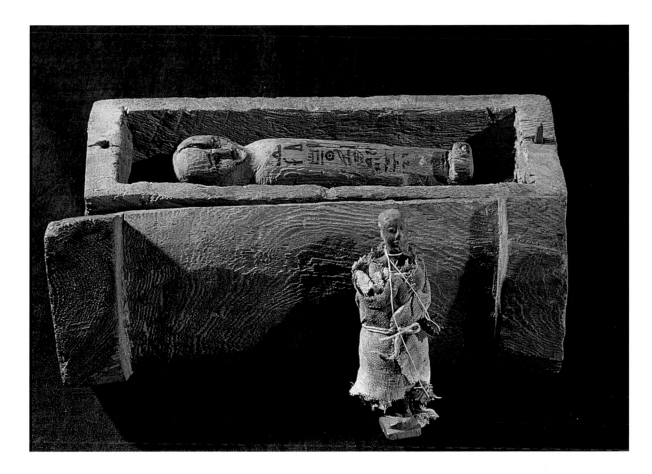

Above: *Model of a coffin and mummy.*

In this respect, the whole of Egyptian civilization could be described as a comment on the text '… et in arcadia ego'. The national motto was *memento mori* (remember you must die). Perhaps the best-known sequence in the whole of Egyptian literature was the counsel from Hordedef, one of the earliest of the wisdom writers: 'Furnish thy house in the necropolis, enrich thy place in the West.' More than 2,000 years later, in Ptolemaic times, the priest-sage Petharpokrates was giving the same advice. A man's greatest virtue, he says, is 'to keep his death in mind when he is strong'. By and large the Egyptians heeded these councils. Once a year, the memory and immortality of a well-to-do man was celebrated by his friends with a banquet in the chamber outside his tomb. Special anniversary songs were written for these gay occasions. The poor, having no chamber to use, simply picnicked in the necropolis. Such junkets were called 'the feasts of the Valley'. But at all times it was a pious custom of the Egyptians, so deeply-rooted as to be instinctive, to recall death when they were enjoying themselves. Herodotus was shocked that the Egyptians, when at a feast, customarily passed round small images of mummies during the toasts. The greatest honour a pharaoh could bestow upon a distinguished servant – much more valued, and indeed valuable, than his golden collars and medals – was to build and furnish his tomb. It was an accolade a man's family would boast about for generations.

Like their religion as a whole, the Egyptians' theory of death, judgment, hell and heaven (eschatology) underwent gradual changes. Their oldest eschatology, hinted at in Ptah-hotep (Fifth Dynasty) suggests a highly optimistic and almost automatic

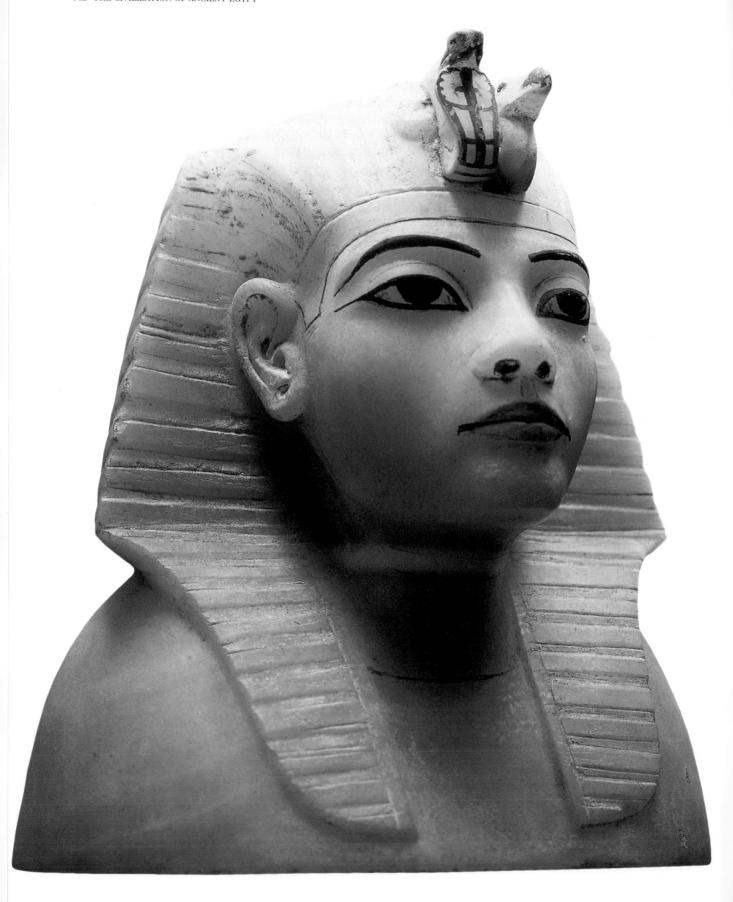

they built burial chambers. To their consternation the bodies, no longer in contact with the desiccating sand, putrified. So, by trial and error they moved towards the clumsy science of mummification, which was first practised, it seems, in the Second Dynasty.

The Fifth Dynasty *Pyramid Texts* make it clear that the basic aim of mummification was to keep the bones intact and in place and above all to keep the head attached to the body. Hence the bandages to maintain the characteristic structure and bodily shape, but they quickly discovered that they had to remove the internal organs and, sometime during the Old Kingdom, they began to take these out. The object, so far as possible, was to leave the body visibly unchanged. Either the stomach was cut open with a ceremonial stone knife, the viscera taken out, and the body then sewn up again, or the viscera were extracted through the anus. Herodotus tells us that the embalmers 'drew out the brain through the nostrils with an iron hook, taking part of it out this way and the rest by pouring in drugs.' Experiments prove that the method described by Herodotus is feasible – though the process is messy and expressions like 'drew out' are inaccurate.

Though it was necessary to remove the organs to prevent decay, the theory of immortality demanded that they be kept close to the body. From Old Kingdom times they were placed in four Canopic jars, mistakenly called after Menelaus's pilot, Canopus, at one time worshipped in Egypt in the form of a jar. The jars had human heads and were protected by the four sons of Horus – Duamutef, who looked after the stomach, Kebhsenuef, the intestines, Hapy, the lungs, and Imsety, the liver. The jars were also guarded by four leading goddesses, Neith, Selkis, Nephthys and Isis. Many of the jars which survive, however, date from the Nineteenth Dynasty and onwards, when three heads became theriomorphic – a jackal, a falcon, an ape, only Imsety remaining human. In characteristic Egyptian fashion, the jars remained even after the mummification practices of the Twenty-first Dynasty made it possible to replace the organs in the body.

It was during this dynasty that Egyptian skill in embalming reached its height – though there was never a mysterious 'secret' the Egyptians alone possessed. Indeed, considering the attention they devoted to the matter over more than 2,000 years, they were not very good embalmers. Some of their embalmed corpses have rotted or congealed into a jellied mass. Early mummies tend to be black and dry; later ones yellow and rubbery. There are very few mummies of any kind from the first three dynasties, and thereafter the best embalmers could do was to preserve the basic form over the bones. They did not hit upon a satisfactory method of avoiding shrinking of the skin until the foundation of the New Kingdom, so the few proper mummies dating from before about 1600 BC give us little idea of what their subjects looked like.

However, from about 1400 to 800 we have some fine specimens. Their scientific examination still continues, and opinion has shifted as to the exact methods employed. Herodotus and other authors who describe them wrote in a period when the practice was on the decline. What seems to have happened is that, after the organs were removed, the body was impregnated with natron, a carbonate of soda which dried up the body fats and left the skin reasonably tough and plastic. The extracted organs got separate, but similar, treatment. The body was then subjected to an elaborate cosmetic process to give it the closest possible approximation to its appearance in life. Linen wads stuffed out the interior. Women's breasts were padded out. Artificial eyes were placed in the sockets, then the body was covered with preservative resins and

Opposite page: One of the alabaster lids of the Canopic jar from Tutankhamun's tomb. The jar held the mummified viscera of the pharaoh and the lids were carved in his likeness.

ointments, and wrapped in bandages to give it a natural shape. Amulets in the form of scarab beetles, the 'eye of Horus' or Isis's girdle were wrapped up in the bandages, which also enclosed scraps of magic prayers.

From Early Dynastic times onwards, the mummy was placed in a coffin. But these varied enormously according to the period, and the social standing of the occupant. From the Old Kingdom, kings were buried in great coffins of fine cedarwood from Byblos. The adoption by aristocrats of these wooden boxes, and their decoration with coffin texts derived from the original royal pyramid texts of the Fifth and Sixth Dynasties, was the first evidence of the 'democratization' of immortality. Under the Middle Kingdom, royal sarcophagi were of stone, and these continued to be carved until the end, though under the New Kingdom they became mummiform in shape. Inside the sarcophagus there might be as many as three coffins, the innermost of gold. In addition, the corpse's head was covered with a mask of linen covered in gesso, moulded to fit the face and, in the case of royalty, with a gold and painted layer on top. Sometimes there was an extra mummy-cover inside the inner coffin, so that the corpse was enclosed within a multitude of layers, all elaborately decorated with magic and religious images and covered in hieroglyphic spells.

The existence of these well preserved cadavers has made some contribution to palaeopathology, the study of disease in the ancient world – though mainly in a negative direction. No mummy has been found suffering from syphilis, for example, which helps to bolster the theory that the disease was imported from the New World in post-Colombian times. There is no evidence of cancer either. But the mummy in which the palaeopathologists are most interested – Akhenaten's – has never been found. What has been found and examined is the mummy of a man who died of acute encephalitis (inflammation of the brain) so deforming that he was treated and buried as though he were a sacred ape.

But however deformed or damaged the body might be, the idea of mummification was to preserve the dead man in as nearly perfect a shape as the art allowed. The process, which lasted two and a half months, was a ritual to restore life, in which the *ka* or vital personality of the dead man, would return. At the crucial parts of the ceremony, the embalmers wore the dog-head masks of their special deity, the jackal-god Anubis, while a priest read out a prayer including the story of Isis's restoration of Osiris's body, concluding with the words: 'You live again, you live again for ever, you are young once more for ever.' This was the 'opening of the mouth' – the same process, in essentials, by which a statue-image became a god.

However, it was not enough for the body to recall its *ka* through mummification. It had to keep the *ka* there by providing the necessary food. This was arranged by the endowment of regular services, carried out by professional priests or the family of the dead, but bitter experience showed that these services were not maintained indefinitely, or even at all. So the Egyptians resorted to what anthropologists called 'sympathetic magic'. A so-called false-door stele was placed in the chapel of the tomb. The *ka* would come out when summoned, either to eat offerings placed in front of the false-door; or simply to look at (and so devour) the provisions depicted by art on the stele above the door, or later on the walls of the offering chamber or burial chamber.

It was in this way that the Egyptians developed the scenes in painted low-relief which are among the great glories of their funerary art. Under the Fourth Dynasty they were limited to the offerings themselves. Then, under the Fifth and Sixth Dynasties,

Opposite page: *A royal couple in the style of the late Amarna period, probably either Smenkhkare or Tutankhamun with one of the daughters of Akhenaten. Painted on limestone, Eighteenth Dynasty.*

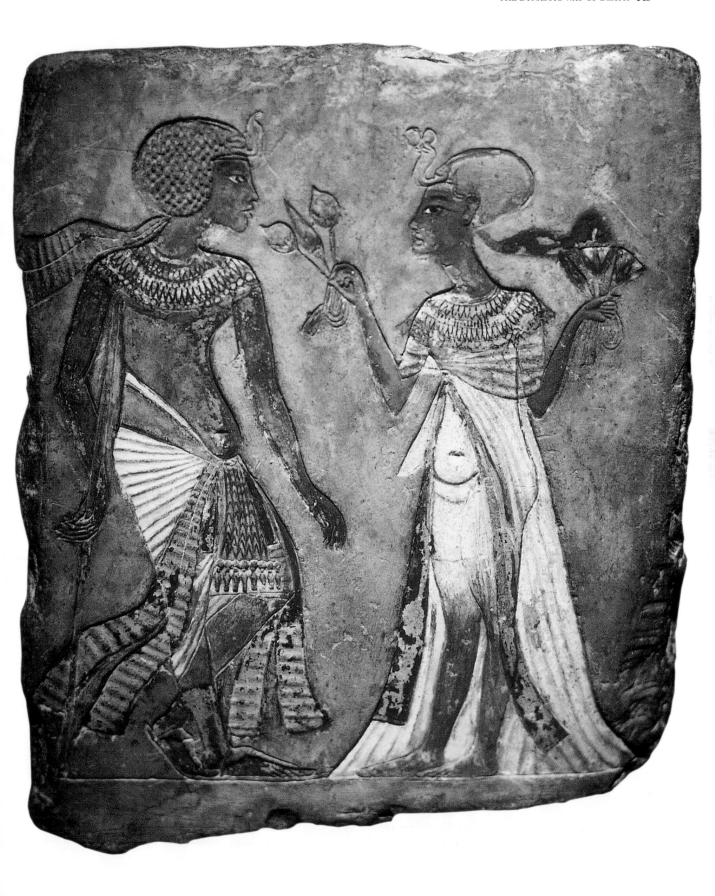

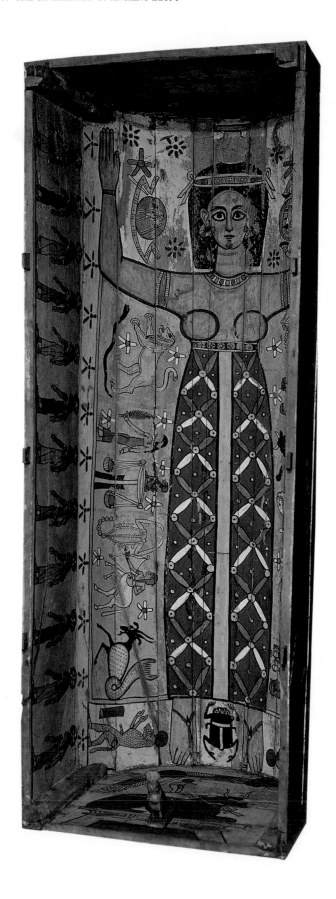

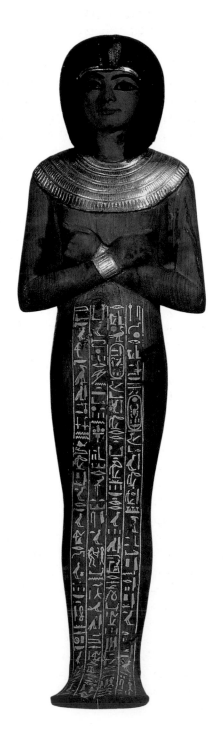

they recreated scenes from the daily life of the tomb-owner, so that his *ka* could re-live them – hence tombs became, to our eyes, pictorial biographies of the dead. In ever increasing elaboration and over an ever-widening social spectrum, we see the dead man with his wife and family; the birth, pasturing and slaughter of the cattle which supply his meat; the sowing and harvesting of the crops which produce the grain, and the baking of his bread; the vineyards which produce his wine and breweries which ferment his beer; and the hunting of game and the fishing which stock his larders and tables. Gradually the process went even further. We see craftsmen making the funerary furniture, or the jewellery on the body; the linen-harvests for the clothes; wig-makers, embalmers, weavers and all who supply the apparatus of the tomb. But, since the *ka* must be given the opportunity to re-live the life of the deceased in every one of its aspects, all his relevant activities are presented in the smallest detail – his work, his voyages, his sports and games, his public honours and his domestic relaxations. All this was done at the command and under the supervision of the tomb-owner himself, during his lifetime. Every Egyptian, if he had the means to do it, made a perfect recording of his whole life, not in wax or on tape or film, but in carved and painted limestone and gesso – so that his *ka* could play it over and over again for all eternity.

The theory of the immortal tomb was, of course, aristocratic if not regal in origin, and presupposed the dead man surrounded by servants. The murder of servants for burial with the king or queen seems to have been abandoned even before the Old Kingdom (though there are apparent instances in the non-Egyptian south under the Middle Kingdom). Instead, we find the progressive appearance and proliferation of *shabti*, *shawabti* or *ushabti* figures (the name varied with the period), small, mummified figures of men and women servants. The hieroglyphic origin of the word is obscure, but the concept plainly derives from the immemorial duty of collective labour according to the seasons. As tomb-life was the mirror-image of earthly life, a dead man was liable for *corvée*. But, as in life too, he could pay substitutes to do it for him, and in the tomb these services were rendered by the shabtis. Chapter 6 of the *Book of the Dead* says: 'Oh, Shabti, if [name of the dead] is summoned for any task to be done there, as a man must, that is to cultivate the fields, flood the banks, and shift sand to the east and to the west, then thou sayest: "Here am I!"'

Shabtis were made in stone, wood, glazed composition and metal. Originally they represented the later owner of the tomb; the servant of the owner. In Middle Kingdom tombs they often appear in groups – as regiments of troops, ships' companies of sailors, forces of agricultural workers, or cooks, bakers, brewers and craftsmen of all kind. As often happens in Egypt, the reinforcement and modification of the concept confuses it, at any rate in our eyes. But these shabtis and models together provide an extraordinary documentary record of everyday life in ancient Egypt – a record second only to the scenes on the walls, and incomparably more detailed and trustworthy than the written documents, which are often difficult to interpret. The tomb was a mirror-image of their lives to the Egyptians, and to us it is a priceless window into their world. Such tomb-objects, too, provide a reliable guide to the evolution of Egyptian art. Scarabs and shabtis were made in prodigious quantities throughout the mature period of Egyptian civilization. Most of them were mass-produced during the New Kingdom and Late Periods. But many are in fine materials and of exquisite workmanship and they allow us to date and monitor artistic development with considerable precision.

Opposite page left: *A painted mummy case showing the goddess of the sky, Nut, with her arms raised.*

Opposite page right: *A shabti statuette from the tomb of Tutankhamun, Eighteenth Dynasty.*

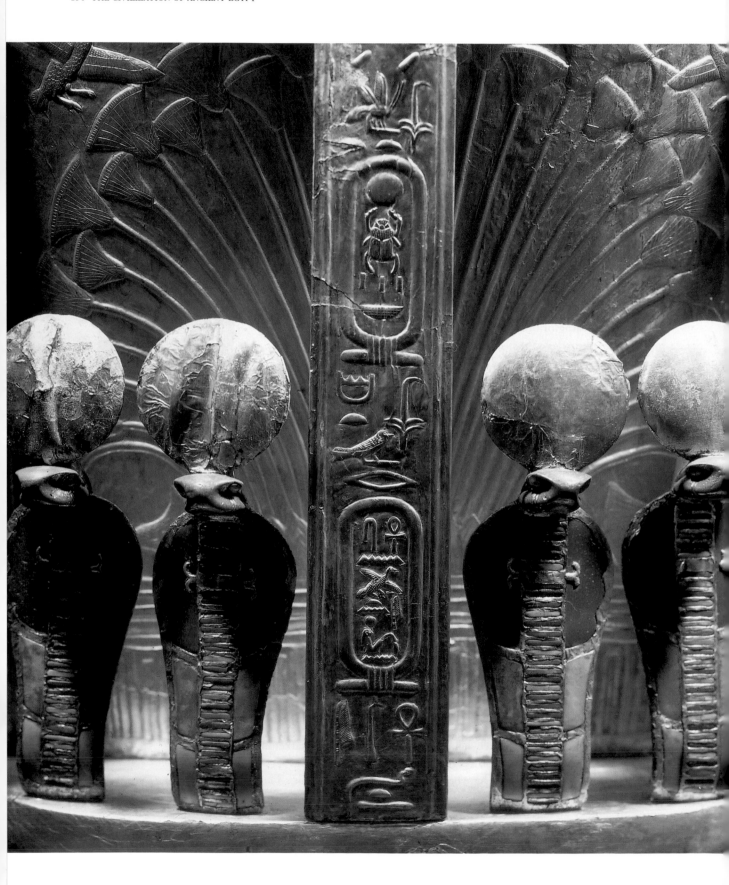

operating as compulsory saving, 'trapping' large quantities of gold in tombs, and so keeping it out of circulation. Thus Egypt, quite by accident, contrived to retain its economic stability during most of the imperial period when it was awash with precious Asian loot as well as its own gold. The inflation did eventually come in the Twentieth Dynasty, and was indeed destructive. It is significant that it followed the wholesale ransacking of the Theban rock-tombs, by far the most valuable in all Egypt, and the consequent discharge upon the market of a prodigious volume of gold.

By that time, and for a variety of reasons – which we shall examine in a later section – the pharaonic system was in general decline. Tomb-robbery was an important part of it. For in addition to damaging the economy it bruised the primeval optimism which, springing originally from the regular food-surpluses produced by the Nile Valley, determined the structure of Egyptian theology. It was the desire to prolong what they considered to be their fortunate life on earth which determined the nature of the burial-customs of the Egyptians. The systematic despoiling of the tombs of the pharaohs, who occupied a central position in their religious life even in the late New Kingdom, struck a blow at the heart of Egypt's morale.

During the first millennium, when the independence of Egypt was gradually extinguished and the pharaohate eventually fell into foreign hands, the religious system changed radically, and in ways which are not always easy to follow. With the decline in pharaoh's prestige, the Egyptians turned away from the great State deities and back towards their local gods. This decentralization of religion set into reverse the anthropomorphizing of the primitive animal deities which had marked the growth of a great unitary kingdom with a strong monarchy. A powerful theriomorphic trend again established itself. In local cult centres the practice began of treating the animal who represented the god or goddess as his or her living embodiment, cultivating it in temples, and mummifying and so immortalizing it after death or ceremonial sacrifice. As a result, we find during this Late Period a series of sacred animal cemeteries. At Bubastis, in the Delta, there was a cemetery for Bastet, the cat-goddess. Thoth was worshipped in the form of a baboon, but was more often represented with the head of an ibis and there was a large ibis-cemetery at Thoth's cult-centre in Hermopolis in Upper Egypt. Crocodiles were embalmed in various centres and sacred bulls were venerated at Memphis, Heliopolis and Hermonthis.

As a rule not much trouble was taken with the embalming of animals, though the bandaging was elaborate, and in fact the whole cult of mummification was in decline by the time that mass-burials of animals became common. But in the case of the Apis bull buried in the great necropolis of Sakkara near Memphis, the full embalming procedure was followed. Apis was a theologically upgraded version of a bull-cult always associated with Ptah, the Memphis supergod. The cult seems to have been transformed into a major affair of state by Psammetichus I, from Sais in the Delta – the home of the biggest animal cults – who founded the Twenty-sixth Dynasty. Apis was a miraculous bull-calf, thought to be the incarnation of Ptah, and was identified at birth by his peculiar marking. The bull was raised and cultivated in the temple of Ptah, and after death and mummification was identified with Osiris, and buried in a huge stone sarcophagus. There was thus only one sacred bull at a time, the new one being providentially discovered by his marking when the old one died – the cycle being a brutish analogy of the succession of god-pharaohs. When the Greeks came to Egypt in the second half of the first millennium they identified the Apis-Osiris (or Osorapis)

Above: *A mummified cat.*

Opposite page: *Reverse of the throne of Tutankhamun, gold with lapis-lazuli and gold uraeus cobra figures.*

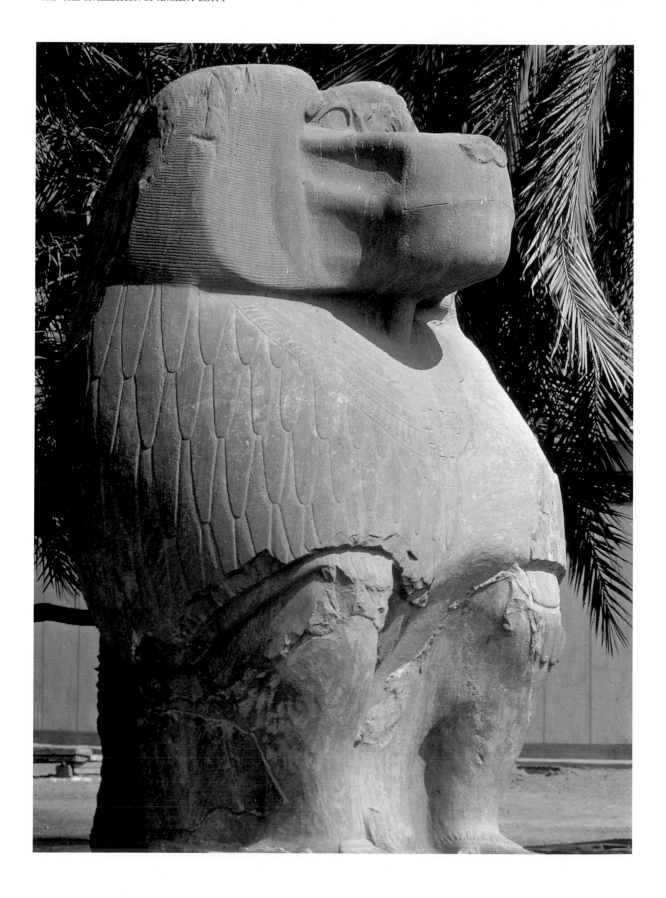

cult with the ceremonies and 'mysteries' of their own cult of Dionysus, god of wine. Herodotus states flatly: 'Osiris is he who is called Dionysus in the Greek tongue.'

Two hundred years later, when the Greeks were established as rulers, Ptolemy I decided to set up a cult-centre at Memphis where Greeks and Egyptians could join in common worship. The common ground was the Osiris myth, which the Hellenistic-age Greeks associated with Serapis, or Serapis-Dionysus. The sacred bull was a part of all these varieties of cult. Hence the Ptolemies established the Serapeum in the midst of the vast royal necropolis at Sakkara, which went back to the days of the Old Kingdom. Within sight of Djoser's Step Pyramid, where Imhotep invented stone architecture, the Greeks set up a semi-circle of statues. A *dromos*, or paved avenue, led between a line of sphinxes to the entrance to the huge, echoing galleries beneath the Serapeum, where the mummified bulls rested in their sarcophagi.

Thus Egyptian religion in its later phase blended into the cults of the classical world. Diodorus wrote that 'there is only a difference in names between the festivals of Bacchus and those of Osiris, between the mysteries of Isis and those of Demeter.' Likewise, Plutarch, describing the burial of Apis, who was taken to the necropolis on a raft, compares it to the revelry of Bacchus, 'for the priests wear the skins of fawns and carry thyrsus-rods and shout and dance exactly like the ecstatic devotees of the Dionysiac orgies.'

Of course the synthesizing of Greek and Egyptian religion took many forms. Among the growing circle of the educated, the Greeks seized eagerly on the private Egyptian wisdom cults which had developed in the second half of the second millennium. During the next 500 years, as more and more individual Greeks penetrated into the Egyptian sphere of culture, they absorbed this philosophical approach to religion, as the Hebrews did, and brought the concept of *maat* into their systems of thought. Egypt thus contributed to the combination of metaphysics and piety which constituted the personal creeds of so many gifted and intelligent men and women in the Greek and later the Roman era.

But for most ordinary Egyptians, there was a degeneration in their religious beliefs. The Late Period is dominated by magic and superstition in the crudest forms. Animal worship of an unsophisticated kind supplemented the official cult of Apis. At Sakkara, not far from the Apis galleries, archaeologists have discovered whole labyrinths containing thousands upon thousands of mummified cats, dogs, baboons and falcons. In searching for the tomb of Imhotep, which has not yet been found, and the Asclepion or medical cult-centre which they presume would be attached to it, they have found pits and galleries containing mummified ibises – whose significance is not fully understood – in stupendous quantities. It is calculated that there must be well over a million embalmed birds in this section of the necropolis alone, and its exploration continues. The truth is that, while Egyptian religion at its surface level contained a complex theology we can respect and even, in private, a speculative element with which we can sympathize, it also contained a huge underground of crude animism which reached back right to the predynastic period, when every village had its sacred creature. The great mass of Egyptians never rose above this level of ideas and the reason they could not do so was that they were condemned to illiteracy by the complexities (and also the beauties) of the Egyptian written language.

Opposite page: *Sculpture of a baboon from the main entrance of the temple of Thoth.*

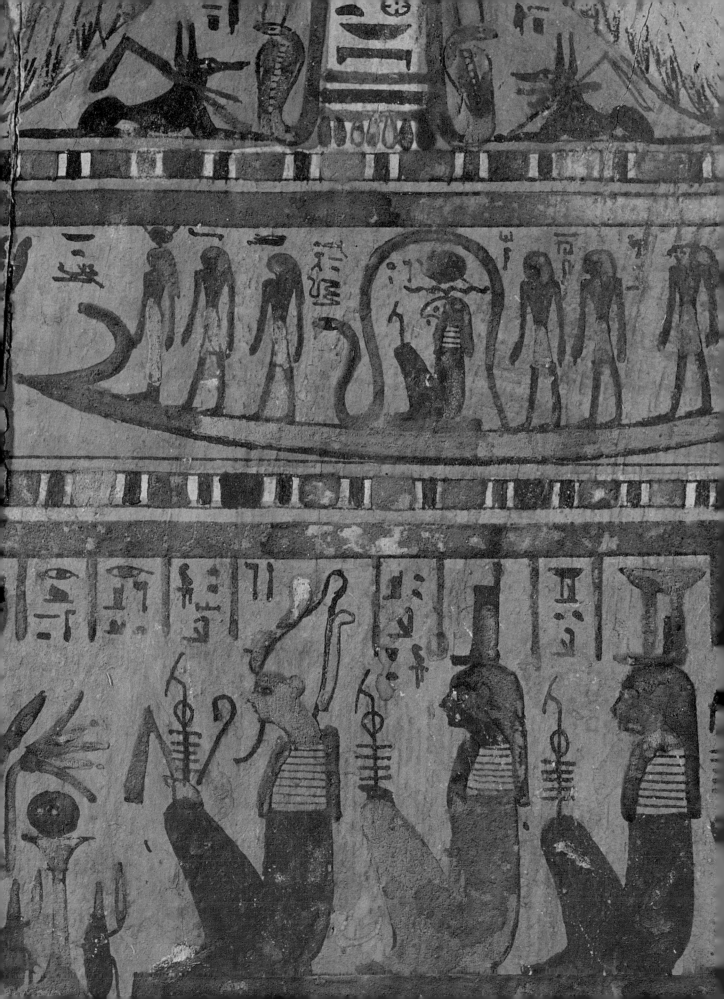

HIEROGLYPHS

The development of hieroglyphics mirrors and epitomizes the history of Egyptian civilization. Originally an import, writing was quickly fashioned by the Egyptians into a system uniquely suited to their requirements and temperament; and it was then maintained regardless of foreign influences and without any fundamental change in its structure until Egypt ceased to be a cultural entity. No one outside Egypt understood it and even within Egypt it was the exclusive working tool of the ruling and priestly classes. For all practical purposes, it was the caption-language of Egyptian religious art: it made clear what the image alone could not do.

THE HIEROGLYPHIC ALPHABET

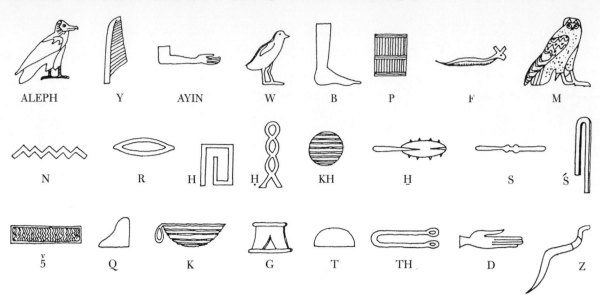

ALEPH	Y	AYIN	W	B	P	F	M

N	R	Ḥ	Ḫ	KH	Ḥ	S	Ś

v5	Q	K	G	T	TH	D	Z

DETERMINATIVES

 nose, smell, joy, contempt

 night, darkness

 eye, see, actions of eye

 boat, ship, navigation

plant, flower

enemy, foreigner

sky, above

 high, rejoice, support

air, wind, sail

wood, tree

stone, sand

 minerals

road, travel, position

or god, king

mummy, likeness, shape

foreigner, foreign country

desert, foreign country

walk, run

savage

hoe, cultivate

house, building

 or goddess, queen

 phallus, beget, urinate

envelop, embrace

tumours, odours, disease

 town, village, Egypt

 praise, supplicate

 tree

 bird, insect

 rope and actions with rope

 knife, cut

 eat, drink, speak, think, feel

 sun, light, time

 small, bad, weak

 break, divide, cross

NUMERALS, WEIGHTS AND MEASURES

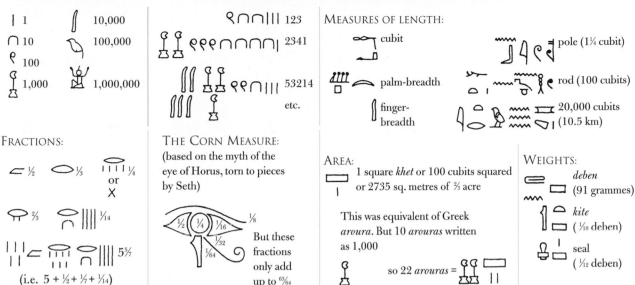

	1	𝄃 10,000
∩ 10		100,000
℮ 100		1,000,000
1,000		

𝄃𝄃𝄃∩∩℮ 123

2341

53214

etc.

MEASURES OF LENGTH:

cubit

palm-breadth

finger-breadth

pole (1¼ cubit)

rod (100 cubits)

20,000 cubits
(10.5 km)

FRACTIONS:

½ ⅓ |||| ¼
or
✕

⅔ ¹⁄₁₄

5⁵⁄₇
(i.e. 5 + ½ + ⅐ + ¹⁄₁₄)

THE CORN MEASURE:
(based on the myth of the eye of Horus, torn to pieces by Seth)

½ ¼ ¹⁄₁₆ ⅛
¹⁄₃₂
¹⁄₆₄

But these fractions only add up to ⁶³⁄₆₄

AREA:

1 square *khet* or 100 cubits squared or 2735 sq. metres of ⅔ acre

This was equivalent of Greek *aroura*. But 10 *arouras* written as 1,000

so 22 *arouras* =

WEIGHTS:

deben
(91 grammes)

kite
(¹⁄₁₀ deben)

seal
(¹⁄₁₂ deben)

THE PHARAOHS

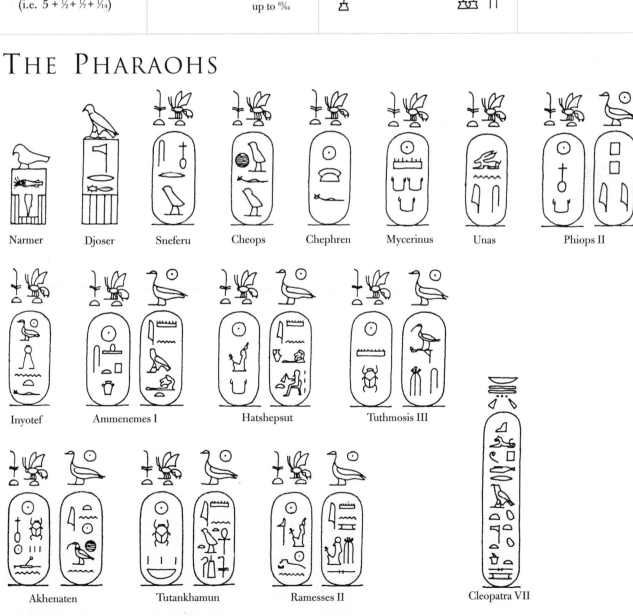

Narmer Djoser Sneferu Cheops Chephren Mycerinus Unas Phiops II

Inyotef Ammenemes I Hatshepsut Tuthmosis III

Akhenaten Tutankhamun Ramesses II Cleopatra VII

Above: *Hieroglyphics from the so-called 'White Chapel' of Sesostris I with dedicatory inscription to the god of fertility Amon-Min. Carved from sandstone.*

Chapter opener: *Funerary stele showing the journey of the sun-god Khnum-Re being towed by Uraeus in the Underworld.*

Therein, of course, lay its origins. The word hieroglyph was first used by the Christian Clement of Alexandria, about AD 200; it means 'sacred carvings'. Such carvings, chiefly on slate palettes, were first made in Egypt during the period of Sumerian influence which preceded the rise of the united kingdom of Egypt. There is no evidence the Egyptians ever used what can properly be described as writing before the epoch of Sumerian contact; moreover, what they got from the Sumerians was a literary idea which had already moved several logical steps towards writing – the Egyptian hieroglyphs were never purely pictographic. Like the Sumerian scripts, they were the offshoots of pictograms. But, unlike Sumerian (and its later Babylonian development), hieroglyphs retained the pictorial element to the end. The principles of both scripts were the same. The signs used expressed actual objects or ideas – that is, they were ideograms or sense-signs – or they expressed vocal noises – that is, they were sound-signs or phonograms. Many signs expressed both ideas and their expression, the actual objects or words or parts of words having the like sounds: this is the rebus principle, from the Latin *non verbis sed rebus*, 'not by words but by things'. Both scripts also used sense-signs, which philologists call 'determinatives' to indicate the meaning of a multi-purpose sign in a particular context, but the Egyptians put the determinative at the end of the word, the Sumerians at the beginning. Sumerian syllabic signs express both consonants and vowels but vowels are not indicated at all in hieroglyphs. Where

the Egyptians introduced a crucial improvement very early, however, was in developing signs for single consonants – that is, alphabetic signs.

Thus hieroglyphics are an archaic language. The Sumerian-Babylonian pictorial script from which they were derived quickly ceased to be non-pictographic and developed into the cuneiform cursive script. Very characteristically, however, the Egyptians retained hieroglyphic, while grafting on to it a number of sophisticated concepts. They evolved a system of unilateral signs, making up an alphabet of twenty-four letters, as well as signs representing two or three letters. To avoid the ambiguities inherent in the dual-system script, they developed what are called 'phonetic complements' as well as pictorial determinatives. And the determinatives themselves might be specific, general or complementary. There were well over 700 signs, of which we have clear knowledge.

The great merit of hieroglyphics is the sheer visual beauty of the signs, which received their classic formulation at roughly the same point in the Third Dynasty as Egyptian sculpture and architecture were also setting in their moulds. As in the sculpture of the human form and animals, they reveal – in an even more economic manner – the wonderful skill of the Egyptians in driving to the heart of a form and rendering it with a combination of brevity and elegance. Once the form was set, the glyphs became astonishingly consistent for over 3,000 years. As a work of art, the Egyptian language has had no peer. As a system of communication, however, it was and is very unsatisfactory. Of course, in our ignorance of the underlying language, which seems to have been a mixture of hamitic and semitic tongues, we approach it as complete outsiders. The Egyptian tongue survived to some extent in Coptic. But this has not been spoken at all (except in the sense that it is used in spoken or sung religious services of an archaic kind) since the sixteenth century. Nevertheless, we can deduce from Coptic words the vocalization of a number of Egyptian words. But for most of them, the absence of vowel-signs is an insuperable handicap and our renderings are pure guesswork. Except to a very limited degree, we cannot *pronounce* ancient Egyptian, and this often inhibits us in grasping its precise meaning.

Then too, in hieroglyphics there were no spaces between words. It could be written from right to left or vice versa (this is easily detected because the signs face in the direction of the writing), or from top to bottom, vertically. By grasping the system of complements and determinatives, we get at the word meanings and word divisions. Sir Alan Gardiner, the great philological scholar, produced a quarto volume of 650 pages called *Egyptian Grammar*, which takes us an amazing distance, considering the paucity of our knowledge, towards understanding the structure of sentences and the

Below: *Papyrus of Nedjemet* Book of the Dead *showing cattle fostering the dead.*

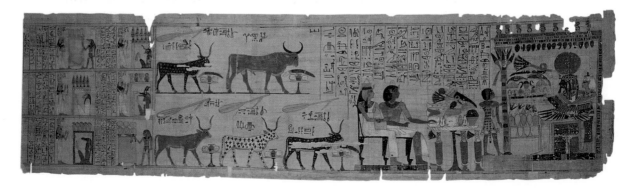

declension of verbs. But ancient Egyptian is peculiarly unresponsive to attempts to set up rules of grammar and syntax. It is accumulative rather than systematic. There are often four or five different ways of writing a word, which may have served different purposes to the Egyptians, but to us are confusing. In a way their language was like their religion (which is not surprising, since the historical connection was so close): old forms, like old gods, were never discarded but retained alongside fresh ones.

In these circumstances, guesswork and logical deduction remain a disturbingly high element in reading ancient Egyptian. By such methods we can almost invariably get at the general meaning. But subtleties of the tense and mood of verbs can only be deduced from their surrounding context and sometimes these are of absolutely crucial importance. For instance, in the *Instructions* of King Ammenemes I to his son, one of the most important historical and political texts in all Egyptian literature, it is not immediately clear whether the king is still alive or is supposed to be alive as a literary convention, or whether he was in fact murdered in a palace conspiracy, the text emanating from his divine person. Ignorance of grammar and the general lack of precision in our knowledge are a particular handicap when we are dealing (as we often are) with fragmentary and damaged texts. Many of the most important Egyptian texts lack beginnings (because the outer section of the scroll is missing or damaged beyond repair) and some lack ends also. So often the context is gone, and context is tremendously important in helping us to get at the meaning. Of course, in the case of hieroglyphs on walls (and in many papyri) we have illustrations as well as words, and such pictures are illuminating. But this method in itself illustrates our weakness and ignorance – for the texts were originally carved precisely to illuminate the pictures, not the other way round. All the most important, and a great many of the less important, Egyptian hieroglyphic texts have been put into English (and other modern languages), sometimes in many versions. But these renderings are often interpretations rather than strict translations, as comparing different versions indicates.

Egyptian hieroglyphs, like the earliest Sumerian writings, were carved on stone for purely religious purposes, funerary texts being some of the commonest. Once non-lithographic methods were used, the divergence in structure became very fundamental and rapid. The Sumerians, and later Babylonians, Assyrians and other Asian literatures, when not carving for eternity in stone, used clay tablets on which they wrote with a stick ending in an arrow-shaped wedge. This cuneiform became the typographical unit in a script for everyday use which rapidly eliminated the pictographic element. Cuneiform was ugly but comparatively easy to write clearly, even for someone who had not spent a lifetime training as a scribe. Clay tablets were universally available. Hence cuneiform, an invention of the third millennium, became in the second millennium a very widely-used script for a variety of western Asian and east Mediterranean languages, and for a time, using the Akkadian language, the normal medium for international diplomatic communications.

Egyptian took a different path because of the discovery and use of papyrus. Nowadays, the papyrus plant can no longer be found in the Nile valley north of Khartoum; but in the fourth millennium it grew throughout the valley and the delta, and was used for a variety of purposes, including food. It almost certainly came into use as a pictorial material before Egypt acquired a written language. The stems of the plant were first cut into pieces about a foot long. Then the rind was peeled off and the pith cut into long, thin slices. These were laid side by side, and a layer of similar thin

Opposite page: The stele of priest Kjedkhonsouiouefankh showing him playing the lute before Horus. An example of pictures and words being used together to illuminate the intended meaning.

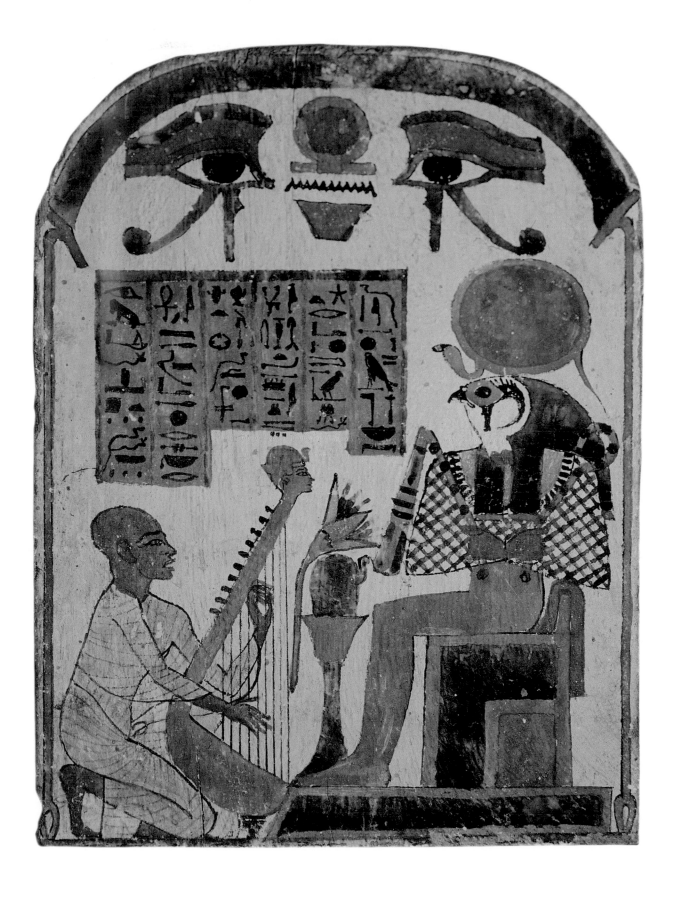

slices laid over the first at right angles. This rectangular lattice-work was then pressed together, or perhaps beaten. The natural starch in the papyrus juices glued the material into a solid sheet when it dried. The upper, or recto, side had horizontal fibres uppermost; the lower, or verso, the vertical ones. Both had a nice matt texture which took paint or ink beautifully, without resistance or shine, and without too much absorption. It is remarkable how legible papyri between 4,000 and 4,500 years old still are – as writing material it is in many ways superior either to vellum or quality paper. Papyrus sheets varied in size, but pieces about twenty inches high and seventeen inches wide were standard, often joined together in rolls, sometimes of considerable length. The biggest papyrus in existence, the Great Harris Papyrus in the British Museum, is 135 feet long.

The evidence suggests that the Egyptians began to write on papyrus in hieroglyphic script as soon as they began to carve pictograms and phonograms on rock. So the earliest papyri were certainly in hieroglyphic. As a matter of fact, the earliest papyrus roll is not written on at all. It was found in the tomb of a First Dynasty aristocrat at Sakkara, ready for his use in the next world. This noble, or his scribe, would have used a script similar to that found on the Narmer palette, or possibly a little more developed. The earliest written papyrus so far discovered dates from the Fifth Dynasty, about 500 years later.

The availability of papyrus had a profound effect on the development of Egyptian writing. It allowed the Egyptians to create an elegance and flexible written (as opposed to carved) script, using a brush made from the stem of a rush, about six to ten inches high. Hence they were able to reject the clay tablet and the cuneiform script – except, under the New Kingdom, for diplomatic purposes – as ugly and limiting. Instead, their written script retained much of the archaic forms as well as the artistic beauty of the hieroglyphs. Clement of Alexandria coined the term hieratic, priestly, for this written script, as opposed to the hieroglyphs. He says it was given to the style of writing used by priestly scribes for religious books. Of course originally, in the Old Kingdom, this hieratic writing on papyrus was virtually the same as hieroglyphic. Only gradually did the effects of speed introduce cursive or running simplifications, followed by basic structural changes.

By the end of the First Intermediate Period and the emergence of the Eleventh Dynasty, it was a developed cursive script, with the signs joined by ligatures. By the time of the New Kingdom, under the Eighteenth Dynasty, there was a further development. Hieratic divided into two offshoots; hieratic proper, still used for religious and literary documents of permanent value, and a more cursive hieratic used by the civil service, businessmen and traders for practical day-to-day correspondence. After the end of the New Kingdom, and especially during the Twenty-sixth or Saite Dynasty, this business or abnormal hieratic evolved into a third type of script. Herodotus called it demotic, meaning popular; the official government of the Ptolemies called it enchorial, from *enkhorios*, meaning native, and Clement himself refers to it as epistolographic. Demotic seems to have developed from abnormal hieratic among the business community of the Delta ports, and spread slowly into Upper Egypt until it superseded all other kinds of script for normal business purposes. All these scripts,

Left: *A detail from the* Book of the Dead, *Heruben papyrus showing the eye of Horus, the sacred barque Uraeus and crocodile. Papyrus was a popular material for the hieroglyphic script.*

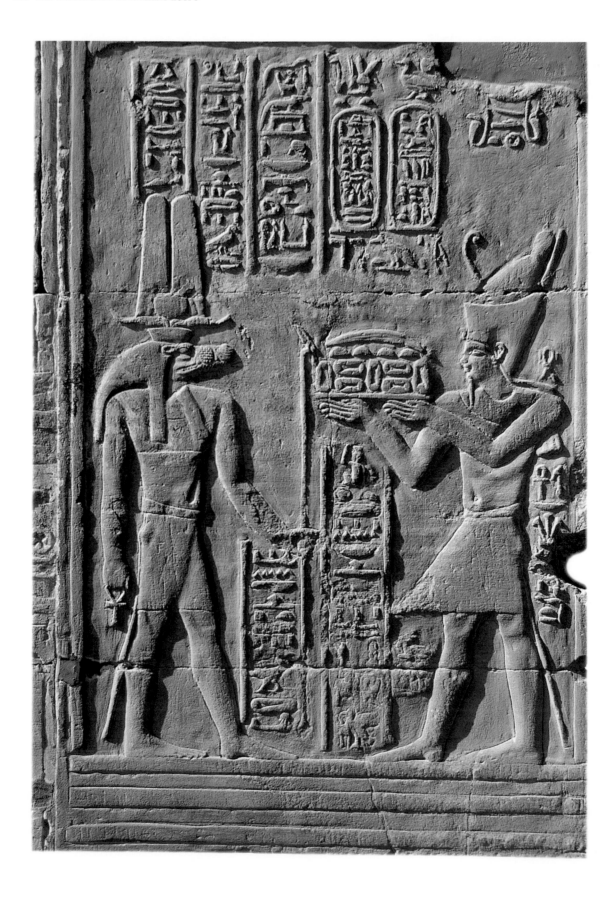

then, were developments of hieroglyphics, and retain some of its structural characteristics (as well, of course, as the same fundamental spoken language underneath). But the pictorial element, though recognizable in a stylized form in hieratic, disappears completely in demotic, and the writing, for those modern scholars trained in hieroglyphic, becomes progressively more difficult to decipher, the more cursive the script.

There was also a widening spread of writing surfaces. Hieratic texts were almost invariably written on papyrus. This was in plentiful supply for most of the dynastic period and even for long after. But it was never cheap and was very likely a royal monopoly, the name, first used by Theophratus in the fourth century BC, meaning 'kingly'. For schoolwork, therefore, papyrus was often replaced by wooden writing boards, overlaid with a kind of gesso substance, which could be washed and re-used indefinitely. For specialized purposes, the Egyptians wrote on a variety of materials, including leather, bronze and gold, bone and ivory. They used clay tablets too, but for

Opposite page: *A wall relief depicting the crocodile god Sebek and falcon-headed god Horus.*

Left: *An ostracon, probably a business record of Prince Sethinkhopsef, son of Ramesses III.*

Above: A seated statue of the scribe Dersenedj from Giza.

everyday writing, when papyrus was considered too costly, they used slices of limestone or bits of pottery, which Egyptologists classify together as ostraca. Most ostraca, which survive in tens of thousands from the Late Dynastic and Postdynastic periods, are written in demotic, which was the ordinary script of the Egyptians, in so far as they were literate at all.

But how many Egyptians were literate? Such evidence as we possess suggests that the answer is very few. Of course it depends to some extent on what we mean by 'literate'. Merchants operating from the Delta ports in the first millennium must have been able to write cursive demotic, at any rate for the purposes of their trade. But this does not mean that they could read classical papyrus texts written in hieroglyphs or hieratic or that they could go to the great royal necropolises at Sakkara or Giza and read the hieroglyphic inscriptions on the pyramids. Probably at all times, over ninety per cent of the Egyptians were illiterate for any purposes, though even the most ignorant could pick out pictographic signs amid the hieroglyphs – signs standing for everyday concepts which remained standard through Egyptian history, and which were repeated as emblems and inscriptions comprehensible to all. But it was rare indeed for an Egyptian to read and write unless that was his business. The pharaohs must have been literate up to a point for they were priests; and a surprising number of the aristocracy also had quasi-sacerdotal functions at various stages of their careers. Tuthmosis III was trained as a priest and Horemheb began his career as an army scribe; both must have had a professional literary training. Probably most pharaohs, and most members of the ruling class were only semi-literate – we know from the Amarna correspondence, for instance, that the so-called diplomatic dispatches were not read by their recipients, or even read to them, but used as *aide-mémoires* for verbal messages. But it is hard to believe that a great king or noble could not make some effort to read the inscriptions he caused to be made in his own tomb – which he constantly visited and in which he rejoiced. And, to judge by tomb biographies, most men who made their way to the top of the State served at some time in roles which demanded a degree of literacy. Literacy was clearly an enormous advantage in the highly centralized, and therefore highly bureaucratic, Egyptian theocracy.

But if most important men in Egypt were partly literate, the complexity of the written language, and the multiplicity of the scripts, created a need for professional writers or scribes. Each important religious establishment had a 'House of Life', which

was a scriptorium and library. Not all priests were professional scribes: scribal priests and lector-priests formed specialized branches of the clergy. Each department of government had its own special scribes: army scribes, navy scribes, treasury scribes, and so forth, who tended to develop specialized scripts of their own. There were business scribes and accountant scribes too. Scribes had their own god, Thoth, the baboon, sometimes portrayed with an ibis-head. They wrote sitting with their legs crossed before them using palettes of wood, with recesses for black and red inks (sometimes other colours); they kept their brushes – pens, after the Greeks introduced them in the third century BC – in recesses in the middle, sometimes with a sliding wooden cover, so that these boxes, which they carried in satchels, were the same in all essentials as the pencil boxes in use in Western schools until a few years ago.

As among the Christian clergy later, scribes were recruited from even the lowest classes – especially orphans – and it was one of the ways in which a poor man could set his children's feet on the bottom ladder of social advancement. Scribal exercises, on papyrus, board and other materials, form one of the largest categories of surviving writings from ancient Egypt, and it is plain from them that acquiring professional status as a scribe was a very long and arduous business – devoted chiefly to the copying of classical texts and didactic exercises – whose rigours the scribes and their teachers justified to themselves by dwelling on the dignity and security of their profession. Scribes, they boasted, were exempt from the *corvée*, from active military service, and from land taxes. Thus an Egyptian learning proverb states: 'What you gain in one day at school is for eternity. The work done there lasts as long as mountains.' Or again: 'Do you not carry a palette? That is what constitutes the difference between you and a man who has to pull an oar.' Or yet again: 'Put writing in thy heart [i.e. learn to write], so that thou mayest protect thine own person from any kind of manual labour, and be a respected official.' Some treatises written for copying by apprentice scribes go through all the occupations, exaggerating the disadvantages of each, and stressing the opportunities open to a scribe. This in the *Satire on Trades*, the scribe boasts: 'I have never seen a sculptor sent on an embassy, nor a bronze-founder leading a mission. But I have seen the metal-smith working in the very mouth of the furnace. His fingers are like crocodile's claws. He stinks like a rotten fish-roe.'

Scribal schools provided indices to the popularity of certain texts. The Middle Kingdom Story of Sinuhe survives in five papyri and twenty ostraca; the *Instruction* of Ammenemes I, early Middle Kingdom, survives, in whole or in part, in four papyri, a leather roll, three wooden-gesso tablets and about fifty ostraca. Granted the enormously high destruction rate of all texts of this antiquity – even in Egypt's exceptionally preservative climate – we can only guess at the prodigious numbers of Ammenemes's warnings which once circulated. Scribal training and activity was overwhelmingly reproductive rather than creative. They might be intellectuals but they were drudges all the same. Any initiative was discouraged. As their own peculiar literature indicates, they suffered from a narrowing *déformation professionelle*. Their conservative, deadening, bureaucratic habits (and their numbers, which tended to increase, especially under the New Kingdom) constituted a major weakness of the Egyptian State. The penetration of Egyptian literature by magical forms from the Twelfth Dynasty onwards meant that literacy in Egypt did not become a barrier to superstition and irrationality, but rather tended to encourage them. The scribe often appears as childish, threatening an unsympathetic reader with magic. Thus *The Story of the Two*

needless to say, set out as poetry and, without vowels, it is hard to detect any metre, though certain patterns of strophe and antistrophe emerge. No one has found any indication of rhyme, but this does not mean that none exists. In fact our ignorance of linguistic subtleties may well conceal from us many features of Egyptian decorative writing. The Egyptians saw words as both living and magic and delighted in manipulating them, in detecting bizarre or accidental parallels, antitheses and convergences and concocting puzzles. Their script, with its rebus element, lent itself gloriously to these activities. The earliest crossword puzzle in history is to be found on a tomb-stele, of a high priest of Amun no less, from the reign of Ramesses II – the main text is horizontal, but the vertical line can be read by itself as well as part of the horizontal text. Another, later stele in the British Museum provides a more complicated example. And Egyptian linguistic ingenuity appears also, from the Middle Kingdom onwards, in the way they explored the resources of their script to devise cryptic messages.

The Egyptians, indeed, loved secrets and mysteries. The thread of secrecy runs through their religious and mortuary texts, which of course form the bulk of their surviving literature. Amun, the 'invisible' god, is described as 'thou most mysterious of the mysterious, whose mystery is unknown'. Priests were the custodians of secrets of such impenetrable obscurity that we can never now hope to penetrate them. Of course secrecy and mystification was their trade – one of the reasons why no attempt was made to simplify the language was to keep it hieratic. The elucidation of texts was part of the priestly ritual. Like parts of the temples, many texts were kept from the public. Mortuary texts were originally sold only to the rich, and are riddled with strident commands to secrecy. To reveal them was to weaken their charm.

Reviewing Egyptian religious literature as a whole – especially through the line of texts which runs from the *Pyramid Texts* (Old Kingdom) through the *Coffin Texts* (Middle Kingdom), the *Book of the Dead* (New Kingdom), and its Late Dynastic revisions, the *Book of Breathings*, the Rhind mortuary papyrus and the *Book of Traversing Eternity* – it is painful to observe the gradual triumph of what might be called the spirit of mumbo-jumbo. The magical spell replaces the straightforward prayer and the direct communion with god. There is, too, a greater stress on a particular sub-department of magic, the oracle, which gradually came to be a

Opposite page: Limestone stele showing a married couple.

Below: Granite cartouche showing the name of Pharaoh Nyuserre from the pyramid of Abu Shir.

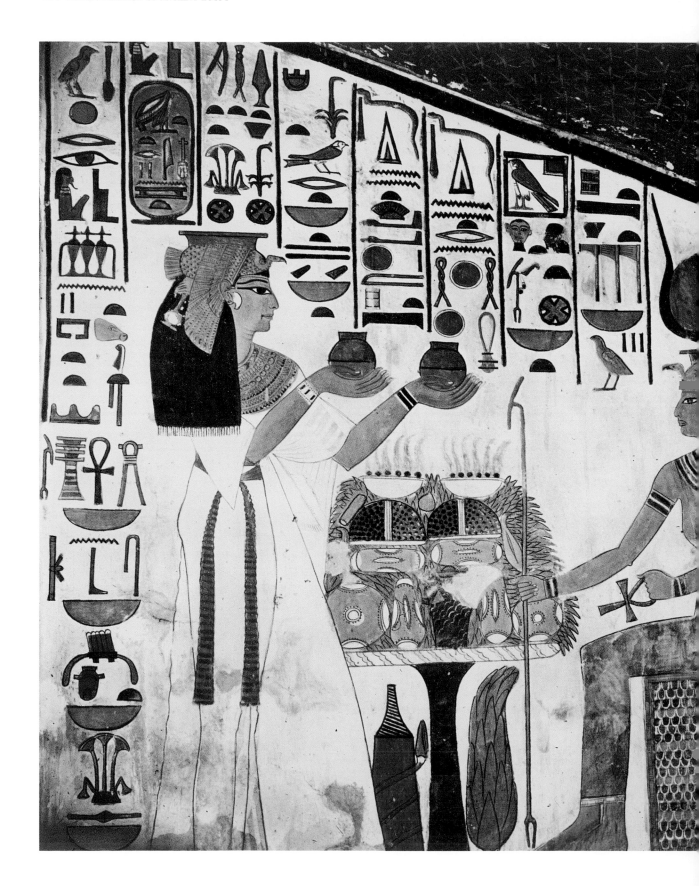

dominant theme in Egyptian religion (and in the secular courts too) and greatly influenced the junior civilization of the Aegean. In Late Dynastic times, a dead man lay in a cocoon of magic, which was written all over his coffin and the walls of his tomb. Long experience having shown that mortuary priests could not be depended on to perform their paid duties, these texts were provided so the tomb-occupant could 'read' them himself, by the act of 'looking', rather as an idol 'ate' its food. So men spent eternity murmuring over to themselves these incantations as, in lifetime, they muttered hypnotic phrases over and over again, to ward off snakes, scorpions and crocodiles – *hi, ti ti, bi, ti ti, hi, ti ti*, repeated endlessly, was one of them.

Egyptian religious literature, though copious, does not constitute a compilation or carefully edited corpus, still less a sacrosanct canon. Priests seem to have changed their texts from time to time, to suit their own convenience. Of course their religion, though it had a cosmogony and a theology of sorts, was not historical and therefore had no canonical narrative to impart and no eschatology to predict, judgment being individual not collective. In this sense their sacred literature could have had no influence on the Jewish Old Testament. However, there was no lack of cultural and indeed literary contacts between the two peoples – they were, in fact, much more regular after the period of the Exodus, and during Egypt's post-imperial decline. Egypt remained a place of refuge for disaffected Jews – one of David's foes fled there, and so did Jeroboam under Solomon. King Solomon himself married an Egyptian princess and received the city of Gezer as dowry. There seems to have been a pro-Egyptian party at the Jewish court, sometimes driven (as in the time of Hosea) to exile in the Delta when things went against them. Even in its decline, Egypt was still sometimes able to come to the aid of its Jewish adherents and campaign in Palestine. Sheshonq I, founder of the Libyan or Bubastite Dynasty, claimed to have conquered over 150 towns in Palestine and Syria. The Saite dynasty campaigned there, killing King Josiah of Judea and replacing him with a pro-Egyptian puppet.

When the Assyrians triumphed in Palestine, there was the first of a series of Jewish migrations to Egypt, putting Exodus into reverse: the Egyptians seem to have received the Jews hospitably and regarded them as useful citizens. Some Jews became Egyptian mercenary soldiers – there was a colony of them at Elephantine, another at Edfu. Some of their letters, in Aramaic, survive. they show that the Jewish settlers remained in regular contact with the religious authorities in Jerusalem but took on a local religious coloration also: 'I bless you by Yahweh and by Khnum!' Jews continued to serve in the Egyptian army under the Ptolemies and were often granted land under the system of creating agricultural colonies of veterans. But dispersed Jews also formed large urban colonies of merchants and craftsmen, above all in the Ptolemaic city of Alexandria where they eventually became the largest, or at least the most coherent, ethnic and religious group. By the time the Romans came, the Egyptian diaspora formed easily the largest and most influential body of Jews outside Palestine.

Egyptian cultural influence was thus present throughout the formative period of the Old Testament. If it is not reflected in structure and purpose it is felt in idiom and imagery, and sometimes in the handling of material. That Egyptian invention, the 'true' short story, was incorporated in the Bible narratives with great effect. In addition to the

Left: *Wall painting showing Queen Nefetan sacrificing two vases to the goddess Hathor.*

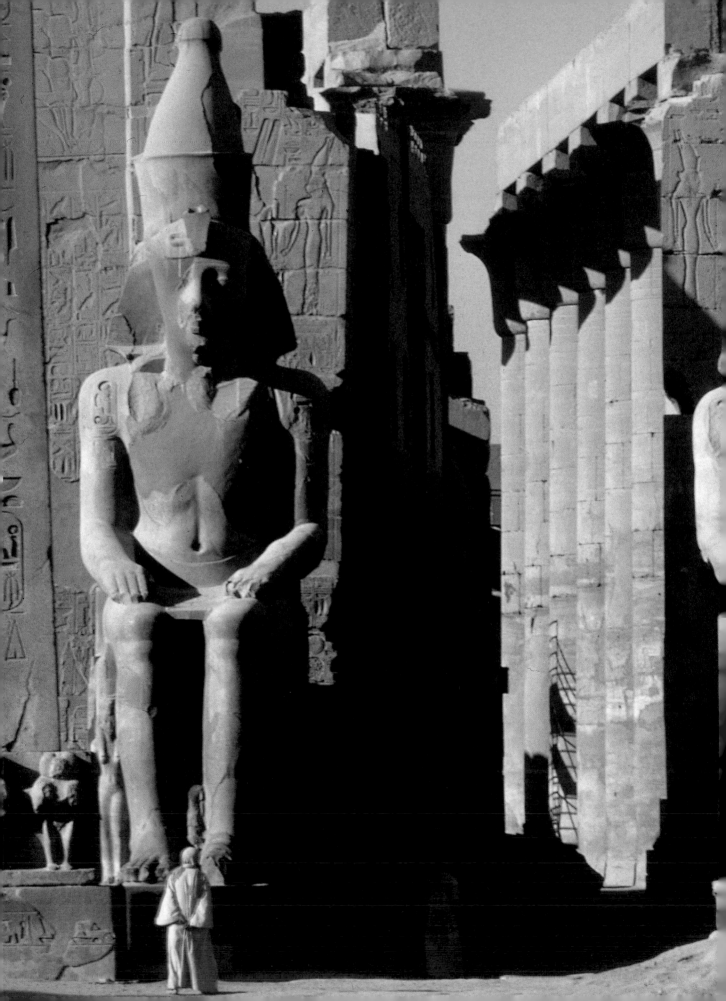

THE ANATOMY OF
PRE-PERSPECTIVE
ART

The very essence of Egyptian civilization was its art. If we can understand Egyptian art we can go a long way towards grasping the very spirit and outlook on life of this gifted people, so remote in time. The dynamic of their civilization seems to have been a passionate love of order (*maat* to them), by which they sought to give to human activities and creations the same regularity as their landscape, their great river, their sun-cycle and their immutable seasons. In public affairs, the quest for order produced the pharaonic political and religious system which, with all its limitations and weaknesses, endured in some form for 3,000 years. The same spirit organized the early pictograms and phonograms into a highly disciplined system of communication, and regulated the diverse artistic expressions of proto-dynastic and early dynastic times into the most coherent and orderly code of art in history. Two or three pioneering generations of leaders accomplished these massive and related transformations at the outset of the Old Kingdom, perhaps within a span of a mere fifty years. Already, by the time of Djoser, it was all there: the visible, unmistakable majesty of a great civilization.

Previous page: *Amon temple in Luxor showing the use of sculpture in architecture.*

Opposite page: *Temple of Remesses II showing the sculptor's hieroglyphic message.*

Below: *This statue of Tutankhamun is an example of Egyptian art now accessible in Western museums.*

The creators of the monolithic Egyptian state were also the patrons and marshals of its art: they drew no distinctions between religion and politics and creativity, and it is important we should draw none either. Unity is the key to understanding. All aspects of Egyptian civilization were informed by the same drive, but they were most successful in art because there the spirit of unity in diversity was most convincingly established and tenaciously retained. In art, the ordering process achieved a wonderful clarity of form, almost from the start, and retained it almost to the end – whether the magisterial simplicity of the monumental sculpture and architecture, or the simple elegance of the merest everyday utensil: the objects produced at every level of expression, cost and material were bound together in aesthetic unity by the same manifest style.

However, when we use the word 'aesthetic' we must beware of giving it a non-functional significance. The unity of the civilization forbids this separation. All art in ancient Egypt, even the shaping of an ordinary spoon in the form of a goddess, had religious, social or political meaning and purpose. We can understand it best if we regard art as an enormous system of communication. An artistic object was a message, usually a message to the gods. The artist encoded it; the gods – or we, if we know the rules – decode it. The language of art was not divided into strict compartments. Almost without exception, for instance, sculpture and its architectural setting were designed together; or, to put it another way, architecture was conceived as incomplete without its sculptural adornment, as that was a key part of the message. There is an analogy here with the façade of a Gothic cathedral. Hence we must remember that the figure of a pharaoh or a god seen in a Western museum, even if complete in itself, was a severed fragment in Egyptian eyes. Equally, a great tomb complex, temple or palace, shorn of its statues, is blind and lifeless by the criteria of its creators. The unity would have been blazingly apparent if we could have seen these creative ensembles in their pristine state, not least because all was painted, the colours having meanings and being part of the system of communication.

Above all, we must not distinguish between hieroglyphs and purely plastic art, since that is not a distinction the Egyptians could or would have made. During the formative period of Egyptian art, these two forms of expression or communication advanced with the same

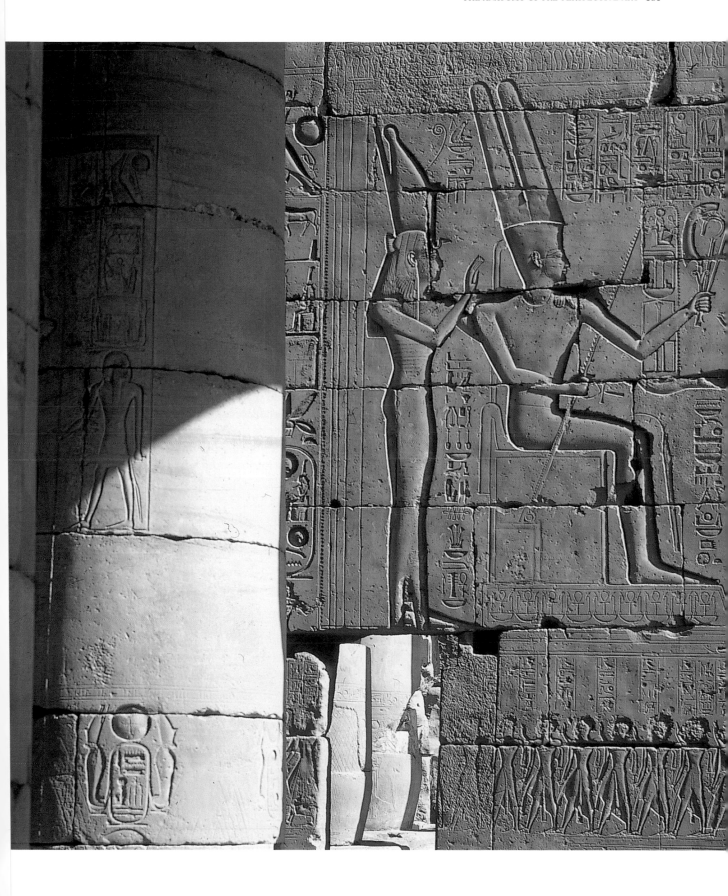

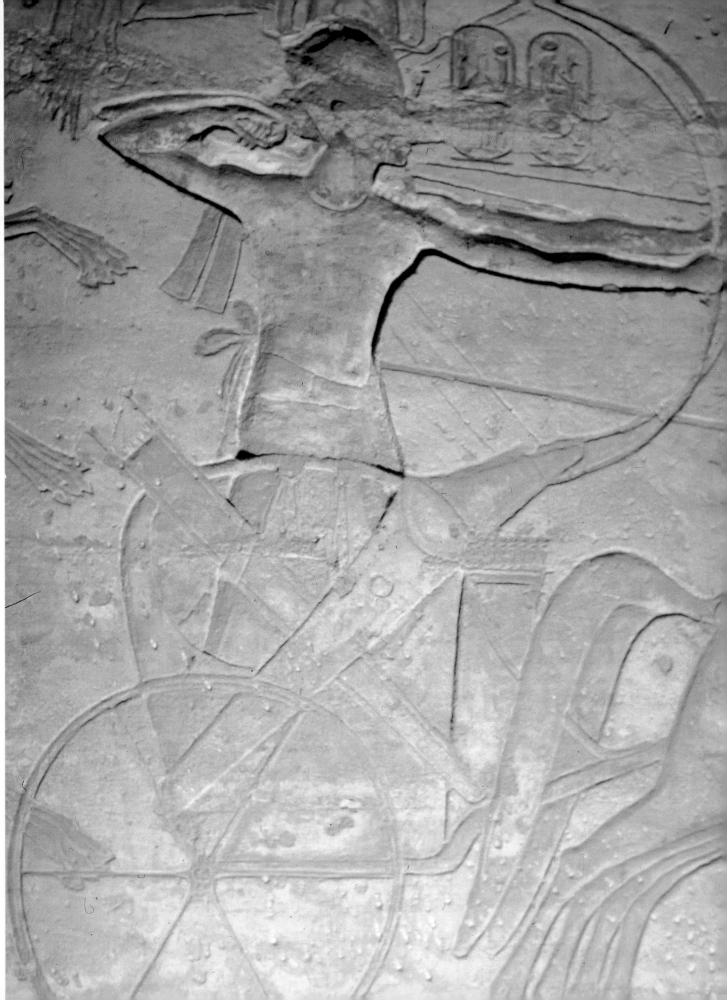

respects, the studio of a successful artist patronized by royalty was like a scribal school, though not officially organized to the same degree. Scribes wrote about their training, so we know quite a lot about it. The artists did not, but we do possess sheets of apprentice drawings on gesso-board or papyrus and trial pieces of sculpture, some of them incomplete. At Amarna, German archaeologists found the ruined studio of the royal sculptor Tuthmosis, together with a large number of carved fragments, including the famous head of Queen Nefertiti, now in Berlin.

The evidence suggests that Egyptian artists were subjected to a highly disciplined and somewhat mechanical training. Able and successful ones enjoyed a very high status in Egyptian society, much higher than in our own, or indeed than in most civilizations. This is not very surprising, considering how important they were to the achievements and therefore to the self-esteem of the ruling class. But we should not see them as individuals, achieving self-expression. They were much more like officials, part of the pattern of court life and politics. In the Old Kingdom, in fact, they almost certainly lived and worked within the patriarchal community of the palace. Long after they acquired their own separate studios and households, they remained the servants of the conventional wisdom and the prevailing idiom of their day, as the senior priests did. Of course, just as gods might rise and fall, and priests bend to the new mood accordingly, so artists conformed to any modifications of the basic pattern laid down by official court policy or pharaonic whim. Egyptian art did not shift much, but to the trained and informed eye the styles and periods can be recognized as clearly as Louis Quatorze, Louis Quinze and so forth. Even within a dynasty there are often perceptible variations when we are dealing with a strong-minded, successful or long-lived pharaoh. Thus there is a style associated with Tuthmosis III, and a variation of it under Amenophis III – just as, under the Nineteenth Dynasty, there is the distinctive 'Ramesside' imperial style of Sethos I and, above all, Ramesses II.

The 'artistic revolution' of Akhenaten began as a continuation and heightening of the style of his father, Amenophis III. But he pushed it to the point where he set up in the minds of his artists a conflict between their loyalty to pharaonic direction and leadership, and their even deeper loyalty to their immemorial studio tradition, a loyalty (we must always remember) which was religious as well as national. When that point came, the artists behaved exactly like the other officials of the regime. The leading establishment do not seem to have followed Akhenaten to Amarna, any more than did the leading religious and secular court ministers. But from the lower ranks of the artistic hierarchy Akhenaten was able to recruit a number of talented men whose names we know – the architects Parennefer and Paatenemhab, his mother's sculptor, Iuwty, the sculptor Tuthmosis, and others. Their spacious studio-villas testify to their prosperity and the warmth of the king's patronage; their funeral-stelae are eloquent on the subject of the king's beneficence, claiming that Akhenaten 'taught' them. Of course obsequious subservience to royalty was universal in pharaonic Egypt, but it is more marked in Amarna art than at any other period after the Old Kingdom.

It is plain that Akhenaten directed his artists in a more detailed manner than any of his predecessors and raised up a collection of time-servers, albeit gifted ones, to carve and paint in his own image. They flourished mightily while he lived, then met nemesis when his regime ended. Tuthmosis's studio was not merely abandoned: someone evidently went through it smashing or disfiguring the model heads of Akhenaten. Tuthmosis had clearly done a good business in such things while Amarna flourished:

Opposite page: *A relief of a warrior in a chariot from the Temple of Ramesses II in Abu Simbel, Egypt.*

the court, reflecting the single will of an all-powerful monarchy, was the arbiter. But it is notable that, when the grip of the monarchy was relaxed, as during the three Intermediate Periods, Egyptian art did not flourish in provincial or individualistic fashion; it simply declined. Private art could not survive alone, without its public or court expression.

Nor was this the result of purely material factors. Egyptian painters, sculptors and architects did not have the self-confidence of the modern individual artist. Their art, at its best, is immensely assured and confident but it is the confidence of the collective. An Egyptian artist saw himself as part of an immensely powerful tradition which had always existed and always would exist, and which was followed by all his colleagues. In individualism lay disaster; in the collective lay strength and security. This professional approach itself reflected the social and religious beliefs common to all Egyptians. Man arrived at knowledge and so justified himself, not by exercising his critical faculties and by his own perception, but by the acceptance of dogmatic truth. The artist is obedient and submissive before the divine order. He does not express a personal viewpoint, his own order as it were, but seeks to integrate himself with the universal order, or *maat*, laid down by god.

Below: *An ornament in the shape of a human heart inscribed with the name Mentuhotep IV.*

All this implies a code and in fact the Egyptian artist worked within the restraints of an immensely comprehensive and authoritative code, taught by example and in the studios and so passed on, and occasionally modified, from generation to generation. As an individual, he could not change the rules any more than a scribe could alter the hieroglyphics. First there were the restrictions imposed by the material. Egyptian sculptors worked in stone as a rule, and by preference in very hard stone, using tools of comparatively soft metal. They eventually coped with this difficulty very successfully, but their initial strivings were inevitably reflected in their traditions, which sought to reconcile treatment of the human figure with the rectangular solidity of the block. The blackboard and the seat, originally employed (we presume) to help overcome the problem of rendering a free-standing figure, remained part of the artistic idiom long after they had ceased to be necessary. Conforming to and expanding this tradition, sculptors during the Middle Kingdom introduced the device of the

squatting figure, which aligned itself even more closely to the block of undressed stone. This marrying of plastic shapes to the demands of the material was conducted with immense elegance and an authority which rested on faith. Indeed, it was faith, for Egyptian art was in no way anthropocentric. The object was more important than the man looking at it. The object, in fact, had religious significance even before the sculptor got to work on it. Gold was for the gods, stone for eternity. A particular stone was never selected arbitrarily but according to well known religious criteria – its very availability might well be the result of divine intervention, as the claims of many stone-quarrying expeditions testify.

The sculptor thus had duties towards his material. He had the supreme duty to vivify it, to make it come to life when he had finished his work: he and the material cooperated in achieving the divine purpose. This compulsion helps us to understand where Egyptian artists, whenever possible, fashioned the objects they made in organic shapes – men and women obviously, but animals, flowers, reeds, grasses, woods and trees, fishes and insects; no aspect of Egypt's fauna and flora failed to find itself in their

Below: Painted terracotta models of a scene of the inspection of the cattle herds.

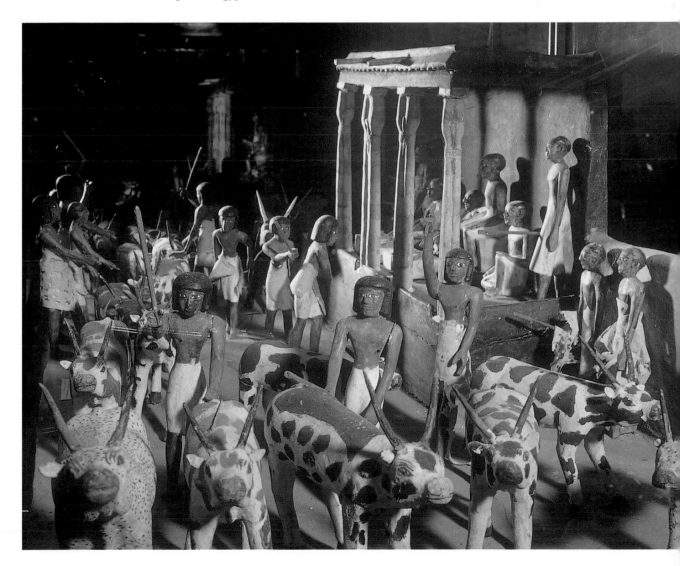

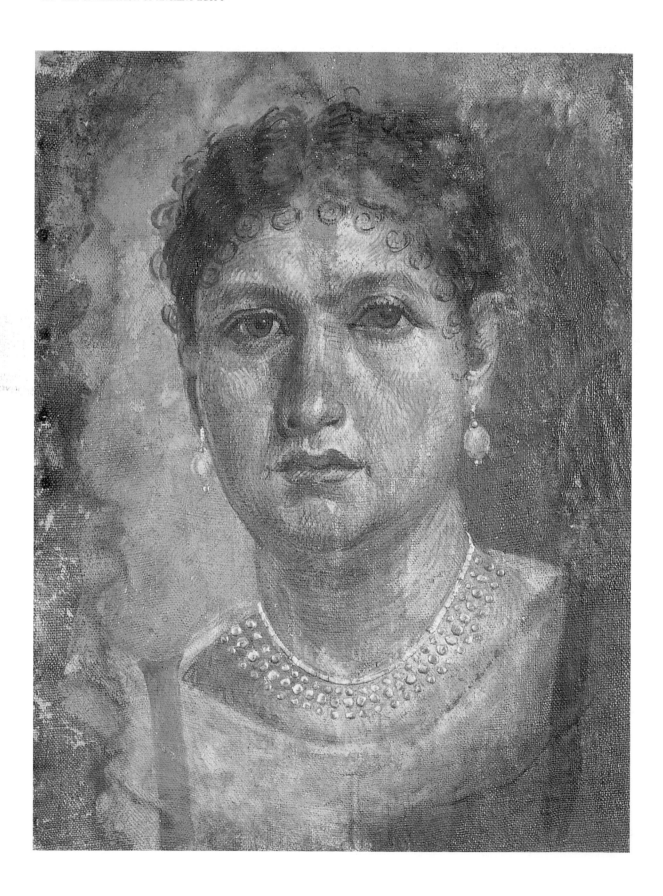

artefacts. Columns were papyrus plants or lilies, a wine cup was a lotus flower, a mirror handle a papyrus stem, a spoon handle a girl, a boy holding a mussel shell on his head an ointment ladle; the three beds in Tutankhamun's tomb each had their sides carved in the shape of a complete animal – a cow, a panther, a hippopotamus. Thus each object, humble or grandiose, was in some way brought to life and the demands of the material satisfied.

Then there were social restrictions, inevitable in any court art, but in Egypt of peculiar power and complexity – so complex that we, in our ignorance, cannot know them all. If the artist owed duties to his material, he also owed respect, in varying degree, to his subjects. The Egyptians seem to have regarded themselves, in a state of nature, as highly emotional and volatile people – mercurial, excitable, galvanic. The essence of civilization, as they saw it, was the subordination of these wild instincts to order, conformity, self-discipline; *maat*, in short. They would have agreed with Yeats's definition of civilization as the search for self-control. Hence a human form possessing a plenitude of *maat* – a god or goddess, a pharaoh or, in descending order, a member of the royal family, an aristocrat, a priest or high official – had visibly to exercise restraint by an absence of motion, a fixed, stationary, self-consciously 'noble' posture. From this necessity came the dominant idiom of the standing figure, left foot forward in arrested motion, arms to the sides in alert repose. We imagine that the pharaoh himself in real life – at any rate when he was on public show – was so burdened with his stiffened linen robes and top-heavy ceremonial headgear that he had no alternative but to adopt statuesque postures and slow, magisterial gestures. 'Ladies,' said Lord Curzon, instructing his new American wife in the ritual of English sexual congress, 'never move.' Pharaoh never moved either, on any occasion, or only to the minimum extent necessary. In art at least, members of the ruling class took on the pharaonic immobility.

However at a certain point down the social scale, movement became permissible, almost mandatory, and artists portrayed it. Stone monumental sculpture did not, of course, deal with the lower classes but the group models, or miniatures, placed in tombs often show them in vigorous motion. In two-dimensional paintings and reliefs, servants, peasants, workmen, artisans, soldiers and sailors, dancers and musicians could be supple, dynamic, even frenzied, jumping, running, leaping and fighting, hammering and pulling. They were imprisoned in much less rigid conventions of depiction. So, too, were enemies and foreigners, whatever their rank. The artist owed them little or no respect and could show them in unusual or uncanonical postures, old and ugly, obese or starving, ill, wounded, dying or dead. It was part of the heresy of Akhenaten that he forced his artists to ride roughly over these traditional class distinctions. He had himself portrayed, even in official monuments, in relaxed or dynamic postures which no previous monarch had permitted, and in familiar situations, playing with his children, embracing his wife, which may well have represented his actual behaviour in public or semi-public audiences and which, therefore, in traditionalist eyes was even more reprehensible. The mannerism he encouraged or dictated was not just an affront to the conventions; it was a positive assault on the magisterial presentation of *maat* as ordered hierarchy which was the very essence of Egyptian style.

Of course the conventions which underpinned the style were supplemented by more mechanical devices. The Egyptian artist was the first to develop a systematized canon for the human form. As we have already seen, the human canon was a metrological concept in origin, the Egyptians having noted the reliability of human

Opposite page: *Mummy portrait of Aline from the pyramid of Hawara/Fayum Oasis.*

of the very essence of the Egypt cult that the image was the god. This being so, it was essential that the rendering of the image should approximate as closely as possible to reality – not the illusionary reality seen by the fallible human eye, from one viewpoint only, but the true reality of the actual appearance of the person or object, as known intellectually and by experience. Usually this takes the form of rendering the frontal image, irrespective of the artist's viewpoint, the frontal image being chosen because it is the one which most immediately conjures up to the viewer the reality. Or, to put it another way, it is most characteristic of the object concerned, and conveys to the viewer the most information about it. In yet another sense, it is also the most objective way of portrayal, since the subjective eye of the artist is subordinated to the objective characteristics of what he is portraying.

Hence, when we look at Egyptian art, we must remember that the artist is not striving primarily to present, whether in two or three dimensions, what he sees in his eye, but to give the maximum information, in pictorial or plastic shorthand, about what he knows intellectually to be there. Once again, we have to see the artist as communicator and his work as closer to hieroglyphics than to photography. Hence, when we look at the Egyptian rendering of human figures in two dimensions, we should never judge them as human forms comprehended in one glance from a single viewpoint. They are in fact composites, jigsaw puzzles of frontal images and characteristic images, put together with right-angle turns in the axis, to provide the archetypal human form, rather than the one seen in the artist's eye. The Egyptians reduced all this to a code which laid down these multiple viewpoints and the images of reality judged to be most characteristic.

Every part of the body was shown from the side which revealed it most characteristically. Thus the head was shown in profile, because that told us more about the nature of the face than the frontal image; but the eye was shown frontally, because it was the only view giving the complete circle of white, iris and pupil. The neck was also shown in profile as part of the head, but it had to be presented in a twisting motion (which was in fact natural) because the shoulders were most characteristic when shown full frontally. The legs, feet, hips and bottom were in profile, chest and stomach acting as transition between them and the frontal shoulders. Here the code became a little awkward, the chest being, as it were, pivoted at forty-five degrees. In the case of a man, one nipple may be shown frontally, the other in profile. With a woman, both are covered by the straps of her dress, which is shown frontally; but one nipple is also, as a rule, shown exposed and in profile. This is a contradiction and a visual impossibility, but it did not seem wrong or absurd to the Egyptians, since it conformed to the code of giving the maximum information by portraying the characteristic profile shape of the female breast – the fact that it could not be seen under the dress was irrelevant since everyone knew it was there.

The two-dimensional rendering of the human form, with its multiple points of reference, involved the axial shifts in the canon we have already examined. It remained absolutely standard for the Egyptians for 3,000 years, and all other renderings of the human form were variations from it. The more important the person in the social or

Below: *A relief of Isis from the gilded tomb of Princess Thuya portrays the characteristic profile shape of the female breast.*

divine hierarchy, the more closely the rendering had to conform to this pattern (workmen, being relatively unimportant, were often shown in strict profile or even with their backs to the viewer). With work in three dimensions, the human form, in addition to conforming to the canonical proportions, could only move on fixed axes. The plane in which it was set was unalterable: it could bend forwards or backwards, but not sideways at the neck or at the hips; and it could not turn within its axis. Sometimes angles of eighty degrees approximately were considered permissible, but any drastic variation from the right-angle approach was ruled out. Hence, Egyptian sculpture is basically composed of four views, each at right angles to the other. Schäfer calls this 'the law of directional straightness'. It enclosed the statue in an invisible rectangular box. Seen from the front, as it was meant to be seen, it does not, to our eyes, give an impression of depth. The Egyptian viewer apprehended the frontal image, then viewed the image at right angles from the side; then, in returning to the front, superimposed the two images in his mind to acquire depth and reality. Modern photographs which show Egyptian sculpture at an oblique angle, so that both front and side images are combined in distorted form, defeat the purpose for which the sculptor was striving and wrench the statue out of the code in which it was composed.

A studio papyrus, dating from the Graeco-Roman period, but used by an artist working in the true Egyptian tradition, shows the front, side and top views of a sphinx outlined within squares on a block preparatory to sculpting. Five sides of the block (all except the bottom) were squared, then the complete outline of the sphinx drawn over them, according to the canon in use for sphinxes. The sculptor 'saw' the sphinx hidden within the block, and a partly modelled sphinx, which we also possess, shows that every side of the figure was worked at the same time, the artist following the outlines on all sides together, so that the creature 'emerged' from the block, and eventually attained life, as in strict theology it was intended.

The same principle of providing information, and of presenting objects in their most characteristic shape, rather than rendering the image from the fixed viewpoint of a 'subjective' artist, applied to all forms of Egyptian art. A table was shown with its legs and top, irrespective of what could actually be seen from the angle of vision subjectively chosen; and if there were loaves and fruit on the table, these were simply piled up vertically on top of the table and presented frontally to bring out their characteristics. If the artist is painting a pool surrounded by trees, the shape of the pool seen vertically is chosen, because that is the pool's characteristic shape; but the trees surrounding it are shown from a horizontal angle, because that brings out their characteristics. Again, a storehouse is shown by portraying its doors and horizontal profile of the roof; but the grain within is also shown in its jars, because the picture would otherwise be meaningless to Egyptians. The fact that objects are opaque is not allowed to hinder the process of information-conveying since the artist is not only allowed to change his viewpoint in composing his picture but may, as it were, walk through doors and wander around inside, sketchbook in hand. There is no distinction in the Egyptian code of art between an outline drawing of a building and a topographical sketch, plan or map, or a series of architect's elevations – all are combined together when and if they exhibit

Right: *A wall painting depicting the beating of a slave from the tomb of Mennah, scribe under Tuthmosis IV, shows that relatively unimportant figures were often shown in strict profile.*

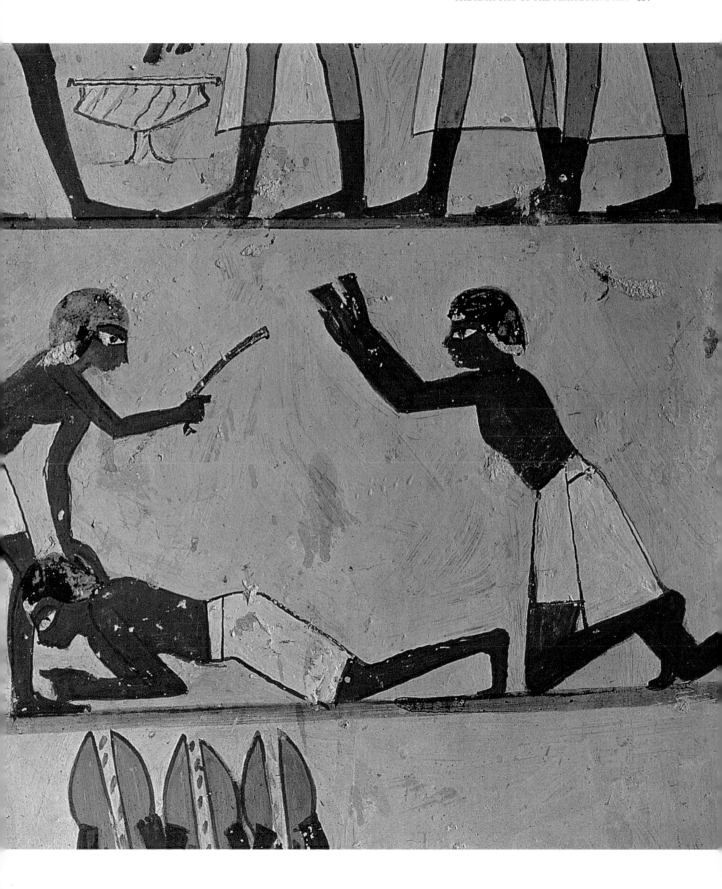

characteristic features and convey the maximum information in the space available. To the Egyptian artist, a picture was closer to an inventory than to a snapshot.

Egyptian low-reliefs and paintings must therefore be 'read', as well as looked at. They were designed to convey information but they also demanded from the viewer a series of intellectual reactions or, rather, a continuous process of analysis as his eyes moved over the surface and translated the pictorial code into the realities as he knew them. In the big compositions combining hieroglyphics with strictly pictorial forms, the mental process involved in apprehending both of them was roughly the same. The art of viewing them intelligibly lies in being able to isolate each point of reference or unit within the picture, and its overriding unity, in mind. This is not easy: it requires a fierce intellectual self-control.

But, equally, it was not easy to compose and execute the multiple reference pictures. Therein lay the civilized art of the Egyptians. As with their ordinary tools and technology, they were operating what was essentially a very primitive method of creating art, but with such refinements of skill as to give it an appearance of immense sophistication. One could draw a similar analogy with their theology: a primitive structure with a dazzling veneer of subtlety. At no point were the Egyptians prepared to adopt illusionist art: they were absolutely committed to the frontal image-based rendering of characteristics. But within this limitation they employed a number of elegant clarifying devices. One was size: size stood for power, authority and importance, so artists drew attention to the pharaoh by size, and to the actual occupant of the tomb, as opposed to relatives and mourners. A chief wife was not shown smaller than her husband, but in the natural human ratios laid down by the canon: lesser wives could be smaller, and servants smaller still. Relative sizes were also dictated by rank in battle scenes. Gods, however, were no bigger than important human beings, since, in strict theology, the latter could become 'like unto gods'; the key dividing line, as with artists' attitudes to movement, seems to have been drawn on an occupational basis – a man or woman was diminished by being condemned to manual labour. These gradations of size were not arbitrary; the dimensions of the subordinate figures in a composition depended on the main figures, being inscribed in grids of simple fractions of the scales used for the master-figures. Hence, even in the great court and battle scenes of the Eighteenth Dynasty and Ramesside periods, covering enormous areas and combining multiple incidents, there was a carefully worked out inner harmony of scale, providing unity of reference, and a focal point or points, with a powerful centripetal attraction, the big figures magnetizing the smaller ones rather as, under the Fourth Dynasty, the royal pyramids attracted the mastabas of the nobles.

All the same, these big compositions (and for that matter some of the much smaller ones also) demanded internal organization of the kind which, in illusionist art, is provided by aerial perspective. The chief form this took was the use of very firm horizontal baselines, which divided much of the mass of the picture into a series of registers. The registers can be seen as a kind of alternative to perspective, piled up one on top of each other, as though receding into space, even though the figures are not of diminishing size. They also compensate for the Egyptian refusal to portray depth. There can be no doubt that Egyptian artists saw the baseline and vertical register as devices for imposing *maat*, or order, on their pictures – the hieroglyph for *maat*, the reader will remember, was the baseline or pedestal of the pharaonic throne, and it is interesting that the king's feet were usually drawn bigger than the strict canon allowed,

to provide him with a firmer baseline. The baseline was stronger than visual perception and, like the size-principle, acted as a magnet, drawing the miscellaneous smaller figures into regimental array. With the mass of the figures firmly fixed in their vertical registers, the central figure of king or god could thus easily be placed in a dominating or directional relationship to them, commanding the entire picture and giving it a visual starting point from which the viewer could begin to 'read it'.

The rectilinear structure of these big reliefs or paintings draws the analogy with reading (and with hieroglyphic presentation) still closer. A famous Middle Kingdom picture of a colossal statue being dragged by huge numbers of men shows them in vertical registers, along fixed horizontal baselines, like military formations, the immense statue, already 'live' for the purposes of the picture, directing its own conveyance. An Assyrian relief, a millennium later, showing a similar group of labourers dragging a huge bull-doorway, scatters them in all directions – it is closer to illusionist art and can therefore be more easily taken in at a glance. Towards the end of the second millennium, under the New Kingdom, when international comparisons with Cretan as well as Mesopotamian art-forms are possible and useful, their tendency towards the curve or even the circle in arranging their material is in striking contrast to the Egyptian preference for rectangular and rectilinear presentation – an approach suited to an art which was pictographic rather than strictly pictorial.

Within this didactic structure of an art intended to be read, the Egyptians gave full play to their intense love of nature and their accuracy in observing it. Like the Akkadians, they were not unaware of aerial perspective; a satirical scribal letter from the late New Kingdom, dealing with Asian geography, describes an awkward soldier trying to control a chariot plunging across a high pass, with a mountain on one

Right: *This statue of Sekhema, superviser of the writers, with his fiancée shows the use of relative size. Size stood for power, authority and importance.*

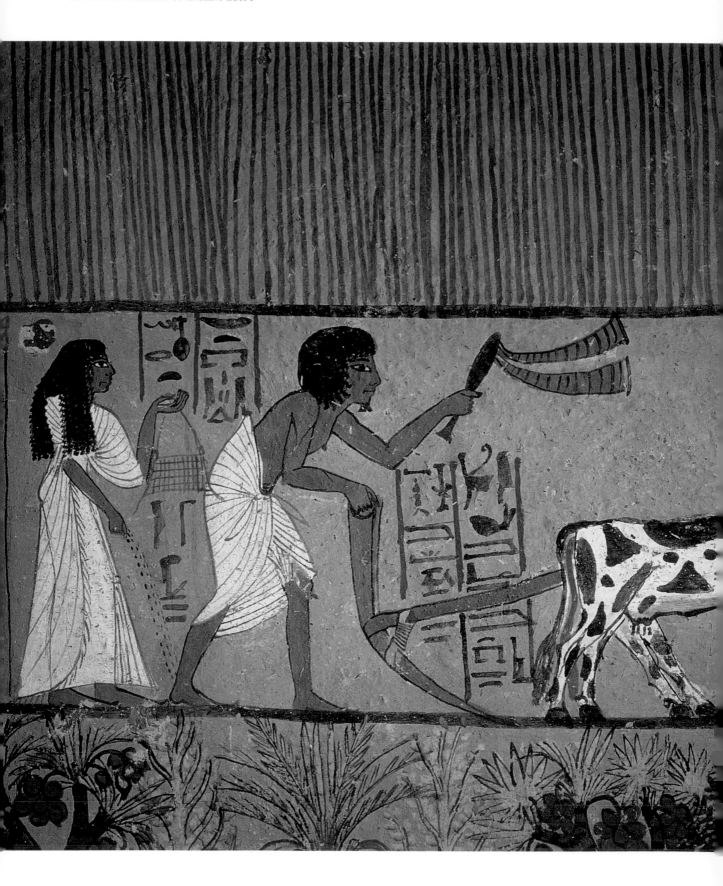

side and a sheer drop on the other. And, as any visitor to Egypt can see today, a view from the high plateau on either side of the Nile shows the cultivated strip laid out like a checkerboard. No artist working in the heights above Thebes, for instance, could have failed to be struck by this phenomenon. There is no doubt, then, that Egyptian artists could have used perspective in portraying landscape. They certainly possessed the technical skill to do so. But it was unacceptable to their search for the timeless archetype of things, their compulsion to break down a picture into its component parts and present each of them as it is in known reality, ideally, always, everywhere and for everybody.

Each part is minutely and accurately observed, simplified into graceful essentials. Then all the bits are put together in accordance with the principles of *maat*. The structure of spatial relationships which thus emerge is incompatible with Western illusionist ideas. But it can create great landscape art all the same. The hunting scenes of Tuthmosis III and his progeny, early in the Eighteenth Dynasty, with their wonderful sense of movement and the elegant ingeniousness of their spatial relationships, the marvellous feeling for nature in the so-called 'Green Room' at Amarna, above all the vast historical reliefs of Sethos I and Ramesses II, mounting to a crescendo in the two panoramic land and sea battles of Ramesses III – when the whole of the civilized world was on the brink of a new Dark Age – constitute a particular manner of portraying the world whose 'truth' may be as valid as the tradition which replaced it.

Indeed, what is reality in art? The ancient world asked the question and disagreed about the answer. Before they staged their perspective revolution, the Greeks learnt virtually everything they knew in art, above all in sculpture, from the Egyptians. When they took the intellectual leap into illusionist art, the change came in three and two-dimensional work at exactly the same time; hitherto, in both fields, they had strictly followed the Egyptian canons and codes. In the seventh and sixth centuries BC, the formative period of classical Greek culture, the Greeks had already set up trading posts in the Egyptian Delta, and were serving as mercenaries in the Egyptian army. The secrets of Egyptian artistic skills were closely kept but the Greeks undoubtedly penetrated the studios, for the so-called archaic Greek sculptures of boys (*kouroi*) correspond exactly to the ratios of the reformed Saite canon – indeed, in the case of a *kouros* in the Metropolitan Museum, New York, a Saite grid has actually been superimposed on the statue and found to fit. These *kouroi* are, for the most part, in the posture of standing Egyptian male figures, with arms to the sides and one foot forward. Diodorus, writing about 50 BC but quoting a passage from Hexataeus of Abdera, *c.* 300 BC, tells the story of two Greek sculptors, father and son, Telecles and Theodorus, who lived and worked in the late sixth century BC. He says the two men (whom he mistakenly calls brothers) produced a statue of the Pythian Apollo for Samos: they agreed between themselves what were to be the total dimensions of the statue, then each produced half of it separately, one in Samos the other in Ephesus. The two halves, when finished, fitted perfectly: 'and they say that it is for the most part rather like the Egyptian statues, having its arms stretched down, and its legs in a stride.' He adds that the brothers had worked in Egypt, and that to produce statues in two corresponding halves was common there, the proportions being standard.

Left: *Wall painting from the tomb of Sennedjem in Dahr-al-Madinah showing Sennedjem and his wife farming.*

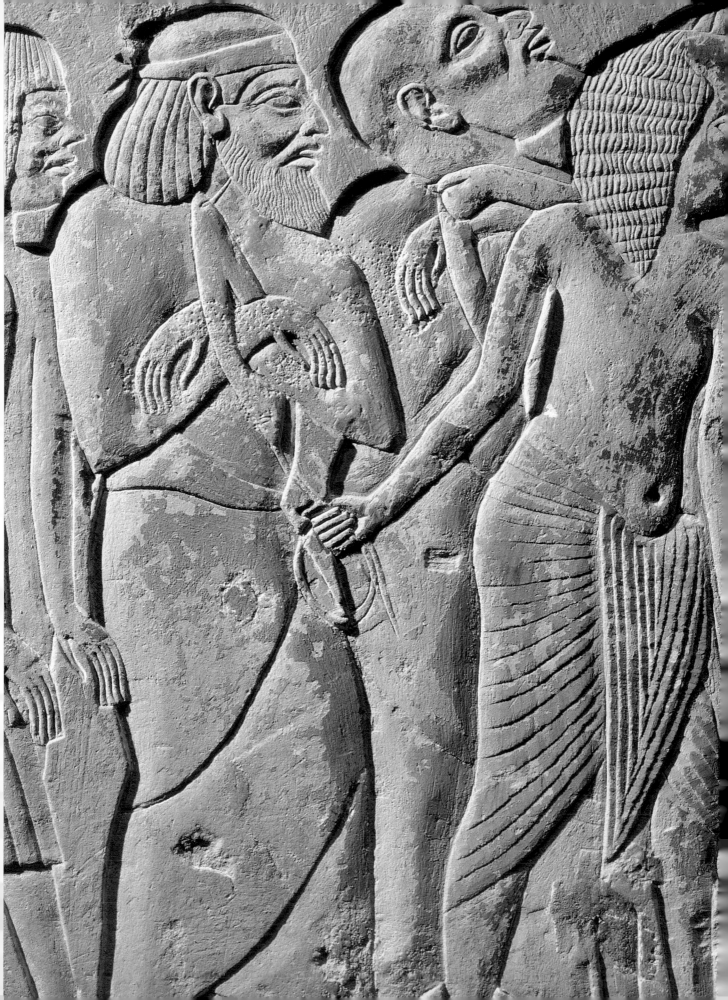

THE DECLINE
AND FALL OF THE
PHARAOHS

T he Late Bronze Age, which can be placed roughly between
1500 and 1100 BC, was the first period of international
civilization in world history. For the first time the light of
culture cast its beams over wide spaces and became, for vast numbers
and varieties of men, a shared system of illumination. It would be
wrong to say that the Egyptian and Hittite Empires, Syria and
Palestine, Babylonia and the Aegean world, embraced a cosmopolitan
culture: they were, in fact, very different societies. But it is possible
to study, as art-historians like Stevenson Smith have done, a multitude
of interconnections and influences which reflected their commercial
and political contacts. There was a shared diplomatic language,
Akkadian; an international script, cuneiform; kings married each
other's daughters, exchanged elaborate gifts, signed treaties of
peace and alliance; experts of various kinds moved from one court to
another; there was a class of cosmopolitan, multilingual scribes.

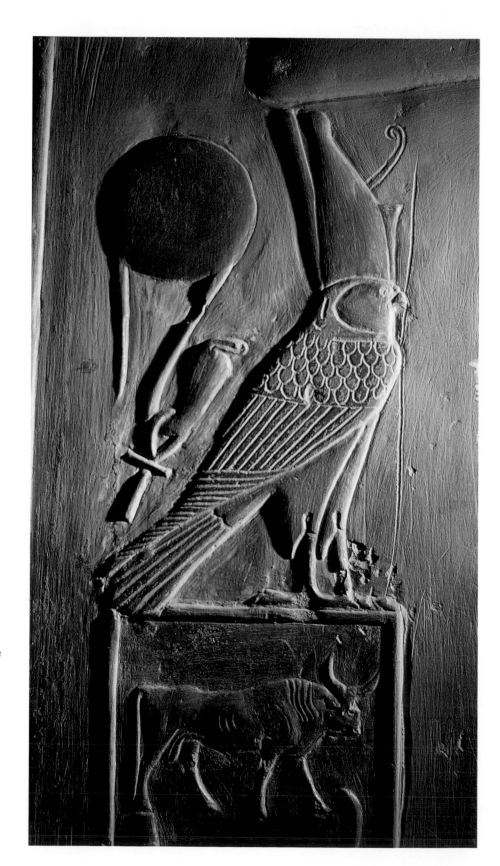

Previous page: *A relief from the grave of Haremhab showing Egyptian officials leading away chained prisoners of war.*

Right: *A relief from the Temple of Seti I, Abydos, showing the Horus falcon with the double crown of the pharaoh.*

To a great extent this internationalism was confined to court and palace, but trade was beginning to radiate into lower levels of society and, perhaps most important of all, the movement of gods and goddesses across the frontiers gave even the humblest a hint of wider worlds. The rise of empires produced also, alas, a cosmopolitan slave class, the pitiful victims of lost battles and fallen cities. Slavery was the great cancer of the ancient world. As slaves rose in numbers, so their price fell and the availability of cheap muscle-power was a deadening disincentive to technical innovation. Enterprise tended to drown in oceans of human sweat. Yet the age was not without massive achievements: in Babylonia, the foundations of mathematic method and astronomical knowledge were laid; Phoenicia produced the first pure alphabet at this time, and the smiths of the Hittite Empire now forged iron in significant quantities. Even Egypt, a land where the structure of society most discouraged change, and where the dull work-rhythms of the sweated multitude throbbed most painfully, there were some advances: notably the first production of high-quality glass.

Under the empire, indeed, exposure to foreign influence was disturbing rigid Egyptian patterns in a number of respects, some of which we have already noted. Might Egypt, which had the advantages of considerable wealth and political stability, have achieved the breakthrough into a self-critical and innovatory society, as Greece did in the next millennium? It was not inconceivable. The immense continuity of Egyptian culture meant that its roots stretched back into very primitive times indeed (we see this particularly in its religious matrices) and so perpetuated elementary patterns of thought, inhibiting intellectual movement. For example, the Egyptians had no sense of history and they did not understand time as we do. Their art, just as it arrested motion in its chief figures, ignored time completely. The first Egyptian painting which expresses time – a brazier indicates night – dates, significantly, from the Akhenaten 'revolution'. Egyptian artistic tradition treated all subjects in their eternal aspect, and so reflected the religious assumption that existence was an endless series of cycles. For Egyptians, time did not consist of unique events, proceeding from an irrecoverable past and projecting into an infinite future. In a sense which we find difficult to grasp, past, present, and future were for them all one. Hence their records were often as it seems to us, pious frauds. Pepi II, at the end of the Old Kingdom, decorated his Sakkara mortuary temple with copies of reliefs describing the victories of his predecessor, Sahure, 200 years before, claiming them for himself. 1,000 years later, the successors of Tuthmosis III were likewise claiming his triumphs as their own, and Ramesses III asserted he won the battle of Kadesh fought by Ramesses II a whole century before – a battle, moreover, which may not even have been won in the first place, since official records were State propaganda. Of course, the idea of hereditary honours is contained in the notion of sacrosanct monarchy: Queen Elizabeth II of Britain still formally calls herself 'Defender of the Faith', a title awarded by the Pope to a pre-Reformation Henry VIII 450 years ago. But here the title is seen as a historical property, owned by descent. To the Egyptians, there was no absolute distinction between the reigning pharaoh and a predecessor who had actually done such things, since both were embodiments of the Horus-god. History was not a series of facts, but the enactment of ritual: Ramesses III re-fought and re-won his predecessors' battles as part of the pharaonic cycle. The Egyptians did not date their history from the founding of the united kingdom. They dated it anew at the beginning of each Horus-reign, unification being commemorated at the coronation and jubilees, each self-contained reign being a ritual summary of the country's entire history.

It says a great deal for the impact of cosmopolitanism on the Egyptian mind, and the shift of fundamental ideas which followed, that under the New Kingdom Egyptian court circles began to move away from cyclical and towards linear time. From this period we date the first king-list, itself an innovation in pharaonic theology. Egypt began to recover her real history, and to see it (as we still do) in terms of the successive dynasties, punctuated by horrific descents into chaos. The acceptance of history was a powerful dissolvent of myth. So also was the recognition of foreigners as 'people' in their own right, with separate and unique histories of their own. Egyptians began to look at the world outside their own immediate experience with new eyes. Queen Hatshepsut's expedition to Punt was in some respects as much a record of scientific discovery and observation, as a commercial venture, and her successor, Tuthmosis III, displayed a similar taste for scientific knowledge in his wall reliefs.

Yet this period of intellectual awakening did not last in Egypt as in the other states of the first cosmopolitan period. The Dark Age descended, as it had done twice before and as it was to do again in the fifth century AD. Though Egypt, under Ramesses III, herself survived repeated hammer-blows inflicted by the Peoples of the Sea and their barbarous mainland allies, other states and cultures did not. The remains of the Egyptian empire of allies and puppet states, the independent city-states of Syria and Palestine, the Mittanian rump, the Hittite Empire, Minoan Crete and Mycenaean Greece, were swept away or submerged for a time. The international community collapsed, diplomatic contacts were broken, trade sharply declined, standards of living fell, learning and literacy disappeared in many areas, and there was a general and abrupt decline in art and workmanship. Of course the ruin was not universal. Gleams of evidence occasionally light up the darkness and reveal elements of continuity, on which

Below: *The ruins of the town of Tanis.*

the civilized successors of the first millennium BC were painfully to build the foundations of the classical world. But that classical world, which began to emerge from the Dark Ages in the eighth century BC, was very different, especially in one fundamental respect. It was a dual world. The culture of the Late Bronze Age was a unity in that there was no distinction between East and West, between Europe and Asia. The eastern Mediterranean was a unifying, not a divisive, factor. With the emergence of classical civilization, we are profoundly conscious of a great cultural divide which steadily widened over hundreds of years and persists till our own day. From henceforth there is a European form of approach and manner of doing things, and an Asian one. The great struggle between the Greeks and Persians is the first manifestation of this conflict of cultures along geographical lines. We see it still today in Cyprus and on the borders of Israel.

'East is East, and West is West, and never the twain shall meet.' They did indeed meet – were one – in the Late Bronze Age. In the dissolution that followed, and the emergence of the new dualistic pattern in classical times, why was it that Egypt fell on the oriental side of the great dividing line? The answer, I think, is that its history was somewhat different to that of the other elements of the cosmopolitan culture. Egypt did not fall to barbarian hordes; it surrendered to a slow process of internal decay. It might be said, fancifully, that Egypt, as the oldest continuing civilization of all, had given birth to much of the Bronze Age culture and now, effete, had nothing more to produce or offer, and fell into the oriental lassitude and subordination which separated it from the dynamic West. But nations, peoples, cultures are not organisms, following the human life-cycle of birth, growth, decay and death. They decay from a combination of definite physical reasons which can usually be ascertained if the records are plentiful enough.

Egypt's written historical records are never plentiful and they are particularly sparse, or rather confused, between the time of the Ramessides, in the Twentieth Dynasty, and the emergence of the Saite, or Twenty-sixth, Dynasty. But from late Ramesside times there are ample indications that the well-ordered Egyptian state, with its apex in pharaonic absolutism, was beginning to break down. The last really masterful king of independent Egypt, Ramesses III, was almost certainly murdered, and as we have already noted, the judicial investigation which followed revealed a ramifying conspiracy which went right through the court, administration and army. This terrible act of *lèse-majesté* struck a doleful blow at the prestige of the throne, and the morale of the men who served it. The kings who succeeded were shadowy, ephemeral figures. Even in Ramesses III's lifetime, the strike of the elite workers at the royal necropolis, because they had not been paid, suggests the existence of chronic and endemic corruption within the administration: the pay was simply not getting through to the men. There is other evidence of such malpractices: a Mid-twentieth Dynasty papyrus reveals monstrously dishonest dealings among the senior clergy in the Temple of Khnum at the First Cataract: about ninety per cent of the grain dispatched from the temple's estates in the Delta simply disappeared into their private warehouses. But the most sinister evidence of all is a papyrus describing the looting of the royal tombs on the West Bank at Thebes under Ramesses IX (about 1142–1123 BC).

The story of the Great Tomb Robbery is incomplete, and will never now be told in full. The investigations began when Peser, the mayor of eastern Thebes, laid information against Pewero, the mayor of western Thebes, before Khamwese, the vizier of Upper Egypt. He claimed that a large number of tombs, most of them belonging to

Below: *The Ramasseum in Thebes.*

private people, but including ten royal ones and four of queens, had been vandalized and stripped, with Pewero's connivance. Evidently the corruption was much wider than Peser realized, for the official judicial commission set up to inquire into his complaint found against him, on the grounds that his information was inaccurate – only one royal tomb had been touched – and acquitted all those he accused. Some time after it reported, Pewero organized an extraordinary demonstration. All the workmen of the necropolis on the West Bank – inspectors, tomb-administrators, policemen, skilled workmen and simple labourers – who felt their honour or honesty impugned, crossed over the river and chanted noisy slogans against Peser outside his house on the East Bank. The furious Peser then threatened to appeal directly to the king, and was then in turn accused before the vizier by Pewero of trying to bypass the correct bureaucratic channels, in itself a serious offence against *maat*. He was apparently tried and found guilty, confessing to perjury. But several years later, again according to the record, he was vindicated, though not fully. Eight tomb robbers were caught, confessed under torture (they were 'beaten with doubled scourges on their hands and feet'), and were convicted. We have the names of five, all humble people: a water-carrier, a peasant, a stonecutter, an artisan, a slave. These men no doubt carried out the actual break-ins, but the officials at all levels whose well-rewarded corruption made the looting possible were, so far as we know, never convicted.

Indeed, the crimes went on, on an ever-increasing scale. The State, operating of course not from Thebes but from palaces hundreds of miles to the north, never succeeded in stopping the robberies. With very few exceptions (Tutankhamun's tomb was one) all the valuable tombs at Thebes were pillaged at this time. The best the authorities could do was to try to protect the actual mummies. Ramesses III was put for safety into three different tombs in turn. Amosis, the hammer of the Hyksos, Amenophis I, the great Tuthmosis III, even the egomanic Ramesses II, all lost their tomb goods and had to be dragged to safer places, finally being collected together, in communal squalor, in one safe sepulchre. This was one cache. Another refuge was found outside the Valley of the Kings, in the rocks near Hatshepsut's temple; and this remarkable cache of wandering royal mummies remained undiscovered until the 1870s.

But the gold, silver and copper had gone – passed into general circulation. It helped to finance yet more open crime and strident corruption. There are references, under the same Ramesses IX, to bands of foreign bandits, described as Libyans, *Meshwesh* and so forth. There were riots, mutinies and popular unrest. The foreign gangs were said to terrorize the West Bank at Thebes; the labourers at the necropolis downed tools, 'on account of the foreigners'. A riot squad of slaves, apparently controlled by the High Priest at Thebes, was sent in to end the trouble. Under Ramesses XI, the last monarch of the New Kingdom, there was a mass revolt against the High Priest. Law and order in Thebes were not restored for nine months: the army was busy elsewhere with other trouble. The High Priest, Amenophis, simply disappeared, perhaps assassinated. The new High Priest, Herihor, was a general, a sort of military priest-dictator, who restored order and eventually set himself up as an autonomous ruler, founding a new Theban line.

What was going wrong? Amid the general picture of the breakdown of *maat*, there is the particular theme of the State being unable to pay its way. We first come across this under the strong Ramesses II, when the necropolis workers went on strike. Corruption was to blame but it was not the only cause. The empire no longer supplied the foreign loot which kept such spendthrifts as Ramesses II afloat, and no doubt paid

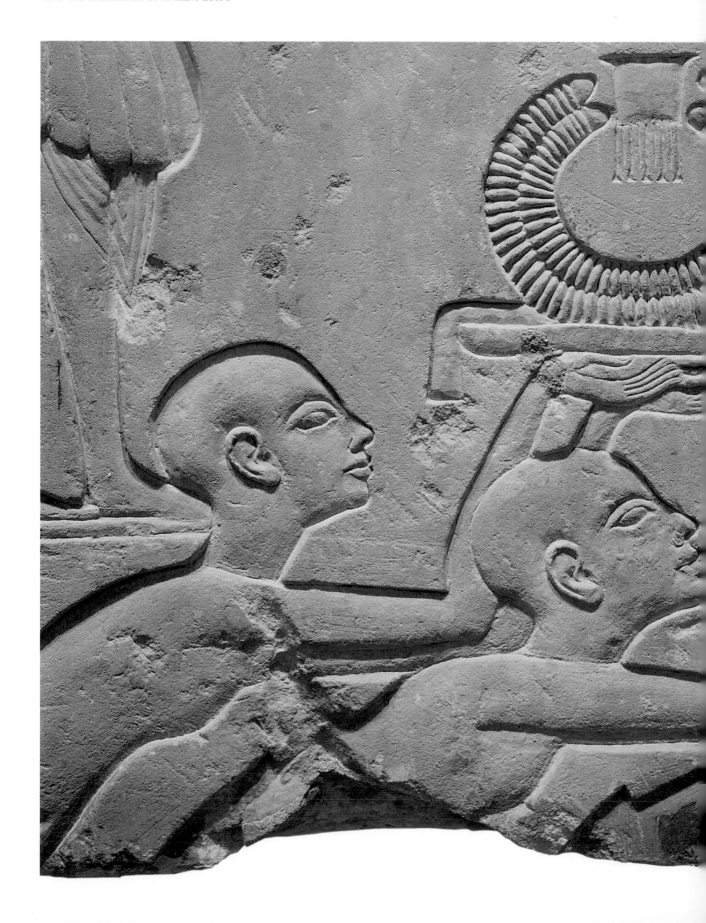

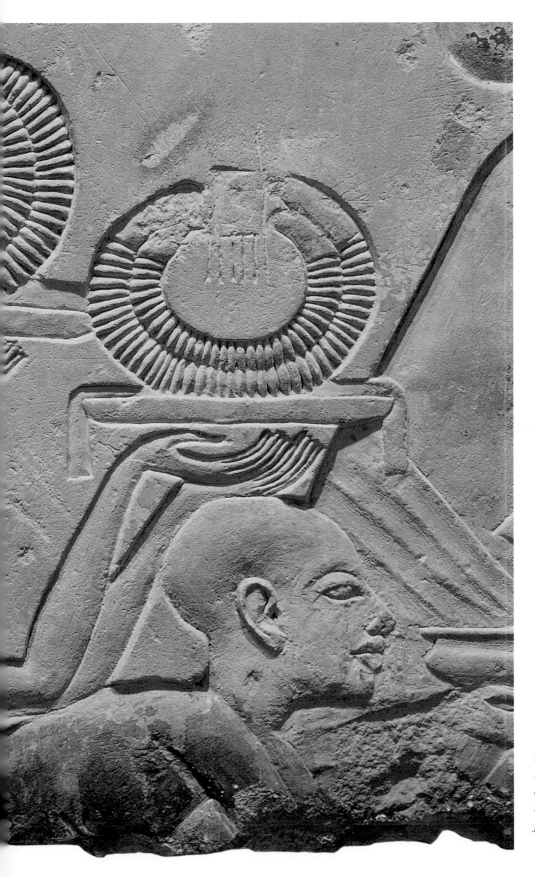

Left: *A relief from the tomb of Horemheb showing the children of the deceased bringing necklaces as grave furnishings.*

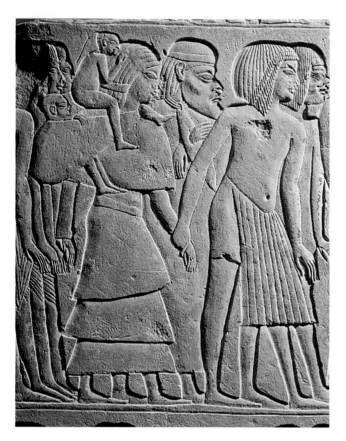

Above: *A relief from the tomb of Horemheb showing an official with his wife and children.*

for the fleets and armies with which Ramesses III defended Egypt from barbarian attack. The empire was gone. But also dwindling was the massive supply of gold from Egypt's own mines. They were exhausted or, in the far south, had passed out of Egypt's control. Egypt had no currency as such, but it was gold which, as it were, oiled the wheels of state; and in the late New Kingdom metals were increasingly the medium of exchange. Above all, gold and silver (and to some extent copper) paid the mercenary soldiers on whom Egypt began to depend from the days the Hyksos were expelled and who, in the late New Kingdom, formed the overwhelming bulk of her army and police. If mercenaries were unpaid they instantly mutinied and formed robber-bands – hence the complaints about the 'foreigners' in Thebes. But other people, civilians and civil servants of every kind – the State was a huge employer of labour – were not getting paid either. It was a sign of the times that the pharaoh appointed more and more clerics to administrative posts: they could be rewarded with benefices, a trick much used by the kings of medieval Europe. But a cleric was less easy to control, discipline or remove than a salaried official wholly dependent on the king's bounty. So the throne was increasingly defied by insubordination and corruption. With the pharaoh unable to pay, State employees, including high officials, began to grab their wages from his entombed predecessors. The pharaoh was, as has been explained, identifiable with his predecessors – they were all one and the same Horus – so this otherwise inexpiable crime could be justified among unpaid officials, at least to themselves. Hence the universal conspiracy to plunder the Theban royal tombs.

The gold and other precious metals thus unloosed on the market set up an inflationary movement. It hit the Crown particularly hard since its own supplies of gold, with which it might have competed for grain and other commodities, were dwindling. From the death of Ramesses III, at a time when prices had already risen sharply, the cost of a sack of wheat (emmer) rose from a *deben* of copper to five-and-a-third *deben* under Ramesses IX. It is significant that, in 'the year of the jackal' men were buying wheat not with copper but with gold. Men without gold went hungry or rioted. They turned against the temples, because the Church had full storehouses from its ample estates, even when the king could not pay in food and the market price had rocketed. That was what the trouble confronting the High Priest in Thebes was all about. When the West Door of the fortified temple at Medinet Habu was broken down, and the sacred person of the High Priest insulted, the mob was hungry rather than anticlerical.

The relative increase in clerical wealth was, however, a major cause of the trouble and was probably seen to be so. There was always the danger in theocratic Egypt that the wealth and power of the Church might erode the authority of the Crown. We have

hints of such a process under the Fifth and Sixth Dynasties, leading to the collapse of the Old Kingdom. Under the 'Divine Contract' of Tuthmosis III, refashioned by Horemheb and his successors, the temples collected a huge proportion of the pillage won by the empire, and held it perpetually in mortmain. In strict legal theology, the king could get such property back at will, or at any rate could use it for State purposes. But such forced loans, requisitions or whatever they were termed were bitterly resented: Horemheb's decree, for instance, was very likely aimed chiefly at State officials who commandeered Church property. We do not know how much, in total and in proportion, the Church owned. Diodorus put it at one third of the land. The Great Harris Papyrus in the British Museum, in which Ramesses IV recorded the lavish donations in land and slaves made by his victorious father Ramesses III to the gods and their temples, indicates that they owned, as a result, 450,000 people and 1,100 square miles. Professor John Wilson of Chicago calculated that this represented one tenth of the population and one eighth of the cultivable land. Moreover, the inventory may not have been complete. The full extent of Church property may have approached Diodorus's figure even in Ramesside times (for purposes of comparison, the Church owned roughly one-fifth of the land in England on the eve of the Reformation).

The alienation of royal land to the Church might not have mattered so much had the remaining Crown estates been well run. But the evidence suggests that they were supervised by swarms of bureaucrats who often imposed intolerable burdens on the peasants who actually worked the soil. A letter from the time of Merneptah, Ramesses II's successor in the Nineteenth Dynasty, reports officially: 'Of the cultivators of the estate of pharaoh which is under the authority of my Lord, two have fled from the stable-master Neferhotpe, as he beat them. Now look! The fields lie abandoned, and there is no one there to till them.' We have other evidence of a flight from the land by an oppressed peasantry, a phenomenon which became a feature of the Roman Empire in its decline. Peasants had to be requisitioned, *glebae adscripti* – tied to the soil. But no one cut down the bureaucrats; they were part of the very fibre of the pharaonic State even in its dotage. They were part of its culture, for young scribes gleefully learned to chant: 'It is the scribes who order all. No one orders the scribes.' Or: 'Put writing in thy heart, so that thou mayest protect thine own person from any kind of labour, and be a respected official.'

The Wilbour Papyrus, dating from late Ramesside times (about 1150 BC) shows the weighty hand of the central fiscal administration at the village level. When the Greeks took over under the Ptolemies, no mean bureaucratic experts themselves, they simply adopted the pharaonic system, merely changing the terminology. The royal Ptolemaic scribe, the *basilocogrammateus*, was merely a new name for a very ancient Egyptian

Below: The coffin of the priest Ken-Hor with funerary accessories.

Below: *The mortuary temple of Queen Hatshepsut at Deir el-Bahari, in the cliffs overlooking the West Bank of the Nile at Thebes.*

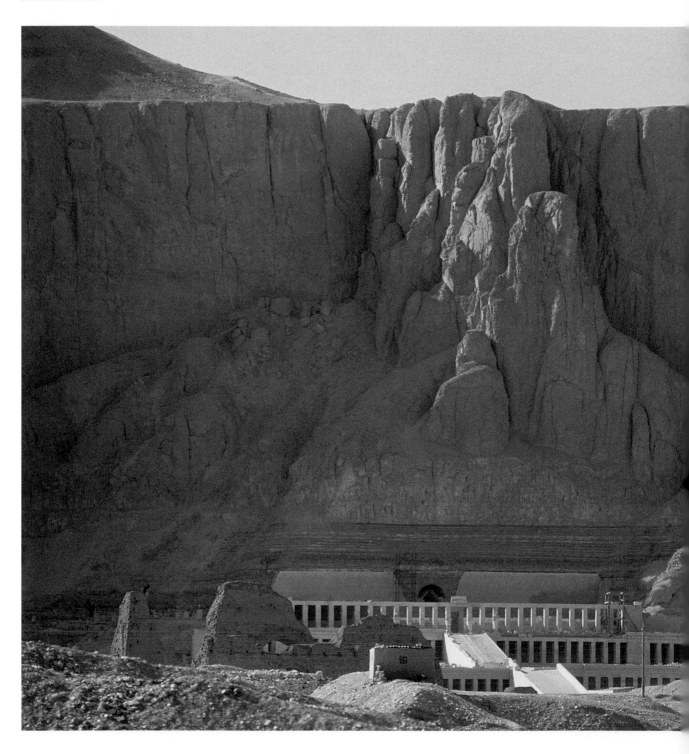

official – all the classical authors agreed that it was the Egyptian kings who had first measured land for administrative purposes. A study of one Egyptian village, Kerkeosivis, by Dorothy J. Crawford, shows that it contained ten full-time bureaucrats (the estimated total population was 1,520) who actually lived there on the spot; others arrived for the seasonal accountings. An Eighteenth Dynasty text lists the orotund titles of these parasites: 'the holder of the measuring cord', 'two clerks of the land', 'the messenger of the steward', 'the custodian of the book of regulations', and so forth.

With these many and greedy hands at work, the State's disposable income declined, and there can be little doubt that the principal cause for the collapse of the New Kingdom was lack of money. The *Tale of Wenamun*, and his expedition to Byblos to buy cedarwood, illustrate the point. It seems to date from the very end of the Ramesside period, or shortly after, when authority in Egypt was already divided between two or more centres. Wenamun was an official of the Temple of Amun at Karnak and was robbed before he could complete his mission. He, or his superiors, apparently believed that the mere reputation of Amun, chief of the 'imperial' gods, would be sufficient to persuade the Prince of Byblos to provide the timber, which was needed for Amun's ceremonial river-barge. But the Prince, while paying tribute to Egyptian glory and power in the past, wanted a straightforward cash or barter transaction. The tale, no doubt fanciful but with a clear factual basis, exposes a conflict between Egyptian metaphysics and Phoenician commercialism. It is also a sharp little vignette of Egypt as a faded great power, a has-been, still not quite grasping her impotence. The brutal truth is that, after the death of Ramesses III, Egypt never seems to have had the money to pay a mercenary army, certainly not for overseas service, or only for very short periods, and it no longer had the internal coherence or will to create an army of Egyptian peasants. The pharaohs still occasionally interfered in Asian, and especially Palestinian politics, as the Bible and other written sources testify; but with only ephemeral success, or none at all. No one any longer believed in the colossus of the Nile, certainly not the rising power of Assyria, a militaristic state in a way Egypt never had been, or could be. Egypt had been letting down its allies, from weakness or folly, since the days of Akhenaten. The Old Testament tells us that the Assyrians taunted the Jerusalemites for ignoring this historical lesson: 'Thou trusted upon the staff of this broken reed, even unto Egypt, whereof if a man lean, it will go into his hand and pierce it; so is Pharaoh, king of Egypt, unto all that trust on him.'

But who was pharaoh? In the closing decades of the second millennium BC the question was increasingly difficult to answer. Under the late Ramessides, the power of the priests grew, as their income outstripped the king's. Until he was thrown out by the mob, Amenhotep, High Priest of Amun at Karnak, was portrayed by official artists – always ready to reflect political realities in their work – as the same size as the pharaoh, when the latter bestowed gold collars of honour on him. His successor, the general Herihor, combined the High Priesthood at Thebes with the command of the army in Upper Egypt, his real source of power. He used the growing dependence on oracular pronouncements from the temple gods as guide to official policy – the later Ramessides would not move a step without such divine sanction – to stage a miraculous pronouncement by Amun, no less than a restoration of the divine order, marked by a 'miracle' at the great festival of Opet: regal and priestly power were to be reunited, in his person naturally. He seems to have ruled as an independent potentate even while Ramesses XI was still alive.

The last king of the Twentieth Dynasty died without presentable heirs, whereupon Herihor took formal power at Thebes; and in Tanis, Smendes, the Vizier of Lower Egypt, founded his own dynasty, the Twenty-first, by virtue of the royal blood of his wife, Tanutamun. These two dynasties, secular kings in Tanis, priest kings in Thebes, coexisted for 100 years, marrying, begetting, handing on to their successors, occasionally exchanging sons and daughters in marriage, and as a rule on amicable terms with each other. Neither could honestly claim the double crown and rule over the 'Two Lands'; the priest-kings often did not place their proper names in a cartouche, thus doubting their own titles. The Tanite kings were weak and reigned in a feudal atmosphere, by tolerance of the Libyan tribes to the west, and various groups of migrants such as the sea marauders who still patrolled the eastern Mediterranean. It was very likely a coalition of these tribal groups who eventually, about 935 BC, while the Tanites still reigned, installed a Libyan, Seshonq I, who ruled from Bubastis, also in the Delta, as the founder of the Twenty-second Dynasty. These Bubastite kings occasionally campaigned in Palestine – they once carried off the Temple treasure from Jerusalem and aided pretenders to the Jewish throne – but few could fairly claim to be undisputed kings of all Egypt.

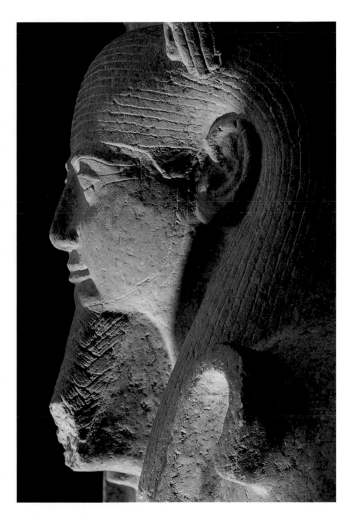

Above: *A detail from the tomb of Smendes, Twenty-first Dynasty.*

Sheshonq himself made his eldest son High Priest at Thebes. But Thebes continued to be semi-independent, if not wholly so – one High Priest, Harsiese, definitely encartouched himself – and the Bubastites were not even supreme in the Delta, for in the reign of Sheshonq III (822–770) Petubastis set up a rival Delta line, which reigned concurrently and is known as the Twenty-third Dynasty. Yet a third Delta dynasty, the Twenty-fourth, produced two kings.

No doubt the feudal divisions of the country, the rival lines and dynasties, and the involvement of the Theban priests in politics and warfare, led to the prostitution of religion and the neglect of the proper ceremonies. It was in defence of religion, and in the name of pharaonic orthodoxy, that Piankhi, Prince of Napata near the Fourth Cataract, invaded Egypt from the south and set up the Twenty-fifth Dynasty. He left behind him a frank biographical stele, so we know more about him than about most pharaohs: he emerges as a definite and robust personality, a religious crusader, puritanical and fierce. Whether we should see these Kushite princes as blacks or Nubians is a matter of argument. They had long lineages and were very aristocratic and proud. Under the empire, their ancestors had been trained in the *Kap*, the elite school for princes attached to the pharaoh's palace, and they tended to be more regimental-minded, ritualistic and conservative than the Egyptians themselves. Round about 1050

Opposite page: *Fragments of columns from the ruins of the town of Tanis.*

Herihor had called a son Piankhi, and it may be that the Kushite prince Piankhi who conquered Egypt 300 years later was a descendant, claiming blood royal from the priest-kings of Thebes. He owed his success not merely to his puritan single-mindedness but to his army, the first seen on the Nile for many hundreds of years which was not composed largely of mercenaries but consisted of Piankhi's feudal or rather tribal array, including some magnificent cavalry regiments. The king was a terrific horseman, thus reviving memories of Tuthmosis III and other New Kingdom giants. When he took Hermopolis after a siege, he visited the royal stables, so he tells us on his stele, and was outraged to find the horses starving. He stormed at the prince of the city: 'By my life! By my love of Re! As my nostrils are rejuvenated with life!' – all very good and orthodox royal Egyptian expletives – 'To see horses so hungry grieves my heart more than all the evil that thou hast done in thy wickedness.' When Piankhi died and was buried at Nuri, his four favourite chargers were buried with him, a custom followed by his successors, Shabaka, Shebitku Tahrqa and Tanutamun – a practice of the South, not Egyptian royalty.

In other respects, however, Piankhi and his family were not so much conservatives as reactionaries. They seem to have known more about Egyptian history than the Egyptians themselves. In some ways they put the clock back to the Old Kingdom, reviving royal funeral-pyramids, though on a much smaller scale. They brought back the Fifth Dynasty pyramid texts, and had their funeral dispositions carved in antique hieroglyphics. Piankhi was formidable in battle, but he conquered Egypt in part at least

Below: A relief from the Palace at Nineveh depicting a banquet of King Ashurbanipal.

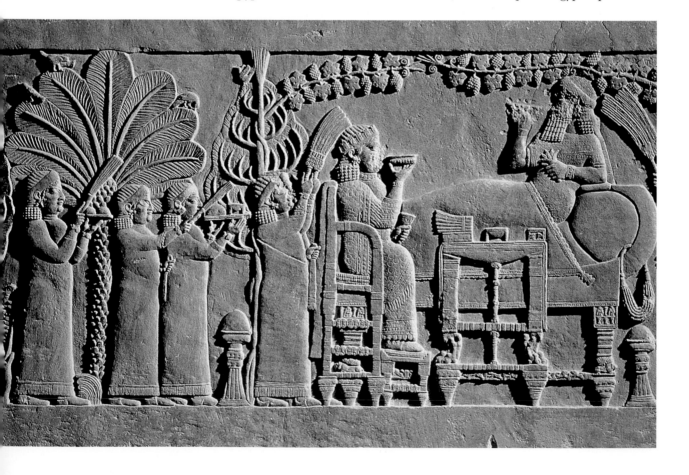

by appealing to the Egyptians' fear of sin and blasphemy, and their terror of powerful magic. He claimed he killed only 'the impious who had blasphemed against god'. Unlike the Mahdi, whom he prefigured in some other respects, he did not claim to be a prophet, but god incarnate, as all true pharaohs were supposed to do. He not only stuck to the purification and dietary laws in all their rigour, but insisted that anyone who wished to have dealings with him must do likewise – fish- and pork-eaters, and the uncircumcised, could not enter his palace. He found it necessary to purify Memphis when he captured it, and indulged in formidable lustrations in the temple of Ptah.

He interpreted literally the notion that pharaoh was the only priest. When he went to a temple for the service, he entered the sanctum alone, shut the door, performed the cult himself, and then afterwards sealed and stamped the portals. In all likelihood, no pharaoh had done this since the days of the Old Kingdom, 1,500 years before. He was very conscious of his ancient heritage: he and his successors recorded the royal annals in classical hieroglyphics, as in ancient days. They patronized the old state gods and adorned their temples in traditional style. Their splendid shrine from Kawa, now in the Ashmolean Museum, Oxford, testifies to their devotion to classical Egyptian art.

Kushite religious orthodoxy was well received in Thebes, where Amun once more rode high in royal favour and largesse. In their enthusiasm for Amun, the Kushite kings formalized, or more likely restored and embellished, the institution of a High Priestess, reserved for royal princesses, called the Divine Adoratrice of Amun. The Kushites restored the proper worship of Ptah at Memphis, but they carried less popular weight in the Delta, a country where royal control was always more difficult because of a complete absence of lateral communications, where power was divided among many centres and towns, where supergods had little impact, and feudalism was the rule. In Lower Egypt, too, the Kushites had no answer to invasions by the Assyrian military machine, the true precursor of the Roman army in its relentless methodism. The Assyrians thought little of wild Kushite cavalry, especially in the broken country of the Delta. They got as far as Memphis in 671 BC; Ashurbanipal was there again in 667, and may have penetrated up-river as far as Thebes. Much booty was carted off to Nineveh, the seat of their empire. The Kushites, baffled, retreated to their own territory – their kings were always buried at Napata anyway – and a new hegemony was established in the Delta by the princes of Sais, who formed the Twenty-sixth Dynasty. The Greeks later called this period the Dodekarchy, for no one king ruled Egypt and power was distributed among local rulers. In Middle and Upper Egypt, the focus of power, such as it was, was on the Divine Adoratrice and her High Priest coadjutor at Thebes. One of the Saite rulers, Psammetichus I, contrived to get his daughter, Nitocris, adopted as heiress and successor by the reigning Adoratrice: thus the country was reunited.

The Saite Dynasty was the last period of genuine Egyptian independence until President Nasser seized the Suez Canal in 1956. Its kings emphasized their embodiment of Egypt's immense past by reviving many of the artistic devices of earlier periods and by encouraging craftsmen to work in the archaic style. Thus at the very time, in the sixth century, when Greece was moving rapidly towards a fundamental revolution in artistic perception and intellectual method, Egypt turned its face towards the past. The products of this archaizing style, which was practised until the art of ancient Egypt disappeared completely, are often of high quality, but nowhere outstanding. No royal tombs from Late Dynastic Egypt survive. In most cases we have

not yet even identified the necropolis of the later dynasties. At Tanis, there are tombs of some Twenty-first and Bubastite kings: these are simple, of no great elegance, entirely above ground, for in the Delta water hovers just below the surface. The Saite kings, like the Kushites, avoided the traditional necropolis for royalty at Thebes: no doubt they thought it unsafe, or tainted by unpunished sacrilege. Yet local feudal notables continued to be buried there in considerable style, in the hollow of the valley below Deir el-Bahari called the Asasif. Some of these tombs have underground hypostyle halls and long passages adorned with inscriptions and reliefs in the grand traditional manner. The tomb of the Chief Lector Priest Pediamenope covers nearly 2,500 square feet, and that of Mentuemhat, another official, has fine reliefs which echo the Middle Kingdom and even the Old – there was a revival of the royal *Pyramid Texts* at this time. But these were among the last of the old-style tombs. The tradition was dying. The Saite kings lacked the religious fundamentalism of the Kushites, and their revival of old customs was aesthetic rather than theological. It was men's intense faith in eternity which made them spend more money and energy on their tombs than on anything they built for life. But faith was receding.

Egypt's religious intensity had always been linked to the homogeneity of the Egyptian nation, in a cultural if not also in a racial sense. The distinctiveness was now being eroded. Under the Saite kings, foreigners poured into Egypt and formed a growing number of permanent colonies. Many of these groups were no longer poor men – economic refugees – forming a category of second-class citizens who could be used for unskilled labour, as in the past. These immigrant colonies were often richer and more skilled than the native Egyptians; the proud kingdom of the 'Two Lands' was now technically backward compared to the rising cultures of the first millennium BC. Indeed, the Saite kings, to raise taxes, even awarded privileges – forerunners of later 'capitulations' – to foreigners. At Naucratis, Greek traders were allowed a city of their own, a Greek-style *polis*, where Greek law, customs and religion flourished: not essentially unlike the other colonies of Magna Graecia now scattered about the Mediterranean coasts. Thus trade, once a royal monopoly, fell into alien hands. It was only a matter of time before the rest of the country became booty.

Amosis II, the longest-lived of the Saite kings, died in 526 BC, and the next year his successor, Psammetichus III, was overwhelmed by the Persian army at Pelusium. Egypt became a satrapy of the Persian Empire. Cambyses, Darius I, Xerxes and their successors formed the Twenty-seventh Dynasty, wrote their names in cartouches and in some respects attempted to behave like Egyptian pharaohs. Of course the throne of the Two Lands was now by far the oldest political institution in the world, and in the eyes of the ancient world to occupy it gave to successive conquerors an increased legitimacy and prestige: no other monarchs had an ancient historical claim to be gods. The Egyptian evidence suggests that the Persians revivified the old central administration. Here, as elsewhere, they improved communications, laying down the infrastructure which made the later successes of Alexander so astonishingly rapid. They finished or redug the canal from the Nile to the Red Sea.

Herodotus, who toured Egypt under Persian rule, was critical of the Persian rulers, whom he sometimes presents as monsters. The Greek sources stress the appalling sufferings of the Egyptians as Persian helots. But of course Greece and Persia were now locked in a continuing struggle for the mastery of the civilized world, and Egypt was not much more than a puppet in it. The Egyptians had had friendly and commercial

relations with the Greeks for over 1,000 years, and for many centuries Greeks had served the pharaohs as mercenaries. Throughout the Persian occupation, Egyptian nationalists looked to the Greeks for help. After the Persian defeat at Marathon, the Egyptians rose in revolt, but were put down by Xerxes; there was another revolt in 465, supported by the Athenian fleet, but this too was suppressed. In his schematic treatment of history, Manetho ends Persian rule in 404 (the death of Darius II), and then sets out three more, native, dynasties – twenty-eight, twenty-nine and thirty – covering the first two-thirds of the fourth century BC. These Egyptian kings - Amyrteos, Nepherites, Achoris, Nectanebo and so on – were the last native rulers of Egypt, but it is not clear how completely they controlled the country. They may be seen as insurgent leaders, or even guerrillas, or Greek puppets, rebelling against a continuous Persian presence with Greek assistance. In 343 Persian supremacy was definitely re-established, but the subsequent Alexandrine victories dismembered the entire Persian empire, and in 332 BC Alexander resolved all uncertainties by turning Egypt into a subject-kingdom of his own.

Alexander and his Ptolemaic successors treated Egyptian sensibilities with much greater consideration than the Persians had done. Alexander's body was brought back to Egypt for burial, he sacrificed to Egyptian deities and observed many of the forms of pharaonic behaviour. The Ptolemies did not alter the basic structure of the Egyptian State and in some ways they actually behaved like pharaohs, certainly to the point of striving to keep their blood pure by intermarriage. But they were Greek. Their language

Above: Interior of a Graeco-Roman tomb at Alexandria.

and culture were Greek; their ideas were formed by the Greek *polis*. Their only major administrative change was to impose Greek as the language of government; but it was a decisive one – the Egyptian script, in its original form, went right back to the creation of the kingdom, and was identified with it. The Ptolemies used it for burials and formalities, but the real business of the country was done in Greek. The contrast in cultures was stark: Greek life revolved round cities, in which a palace was an alien appendage; the Egyptians were semi-rural people for whom the palace was a substitute for the city as a focus. What is more, the Greek court could no longer sustain the priesthood, which remained huge in numbers but of dwindling cultural and social consequence.

The Ptolemies, as we have seen, attempted a religious synthesis, to serve both communities; but hybrid gods like Serapis proved much more popular with the Greeks and other cosmopolitan communities along the Mediterranean shore than with the Egyptians themselves. The Ptolemies actually spent more on the Egyptian religious cults than any rulers since the early Ramessides: the temples and shrines they founded on the banks of the Nile, at Dendera, Edfu, Kom Ombo and elsewhere are among the most conspicuous antiquities left to us, and in some cases are exceptionally well preserved. But the vital element in Egypt under the Ptolemies lay in the cities, except in the Fayum, which became a Greek-speaking agricultural colony, settled largely with retired mercenaries. The cities were Greek, above all Alexandria, which took over the trade of Naucratis and rapidly became the largest and richest city in the Greek world. It had its lavish royal endowments, the largest library of antiquity, a university which took over from Athens its intellectual leadership. But its culture was predominantly Greek – the Alexandrines did not even mummify their dead – and the Egyptians themselves were excluded from any part of it. The Jewish community enjoyed a higher social, material and intellectual status than they did. The scribes and priests, once Egypt's cultural elite, degenerated into touts for the hordes of cosmopolitan tourists who flocked to the Nile to see its crumbling wonders and to gawp at its bizarre religious customs.

Against this background, Egyptian religion, the very core of its culture, stratified itself along lines of class and education – it was a tendency, as we have noted, already apparent under the New Kingdom. Among educated, literate Egyptians, private religious cults flourished. The stress was on personal piety, resignation and quietism, the religion of a defeated people. Silence was accounted a virtue; the blessings of poverty recommended. Men were exhorted to show compassion for each other. One of the ethical tracts much read at the time counsels: 'Do not laugh at a blind man or mock a dwarf; help the lame. Do not taunt a madman or shout at him when he does something foolish. For every man is clay and straw, created by God the Builder.' This upper-class religious mood was not exactly new but it tended to replace the intricate theology in which cultured Egyptians once delighted. Tomb-religion declined, and once the Egyptians began to doubt the certainty of life after death, their theological structure was finished. Services in the temples continued; the formalities were kept up; the great Temple of Amun at Karnak was restored. But the statues from the courts and in front of its pylons were cleared away and dumped into a nearby pit – they were not unearthed until 1903, the greatest find of Egyptian statuary ever. We do not know who ordered this demolition, a positive assault on the central cultic doctrine of image as reality.

In the classical world, the Egyptians were celebrated for their piety: Herodotus calls them 'god-lovers'. They were praised by Cicero, who saw religion as an aid to social decorum, and by Celsus, who preferred pagan traditionalism to Christian innovation. Tacitus agreed the Egyptians were pious, but thought them absurdly superstitious also. They paid inordinate attention to ritual forms, solemn lustrations, omens, prophecies, oracles and symbols. Statues were hollow and 'talked'. Public men would not stir without some kind of religious advice or sign, and there was an accumulation of religious rules. A man following his natural instincts fell into error, it was argued; only by following the commands of ritual was one safe. So, says Diodorus, 'every hour of day and night was planned, and when the programme indicated it, the King was absolutely bound to do what religion laid down, not what he himself thought right.' Religious processions were kept up in a similar spirit.

Below: Ptolemaic painting showing the deceased between Osiris and Anubis.

The Greeks had once held the Egyptians in great respect, conscious of what they owed to them. In Herodotus's great book their achievements, indeed, are held in awe. But the Greeks changed their attitude during the Ptolemaic regime. Egyptians were not even allowed to serve in the army, except in periods of great emergency. They were treated as second-class citizens. Though the Ptolemies made Egypt into a great trading nation, the beneficiaries of their economic achievements were all Greeks or other aliens. The land degenerated; the lot of the peasants became worse. Investigation of the Ptolemaic records at village level tells a sad tale of falling yields and living standards, collapsed dykes, blocked irrigation channels and general apathy. The last century of the Ptolemies was one of degeneration.

The Romans, who took over in the first century BC, had no respect for the Egyptians whom they regarded as orientalized Greek troublemakers, like Cleopatra, or faceless, incomprehensible natives, no better than slaves. Egypt was important to them because of its continuing ability to produce corn for export. They treated it accordingly and Egypt was sealed off from the normal processes of Roman politics and reserved for tourists. Like the Ptolemies and the Persians, the Roman Emperors played

the role of pharaoh, but with increasingly less conviction. They built shrines in the Egyptian style, notably at Philae, the holy island near the First Cataract. They finished and adorned the temples at Edfu and Dendera. But Egypt was never anything other than a Roman colony. In some respects it was a prosperous one. When the Romans came, says Strabo, Heliopolis was deserted, and once powerful places like Abydos and Thebes mere collections of hamlets. The Romans brought organization, transport and justice, and some technical improvements, such as locks and keys, the lathe, terracotta, pens, more glasswork and iron utensils and tools. They strengthened security, driving the Kushites from Napata to Meroe, where their quasi-Egyptian civilization, which we know as Meroëtic, lingered on into early Christian times. The Romans opened up the southern gold mines again, and ensured that navigation on the Nile was efficient and safe. Thebes was no longer a city, but it became a great tourist centre. Tourists admired the Ramasseum, which they called 'the Tomb of Osymandias', the Colossi of Memnon, one of which 'rang' when the sun's dawn rays hit it – until Septimus Severus repaired its crumbling mass – and the 'syringes', as they called the royal tombs, which stood open and empty.

Below: Philae, the sacred island much patronized by Ptolemaic kings and Roman emperors, was the last stronghold of the ancient religion to fall.

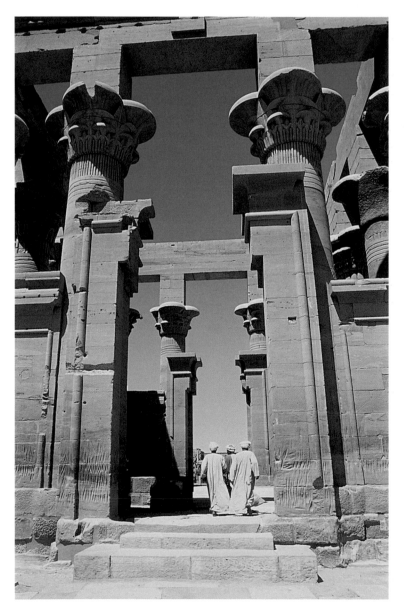

The Romans did not interfere with Egyptian burial customs, which now entered a final phase. During the Greek period, and especially in the Fayum, an area of intensive Greek-speaking settlement, the custom had grown of placing the mummies in coffins adorned with portraits of the dead. These early portraits were idealized. In Roman times they came to resemble true portraits, taken from life, with shading and highlights, in tempera or with beeswax as a medium. They are often of singular, moving beauty, among the finest portraits of the ancient world, but not in the true Egyptian tradition – to begin with, they are always full-frontal, whereas the Egyptians thought that the head, when created in two dimensions, must be seen in profile.

There were aspects of Egyptian religion which the Romans did not like. Wherever they conquered, they tolerated religious cults provided their devotees did not practise human sacrifice or black magic. The Egyptians were certainly guilty of the second sin in Roman eyes, and for a time the Roman

authorities tried to ban the Isis mother-and-child cult, which by this stage had replaced the related cult of Osiris as the chief form of popular devotion. But Isis proved too attractive, not least among Roman citizens themselves; the ban was relaxed and she and her temples spread throughout the empire (there was a famous one in Pompeii), thus preparing the way for Christian mariology. Indeed, the Romans did not succeed in stamping out any aspect of Egyptian religious magic. With the destruction of the Egyptian State and its political-religious institutions, magic gradually took over the whole of the system of popular Egyptian belief, as it had been threatening to do for a millennium. Of course magic texts had always been buried with the dead. It was characteristic of magic-theology that these texts were rated effective even if the dead and their relatives were illiterate. Another popular form of magic was a hieroglyphic healing text in stone, with a basin mounted above; when water was poured in the basin it absorbed the magic words of the text and was then used as a potion or balm by the sick (this later became a Christian practice and survives in the shape of 'Lourdes Water').

In the cosmopolitan atmosphere of the Roman Empire, Egyptian magic religion, originally so pure in its isolation, took on all kinds of weird hues. With its mild winter climate, easy living and its relaxed atmosphere of intellectual tolerance, Roman Egypt became a haven, like modern California, for abstruse religious cults, cranks and heterodox preachers and seers. Even before the coming of Christianity, it gave birth to innumerable gnostic sects, who claimed to possess secret knowledge about the infinite, and to hold intellectual communion with angels and other spirits. These movements were Greek in origin, but they seized eagerly on Egyptian hieroglyphic formulations, themselves marked 'Top Secret', to add to their stock of arcane material and this was further reinforced by Jewish lore, supplied by refugees from the persecuted sects of the Dead Sea region.

Alexandria was naturally the centre of these cults, many of which took on a Christian structure when the new religion won mass converts, and it cannot be denied that Alexandrine Christianity supplied much of the subtlety and dynamism of Christian theology in the heroic age of the Greek Fathers. But the gnostic cults bred an enormous quantity of mumbo-jumbo litanies and spells, compounded of neo-Platonic pseudo-science, fragments of Greek mystery hymns, material which later went to compose the Jewish cabbala, and a leavening of hieroglyphic texts in very corrupt forms. These texts were often incomprehensible, a positive virtue in the eyes of the superstitious tourists and travellers who bought them. They afforded a frugal living to the now impoverished Egyptian priests who produced them in enormous quantities. Slightly less reprehensible were the magic amulets or engraved stones, manufactured throughout late antiquity in Egypt. Their purpose was magical and their potency was believed to be increased by their ceremonial 'magicking' on the right day and hour, according to astrological calculations. But at least many of them were pretty, the best and most numerous being the scarab-beetle charms, based on the ancient Egyptian symbol for autogenous birth, a theological concept going back to the Heliopolitan theology of the very early dynastic period. Scarabs were made in hardstones and semiprecious stones of all kinds and found their way to every part of the Roman Empire, and even to India and China. They reflected the lingering skill of the Egyptian craftsmen, going back to the end of the fifth millennium BC, who were now ceasing to work in hardstone for buildings or statuary. In the twilight of Egyptian civilization, scarabs became the ubiquitous memorials of its unique gift for stylizing the forms of nature.

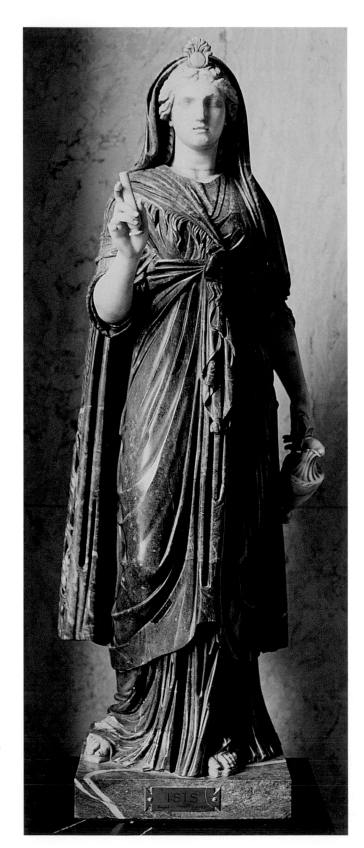

Right: *Isis wearing a Roman
toga. The Roman authorities
first tried to ban the Isis
mother-and-child cult,
but later adopted and
Romanized it.*

By the third century AD, there was very little left of the elements of the ancient Egyptian way of life. Emperors no longer bothered to pretend they were pharaohs; the temples were often in ruins; the clergy had lost their status and prestige and their learning was held in contempt. Nothing remained of the old Egyptian ruling class. The Nile Valley was swept by the fierce economic storms which ravaged the empire at this period. Christianity, originally confined to the Hellenized Jews of the Delta, now began to make rapid progress among the native Egyptians: the Coptic church dates its origin from AD 284, Diocletian's accession, for it attributed its eventual triumph to his fierce persecutions. In a few short decades, the creation of the Greek-based Coptic script, and its use to translate the New Testament (and later the Old) into the native Egyptian tongue, dealt a mortal blow to the hieroglyphs and the hieratic scripts. Demotic, once the language of commerce, had already been ousted by Greek. The ancient Egyptian religion transmuted itself into Christian practices in a number of ways, and the birth of monasticism in the desert east of the Nile enabled ancient religious institutions to survive in a new form. Many of the first cenobitic monks were probably Egyptian priests or their children. But Coptic religious art reveals few traces of earlier Egyptian forms, which seem to have died with the hieroglyphs. Tomb-religion was finished by about AD 300, the beginning of the first 'Christian century'. Mummification, embalming, linen bindings, painted wooden coffins, plaster death-masks and portraits, funerary stelae and stone memorials of all kinds disappeared together. The dead were buried without ceremony, wrapped in rags, just below the surface of the earth.

Christianity travelled rapidly up the Nile, leaving temple-worship, already moribund, stricken to death. At Thebes, where the cult of Imhotep and Amenhotep as healing deities had lingered on and where, at Deir el-Bahari, the upper levels of the great mortuary temples had been used as sanatoria for miracle-cures – as at Epidaurus – the old priests were chased away, and little Christian basilicas were set up in the courts and halls of the temples. Philae, the sacred island much patronized by Ptolemaic kings and Roman emperors, was the last stronghold of the ancient religion to fall. Nearby was another island, Bigga, with 365 offering tables, one for each day of the year. Only priests were allowed on Bigga: they went there once a month to put milk on each offering table. These cataract shrines resembled the Greek island of Delos – holy and neutral ground, supposedly respected by men of all races and religions. Savages came from the heart of Africa to worship Isis at Philae, and it welcomed pious men (and women) of all persuasions. Strabo says that, above the imposing main door of the Temple of Isis, there lived a huge, multi-coloured falcon, the living representative of Horus himself, which squawked phrases in the old Egyptian tongue. The Roman authorities respected the religious truce of Philae, even after the emperors became Christians. But towards the end of the fourth century, Christian fanatics, whipped on by their bishops, destroyed the Serapeum at Memphis and many other shrines which had hitherto survived. Even Philae was not spared, and the sacred falcon was slaughtered. Justinian gave the zealous his official approval and formally closed down the shrine, the last of its kind. The priests were dispersed and no more hieroglyphs were carved. Thus the last link with the ancient culture of Egypt was severed. All living contact was irrecoverably lost, especially after the Coptic tongue ceased to be spoken or written in the late Middle Ages. Happily, however, the dry sands and the protective climate of Egypt cocooned the relics of the past against the ravages of time and preserved them for the modern world to rediscover.

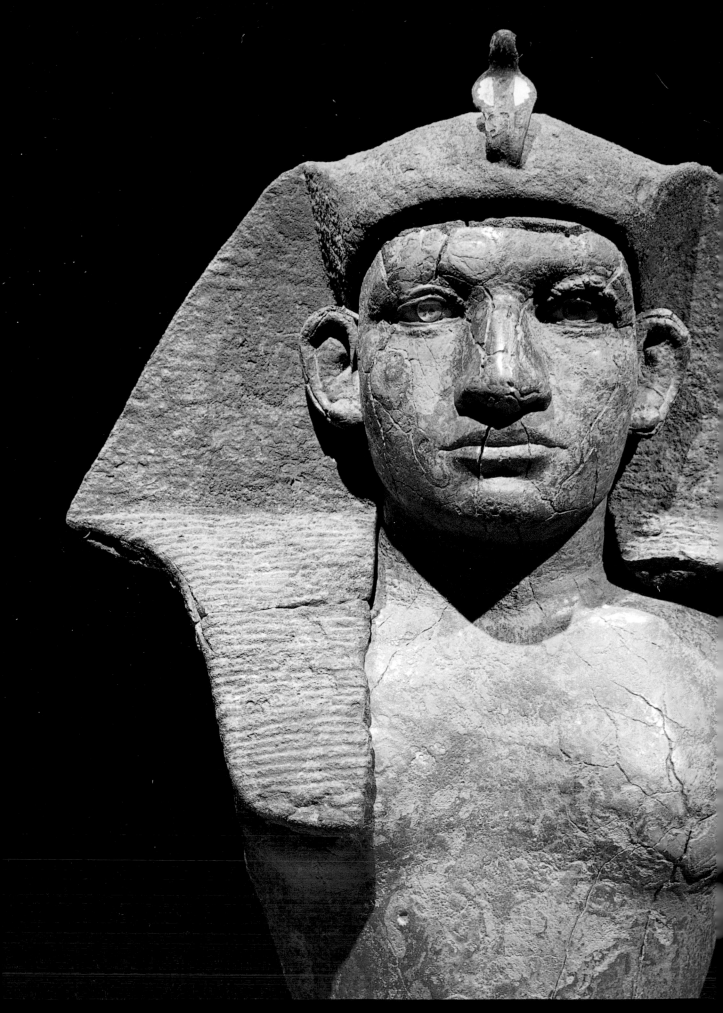

THE REDISCOVERY
OF THE PHARAOHS

B y the time the last hieroglyphs were carved on the island of
Philae towards the close of the fourth century AD, the
civilization of ancient Egypt was dead; it had already ceased
to function in the rest of the country. The inhabitants of the land seem
to have shown no interest in preserving or perpetuating it, or
protecting its survivals. Once they became Christian, the memory of
the past was effaced as shameful. A great chasm yawned between Late
Roman and Byzantine Egypt, and the Egypt of antiquity, which no one
had the knowledge to cross.

Above: *Pythagoras who possibly troubled to learn hieroglyphs.*

Opposite page: *The colonnaded entrance hall of the Temple of Isis on the island of Philae.*

Previous page: *Ammenemes III. He was the legendary builder of the Labyrinth, and the last great king of his dynasty, ruling for nearly fifty years.*

The chasm might not have been so wide had classical authors taken the trouble to explore Egyptian culture while it was still a living tradition, and while Egyptian scholars were still available to teach them. But so far as we know, no Greek or Latin historian or geographer troubled to learn hieroglyphics, with the possible exception of Pythagoras, and their ignorance of the language is reflected in the half-truths and fantasies they concocted about Egyptian history and culture. It is astonishing that Herodotus, at a time when Egypt was still a looming immensity on the cultural scene, and who appeared anxious to learn about it, did not even attempt to discover the principles of the hieroglyphic script, which would have made his many conversations with Egyptian priests so much more fruitful.

There seem to have been severe limits to the curiosity of these classical writers. The site in Egypt which most intrigued them was the temple of Ammenemes III near the Fayum, which they all called the Labyrinth. It is now utterly destroyed but throughout the classical age it stood in all its splendour. Numerous classical authors described it, and Herodotus and Strabo (at least) saw it with their own eyes. Yet the information they give us is not only useless but positively misleading. Herodotus said that it was a more astonishing piece of architecture than anything created by the Greeks, which surpassed even the Pyramids, but he erroneously states that it had 1,500 underground chambers, which he did not even bother to visit. Diodorus and Strabo claim it was built by 'Mendes' or 'Imandes', a name the more ignorant Greek or Latin travellers often attached to notable antiquities in Egypt. Diodorus and Pliny both say it was the model for the Minoan Labyrinth in Crete, Pliny adding that it had always been viewed by local Egyptians 'with extraordinary hatred' and that some of its doors 'caused a thunderous noise when opened'. Pomponius Mela asked his readers to believe its walls contained 1,000 houses and 12 palaces. Not until Sir Flinders Petrie excavated its pathetic debris in our own age were any dependable facts brought to light (*The Labyrinth, Geizeh and Mazguneh*, London 1912).

The case of the 'Labyrinth' is, alas, characteristic of the muddled view of Egypt which classical writers handed on. Earlier Greek writings, which may have contained more factual material, perished. Among classical authors who wrote about Egypt, usually briefly, were Theophrastus and Dioscorides, Abuleius and Pliny, Cicero and Plutarch. They had more to say about religion than any other aspect of Egyptian life

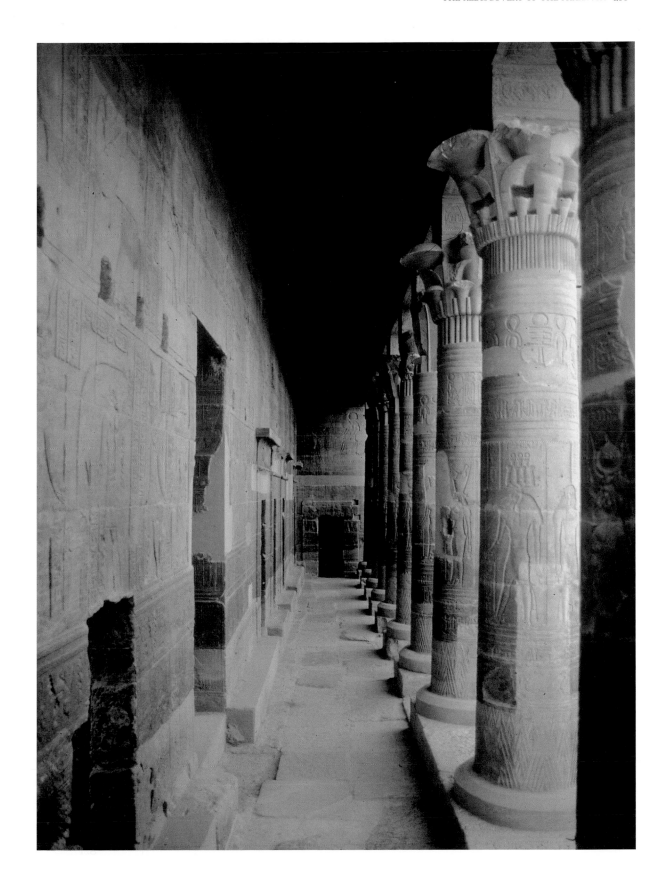

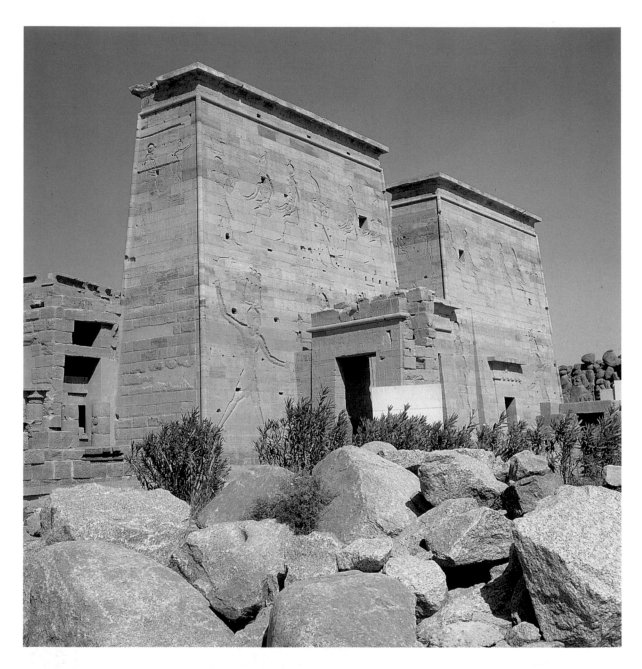

Above: *Temple of Isis on the island of Philae.*

and culture, and even there were often ill-informed. No one is likely to form a high opinion of the sagacity or industry of the classical intelligentsia from their handling of Egyptian topics. But ignorance is forgivable: less so is the view propagated by classical intellectuals, at a time when the truth was available to them, that the Egyptians possessed a *corpus* of secret knowledge, which the hieroglyphs enshrined.

The belief appears to have sprung from the undoubted fact that the Egyptians had a clearer eschatology than any other ancient people, and in particular offered the road to eternal life. Early in the first millennium BC knowledge of Egyptian religious teachings and of their salvation-texts, painted on coffin lids or written in the *Book of the Dead*, circulated very widely in the Mediterranean area. By comparison, the Greek

religion had little to offer on the far side of the grave. The attractiveness of the Egyptian thesis of bodily resurrection and immortality foreshadowed the far greater success of Christian universalism in the first millennium AD. Grave customs based on Egyptian models are found in south Italy, Sicily, Sardinia and North Africa. 'Mysteries' and arcane texts connected with these beliefs appealed also to Greek intellectuals and metaphysicians such as Pythagoras and later Plato. Herodotus constantly refers to knowledge he is not in a position to reveal. These authors knew that writing had come to the Greeks through the Phoenicians, and they believed that Phoenician writing was an adaptation of Egyptian scripts as in a sense it was. They thought the Egyptians were the first to use writing – they knew nothing of the earliest Mesopotamian scripts – and believed it to be a gift of the gods. In his *Philebus*, Plato says 'Theuth' invented writing for the Egyptians; he identified 'Theuth' in the *Phaedrus* with the god of wisdom (Thoth to the Egyptians, Hermes to the Greeks, Mercury to the Romans). The belief, echoed by Cicero, was that 'Mercurius … was said to have provided the Egyptians with laws and letters', and much other intellectual knowledge.

Unfortunately, classical writers also believed this knowledge was locked into the hieroglyphs in symbolic form. They thought the Egyptians used demotic for ordinary purposes, and hieroglyphs to protect their arcana. They did not know that hieroglyphic was a perfectly ordinary script of alphabetic signs and phonograms, plus pictograms. On the contrary, they imagined it was a deliberate code of allegorical symbols. Diodorus wrote: 'Their writing does not express the intended concept by means of syllables joined to one another, but through the significance of the objects which have been copied and by its figurative meaning which is learnt by heart'. In short, they read the script as though it were still at the stage of its pre-alphabetic and pictographic origins, and since (as such) it made no sense, they invested the pictograms with allegorical meaning. This fallacious and highly imaginative view of the Egyptian script should, of course, be seen against an international background of wildly competing religious and metaphysical cults, in which the Egyptians were the outstanding mass-purveyors of magical texts, charms and spells. Many interpretations of the hieroglyphs, written along these lines, were produced in classical times. All have perished, except the first century BC Chacremon, fragments of whose

Below: *Herodotus who constantly refers to knowledge he is not in a position to reveal.*

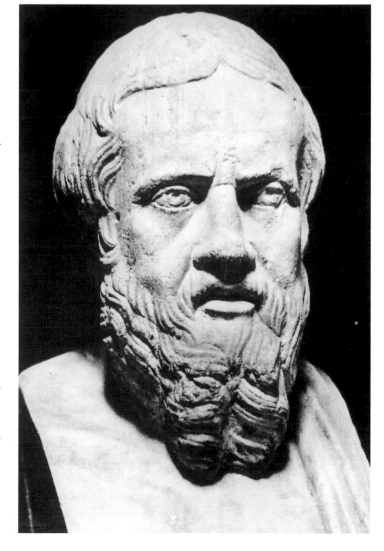

work survive in Byzantine texts, and the fourth century AD Horapollo, which has come down to us.

A further element in the confusion was the revival of Platonist metaphysics between about AD 150 and the age of Justinian. The Neoplatonists, like Plato himself, were really looking for metaphysical short-cuts to the tedious business of acquiring knowledge by exact observation and logical proof – what we call science. They thought they could fathom the secrets of the universe in their own minds provided they had the right key and methodology. Plotinus, the most influential of the Neoplatonists, believed and taught that the Egyptians had discovered (or perhaps been given by 'Theuth' or Hermes) this methodology, and put it into hieroglyphs. Thus they wrote with separate pictures of individual objects – not only letters expressing sounds and syllables – and these pictures did not directly portray the objects they apparently represented but penetrated to the very essence of things and encapsulated knowledge possessed only by the gods. The Egyptians had thus discovered 'pure' philosophy, uncomplicated and unclouded by the barrier of an alphabetic and phonetic language. This material was embodied in a collection called the *Corpus Hermeticum*, reputedly by 'Hermes Trismegistus' compiled in late antiquity but supposed, even then, to go back to prehistoric times.

The medieval Christians in the West knew nothing of these texts at first hand. Isadore of Seville, the great encyclopaedist of the Dark Ages, thought that Hermes was the Greek primeval lawgiver, the equivalent of Moses (some Christians believed Hermes to be much older). Medieval scholars knew Egypt only through the Bible, but much of Christian symbolism, open and secret, was ultimately derived from hieroglyphic forms, and there was a general assumption among scholars that a vast quantity of secret knowledge had disappeared with the collapse of the Roman Empire. In 1414, fragments of Ammianus, the last great historian of antiquity, turned up in a German monastery. He referred to the hieroglyphs on the obelisks brought to imperial Rome and summarized the view that throughout ancient times scholars had drawn on the ancient, god-given knowledge of the Egyptian seers and priests. His text was circulated in Florence and prepared the intelligentsia for the visit of Gemisto Plethon, the Byzantine scholar, in 1438, which began the revival of Plato, and in turn introduced the West to Neoplatonist ideas and books. A manuscript of the *Hieroglyphica*, by Horapollo, also came to light and was circulated in manuscript, along with various Hermetic writings. In the closing decades of the fifteenth century, these, and similar esoteric texts, were among the first to be printed at Florence, Venice and elsewhere, and enjoyed an enormous vogue among scholars.

Egyptian knowledge, or pseudo-knowledge, operated at a number of levels simultaneously. Until the seventeenth century, when an unbridgeable fissure opened between empirical science, on the one hand, and metaphysics, astrology and esoteric knowledge on the other, men saw natural philosophy as a *continuum*. Even as late a figure as Isaac Newton thought the fissure could be crossed. Hence in the sixteenth century, a great mathematician and physicist like John Dee studied the Hermetic texts with fervent hope; until the Thirty Years War, imperial Prague was both the leading scientific centre in Europe and the place where the Egyptian hieroglyphics and the secrets they were believed to contain were most eagerly scrutinized. At the level of allegoric art, compendia of hieroglyphic signs, real and invented, such as Colonna's *Hypnerotomachia Polifil* (2499) and Valeriano's *Hieroglyphica*, were used by court

artists throughout the sixteenth and seventeenth centuries. Masons and other secret societies such as the Rosicrucians used these signs and symbols also, especially in relation to the Roman obelisks; they were among the first to relate the esoteric knowledge of ancient Egypt to its physical memorials in stone, and to the mythology of Egyptian religion – Mozart's opera, *The Magic Flute*, with its famous aria 'Isis und Osiris', reflects this masonic tradition.

At an even lower level was vulgar astrology – associated with 'gypsies', texts on midwifery and magic books by 'Cleopatra' and other female magi – and the medicinal cult of 'mummy'. 'Mummy' is a word derived from the Persian word for bitumen, a form of pitch. This substance had been used for treating cuts, broken bones and even internal ailments in antiquity, and in the Dark and Middle Ages continued to be prescribed by Arab doctors, then regarded as the best. Where bitumen could not be had, some Arab doctors advised that the mummified flesh of ancient Egyptian corpses was a substitute: 'The mummy found in the hollows of corpses in Egypt', wrote one of them, Abdel Latif, 'differs only a little from natural mummy.' Thus, in Arab Egypt, a new dimension was added to traditional tomb-robbing. The Arabs themselves rarely used mummified flesh for curative purposes. But the vogue set in among the Frankish crusaders and continued in the West long after the crusades were forgotten. Arab touts and traders opened up the great death-pits of Memphis and other ancient cities, and mummy, in dry or powdered form, was exported to the West in considerable quantities. Its great vogue was in the sixteenth century, when wealthy and otherwise intelligent men would eat the most extraordinary things to cure themselves. François I of France carried around a supply of mummy in case he was injured out hunting. Apothecaries stocked it. John Sanderson, agent of the Turkey Company in Egypt just before the Spanish Armada, obtained 600 pounds of mummified flesh plus a whole body for the English market (mummy was fetching eight shillings a pound in Scotland in 1612). Most of this stuff had little or no bitumen in it; it was dried flesh, or worse. To supply the market, Arab traders and Jews, it was claimed, bought bodies from hospitals and prisons and treated them with asphalt; 'mummy' was also produced in Europe itself. The trade inspired one of Sir Thomas Browne's most famous remarks, in *Urn Burial*: 'Mummy is become merchandise, Mizraim cures wounds, and Pharaoh is sold for balsam.' There was a widespread belief that the mummified flesh of witches, elderly virgins and red-heads was the most effective. Mummy was still being prescribed in central Europe as late as the mid-nineteenth century.

The image of Egypt in the minds of western man throughout Renaissance and early modern times was so obscured by such myths and fantasies that it was hard even for the most sober scholar simply to look at the factual evidence. In the sixteenth century, popes and cardinals collected fragments of Egyptian sculpture along with Greek and Roman antiquities, but not in any systematic manner. In the seventeenth century the vogue attracted some notable French collectors, such as Richelieu. At a purely aesthetic level, Egyptian art was sometimes cherished and even comprehended, especially by Piranesi, who had a fellow-feeling for Egyptian artists and wrote a sympathetic treatise on the Egyptian style. Actual knowledge, however, was still impeded by Neoplatonic beliefs in the allegorical nature of the hieroglyphic script. The Jesuit philologist and antiquarian Athanasius Kircher published four impressive works on the hieroglyphs and other aspects of Egyptian knowledge in the seventeenth century. Curiously enough, he was one of the first Europeans to study Coptic, and grasped its relevance

Above: *In the seventeenth century the vogue of collecting fragments of Egyptian sculpture attracted some notable French collectors, such as Richelieu.*

to the spoken Egyptian language. But he approached the understanding of the hieroglyphs themselves along the false, philosophical, trail of Neoplatonism and hermetic and cabbalistic imagery, and so got nowhere; his 'translations' of texts from the Roman obelisks he studied bear no relation to their real meaning. Despite his immense learning he did not realize that the problem was philological and cryptographical and had nothing to do with philosophy as such.

The eventual rediscovery of Egypt was a product of French expansionism. Benoît de Maillet, French consul in Egypt from 1692 to 1708, visited some of the pyramids and tombs around Cairo, and presented Egypt to his superiors as a vast, undiscovered treasure-house of antiquity, awaiting systematic exploration. He recommended that public finance should be provided to allow experts in various artistic and scientific fields to make a deliberate and thorough survey of Egyptian antiquities. This scheme was not put into effect until France, baffled in central Europe, frustrated by the British in North America and India, began to examine the possibilities of a world empire based on the Mediterranean. In a way this was a reversion to her past. Under the Carolingians, the Franks had seen themselves as the natural successors to the Roman imperialists. They had taken the Maronite Christians of Syria and the Coptic Christians of Egypt under their protection. The Crusades, and the Frankish kingdom of Jerusalem – France *outre-mer* – had been an extension of this idea, and at various times Frenchmen had won kingdoms in Crete, Sicily and Italy.

In March 1798, the young Napoleon, having overrun most of Italy, revived the idea of a Frankish empire in the east. Alexandria and Cairo were to form the road to the conquest of British India and, at the same time, de Maillet's scheme for a French investigation of ancient Egypt was to be revived. Napoleon was authorized to conduct an expedition to seize Malta and Egypt, to cut a canal at Suez, and to mount a scientific survey of the Nile. He addressed a crowded meeting of the scientists of the Institut de France, and enlisted their support. 'This Europe of ours is tiny,' he said, 'only in the East, where 600 million human beings live, can we found great empires and carry through great revolutions.' In addition to 328 ships and 40,000 men, he took with him a Scientific and Artistic Commission of 175 *savants*, scientific instruments and a library of Egyptology.

Napoleon reached Egypt in July 1798 and was there for a little more than a year.

The cutting of the canal was postponed for over half a century, and the road to India was never pursued. But the country was mapped and surveyed; a French Institute was set up in Cairo; an expedition under General Desaix went up the Nile as far as Aswan, and discovered the islands of Philae and Elephantine; and the surviving antiquities of Egypt – many of which have since disappeared – were recorded. Travelling with Desaix was an illustrator of genius, Vivant Denon, a former diplomat who had become a passionate student of antiquities in Florence. He seized on this opportunity to record the Egyptian past at a time when it was still half-buried in the sands of time, untouched by archaeologist or modern tourist. His book, *Voyages dans la basse et la haute Egypte* (1801) was a curtain-raiser to the monumental record of the three-year scientific and archaeological expedition as a whole, *Description de l'Egypte*, with magnificent engravings based on his drawings, published between 1809 and 1813 in twenty-four sumptuous volumes. The plates astonished the civilized world and aroused an interest in ancient Egypt which has never since flagged.

Denon, founder of the Louvre and the first Director-General of the French state museums, also acquired much antique loot which fell into the hands of the British and was subsequently conveyed to the British Museum. It included a stele of black basalt, with a trilingual inscription, which the French army had found at Rosetta in the Nile Delta. The *Description* recorded many hieroglyphs but made no real contribution to their decipherment; Silvestre de Sacy, France's leading Orientalist, thought the problem 'scientifically insoluble'. The Rosetta Stone, of which the French had copies made from a wax cast, plainly provided a clue. It was in hieroglyphic, demotic and Greek. The Greek texts, in 54 lines, recorded the award by the high priests of special divine honours to King Ptolemy Epiphanes, in 196 BC. Manifestly, the demotic text, in thirty-two lines, and the hieroglyphic, in fourteen, said the same thing. In 1815 it was discovered that a fallen obelisk at Philae, found by W.J. Bankes and transported to his park at Kingston Lacey in Dorset, also had a double text in Greek and hieroglyphic. It was now apparent that hieroglyphic was not a philosophical ideas-code, but a script, albeit a strange one. It was also clear that groups of signs set in cartouches were the names of sovereigns. A British doctor and antiquarian, Thomas Young, using these texts and a papyrus, isolated two groups and showed that they stood for 'Ptolemy' and 'Cleopatra'. By a study of the demotic texts, he demonstrated that it was, in essence, a cursive form of the hieroglyphs, which was not a symbolic language at all but a form of alphabet. He set out his findings in the *Encyclopaedia Britannica* of 1819.

Three years later, a young French philologist, Jean-François Champollion, carried the decipherment a decisive stage further. He knew Arabic, Persian and Sanskrit, and had compiled a dictionary of Coptic. He rightly saw that Coptic was the successor-language to the spoken Egyptian which lay behind the demotic and possibly the hieroglyphic scripts. He was slow to accept Young's contention that hieroglyphics contained alphabetic signs, and was basically a phonographic script, but once he did so he was able to bring to bear expert knowledge and a trained methodology, where Young had worked mainly by intuition. In 1822 Champollion communicated his famous *Lettre à M. Dacier, secrétaire perpétuel de l'Académie royale des Inscriptions et Belles-Lettres, relative a l'alphabet des hieroglyphes phonétiques*, in which he gave to the learned world transcriptions of hieroglyphic cartouches of over 70 rulers of Egypt, from Alexander to Antoninus Pius. Later he published the deciphered texts of the cartouches of Ramesses and Tuthmosis, indicating that the hieroglyphs were phonetic

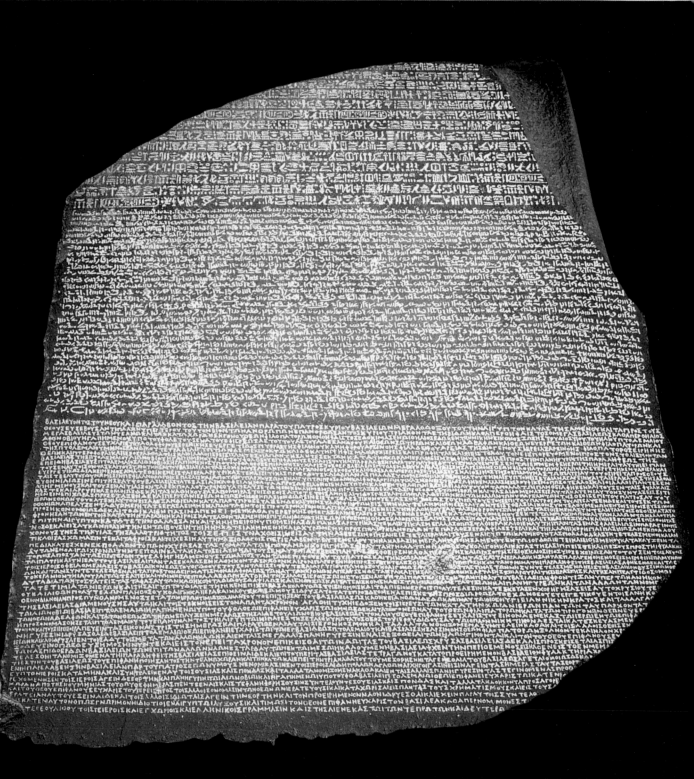

at a much earlier period; and in his *Précis du Système hieroglyphique* (1824) he was able to translate systematically whole phrases and sentences. Champollion subsequently led an expedition to Egypt and compiled a dictionary and grammar (published 1836–44). Thereafter, French, German and English scholars systematically elucidated hieroglyphic, hieratic and demotic signs and discovered the principles of the grammar and syntax beneath them. The historical development of the language, as well as the scripts, was traced, and its transformation into Coptic explored. Sir Alan Gardiner's *Egyptian Grammar* (latest edition 1976), which is both a primer and a dictionary, summarizes the work of more than 150 years.

The discovery of the principles of the hieroglyphs demolished at one stroke the pretentious monument of nonsense which had been erected on the basis of a false symbolism for nearly two millennia. It robbed the ancient Egyptians of their non-existent esoteric knowledge, but instead it allowed scholars to begin the serious reconstruction of their true history and way of life, and the interpretation of their religion and culture. A new generation of professional Egyptologists emerged, combining some knowledge of the language with the elementary skills of the archaeologist. From 1837 to 1841, Sir John Gardner Wilkinson published his *Manners and Customs of the Ancient Egyptians* in six volumes, and this was followed by the first serious historical survey, John Kenrick's *Ancient Egypt under the Pharaohs* (1850). In 1843–5, King Frederick Wilhelm IV of Prussia financed a state expedition in Egypt, under Richard Lepsius, which surveyed the Nile up to Khartoum, spent six months cataloguing the antiquities near Memphis and seven months at Thebes, and made the first systematic underground explorations. Its findings were published in the earliest scientific monographs of Egyptology, and in the comprehensive *Monuments of Egypt and Ethiopia* in twelve volumes, with 894 plates in folio, perhaps the bulkiest work of Egyptology ever published. Lepsius also brought back to Berlin 15,000 items which form the basis of its magnificent collection of Egyptian art. Hundreds of stone inscriptions and sculptures and thousands of papyri were transported to State and private collections in western and central Europe, and in North America.

During the first half of the nineteenth century, the looting of Egypt by wealthy antiquaries and museums was virtually uncontrolled. Of course these depredations must be placed in the perspective of vandalism going back millennia. The pharaohs themselves did not show the respect to their predecessors' monuments which the modern mind would expect. At his new city of Tanis, Ramesses II equipped the Temple of Amun with what might be described as a museum of Egyptian sculpture, taken from all over the country. Tanis itself was a cannibal creation, which utilized the fine Tura outer casing of the great pyramids, torn off without compunction, and granite pillars wherever they could be found; the old Temple of Ptah was pillaged. The Romans respected Egyptian antiquities, sometimes keeping them in repair, until the coming of compulsory Christianity round the turn of the fourth and fifth centuries, when the still-active temples were demolished. Thereafter, Byzantine and Coptic basilicas and monasteries were built from the stones of the pharaonic monuments, a practice followed in turn by the Arab moslems, who often sited their mosques within the ruined temple walls, or on their roofs.

Cumulatively, however, the worst damage by far was inflicted by generation after generation of Egyptian villagers, who stole millions of limestone blocks – painted low-reliefs and all – for burning in the limepits, and who consumed the ancient mud-brick

Opposite page: The Rosetta Stone, honouring Ptolemy Epiphanes in hieroglyphs, demotic and Greek. By translating the Greek text Champollion found the key to hieroglyphic writing.

palaces for agricultural fertilizer: thus the wealth of the pharaohs went back to the peasants who originally created it, and that was how enormous monuments like the Labyrinth of Ammenemes III, which astonished the ancients, literally vanished from the face of the earth.

But Egypt also numbered among its native inhabitants men whose hereditary profession was the pillaging of tombs. What was evidently a well-organized racket as long ago as the twelfth century BC – as the judicial records of the reign of Ramesses IX reveal – never really died out. Thieves were the first archaeologists. In Coptic times they shared tomb-passages and caves of the Theban hills with anchorites and hermits. They were still there when the Arabs and, later, the Turks came. Two eighteenth-century English visitors to Thebes, Richard Pococke in 1743 and James Bruce in 1769, both reported the existence of violent and very proprietary thieves in the necropolis area, and their descendants audaciously attacked the Napoleonic expedition at the turn

Right: *Giovanni-Battista Belzoni, the Italian circus strongman who became the greatest of the tomb-plunderers.*

of the century. Tomb robbery undoubtedly increased during the nineteenth century, when the market prices even of antiquities with no intrinsic value in metal or stones rose steadily. The last great outrages occurred during the 1870s: an investigation in 1881 showed that Kurna, near Luxor, had been a village of professional and hereditary thieves since the thirteenth century. Such thefts continue to this day, though on a reduced scale.

The European collectors and antiquity-traders who followed in the wake of Napoleon's expedition were not, like the thieves, primarily interested in jewellery and bullion, but in carved stone. In their efforts to find it they initially did far more damage. Giovanni-Battista Belzoni, the Italian circus strongman who became the greatest of the tomb-plunderers, actually smashed into sealed tombs with battering rams. Thus he stocked his exhibition in Piccadilly, the 'Egyptian Hall', and, working with the British consul-general Henry Salt, supplied the British Museum with many of its treasures, including the vast granite head of Ramesses II from the Ramesseum in Thebes, its dramatic statue of Sekhmet, the lion-headed fire-goddess, its statue of Sethos II, holding the shrine he built, and the black granite statue of Amenophis III, in perfect condition, one of a pair. Belzoni also removed the obelisk at Philae, now at Kingston Lacey in Dorsetshire, and discovered the tomb of Sethos I, whose great alabaster

Above: *The tomb of Sethos I was discovered by Giovanni-Battista Belzoni.*

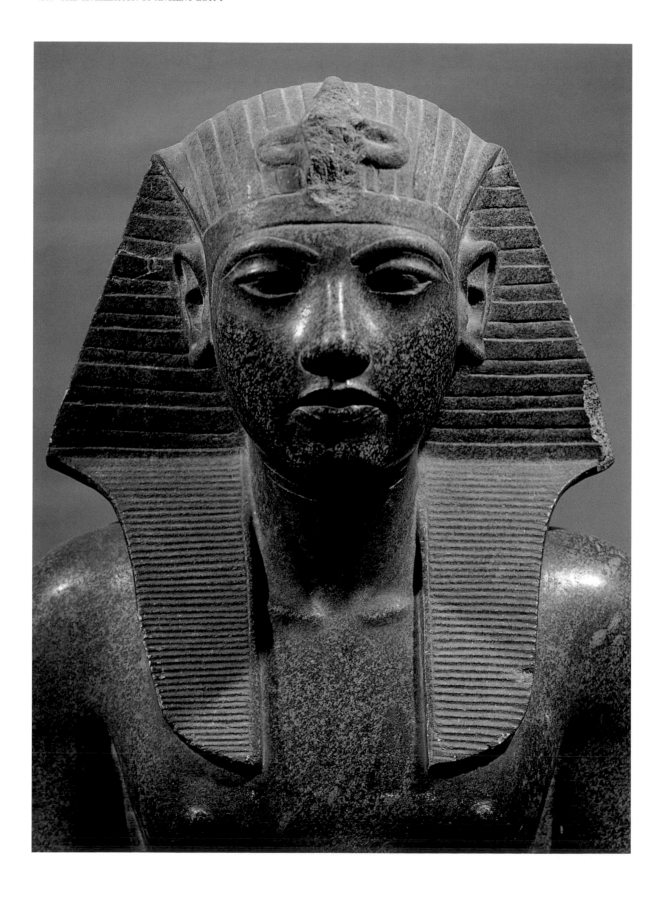

Thanks to Petrie and others, the age of looting and of archaeological brutalism is dead; the age of academic nationalism is dying. Teams of Egyptologists from all over the world now visit Egypt, working for long periods at sites in the Delta and alongside the Nile from Cairo to Aswan and beyond, and as a result of the co-ordinating work of the Egyptian Ministry of Antiquities, UNESCO and other international bodies, reports of discord and demarcation disputes are rare. The theft of antiquities from archaeological sites, and their illicit sale, continues on a large scale, though most important discoveries end up safely in reputable museums, chiefly in Egypt itself. The Cairo Museum is the greatest repository in the world of the art and artefacts of ancient Egypt. Insufficient funding means that its administration and display of the treasures leave much to be desired. Compared with most museums of its class, it is a piece of antiquity in itself, and some exhibits are still captioned with amateurish handwritten cards, dating from the 1920s or even before, reading: 'Object of Unknown Purpose, believed to be a Tool'. Nevertheless, a prolonged visit to the Cairo Museum is an unforgettable experience for anyone interested in ancient Egypt. Since 1975 it has been supplemented by a modern museum of antiquities in Luxor, a model of its kind, crowded with beautiful objects superbly displayed, and constantly added to by fresh discoveries.

Cheap modern transport now enables anyone who wishes to see the major antiquities *in situ* to do so for modest sums. In theory at least, it is possible to travel up Nile, from the ancient Nilometer in Cairo, to the High Dam at Aswan, in luxurious flat-bottomed Nile boats, living on board and visiting all the main riverside sites. There are now literally hundreds of boats, carrying up to 300 passengers, plying the Nile waters, accompanied by expert guides and lecturers. No touristic descent into the world of antiquity can be more pleasurable. Unfortunately, there are difficulties, some of them growing. The ancient Egyptians themselves treated their life-giving river with the greatest respect, knowing that the Nile was not easily trifled with, and had ways of dwarfing her human constrictors, however ingenious. A similar view was taken by all the various conquerors of Egypt, down to and including the British. While Britain had the power in Egypt, from the 1880s to the 1940s, many successful efforts were made to improve the Nile's performance as an irrigation system, and to diminish its periodic destructiveness. In particular, the British built a series of barrages, accompanied by lock systems, which controlled and regulated the flood seasons. These culminated at Aswan in a dam, built in 1898–1902, and thereafter twice heightened. The British, who had immense experience in India and the Middle East of devising river control systems in low-rainfall territories, had learned to respect the nature of rivers and not to risk draconian changes in their flow. However, when Egypt attained full control of its affairs, in the early 1950s, and especially after the arrival in power of President Gamel Abdul Nasser, other counsels prevailed.

President Nasser was an Egyptian revolutionary leader who in some ways resembled his distant predecessor, Akhenaten. He flouted ancient wisdom and defied the advice of the elders. Whereas Akhenaten was determined to carry through religious innovations of a shocking nature, Nasser believed he could transform the Egyptian economy in a single generation by making the Nile work harder. His idea was to construct a new, immensely high dam at Aswan, to create a vast artificial lake in Nubia, to be called after himself and to generate large quantities of electricity. The British never liked the scheme, which they calculated would inflict irreparable damage on the Nile

Opposite page: *Granite statue of Tutankhamun.*

valley and change the climate of Nubia for the worse. They refused to finance it, and the Americans followed suit in 1956. In reprisal, Nasser abruptly 'nationalized' the Suez Canal, hitherto controlled by an Anglo-French company, which had run it since its inception. He said he would use the tolls to pay for the dam. The result was the so-called Suez War of 1956–7, which did no good to anyone, least of all the Egyptians, though it demonstrated, not for the first or last time, the power of the Israeli armed forces.

As a result, the Soviet Union moved into Egypt on a large scale. They agreed to build Nasser's dam for him, and to create his artificial lake, and did so. The long-term results, which continue, were pretty well as the British had predicted. They have a direct bearing on our enjoyment and understanding of the civilization of ancient Egypt. The effect of the High Dam was to drown many ancient sites in the new lake. International projects rescued a few major artefacts, such as the Graeco-Roman buildings on the island of Philae and the Ramesside Colossi at Abu Simbel. But these projects, laudable though they were, merely served to obscure the enormity of the damage inflicted. Many sites, including partly explored ones – and still more waiting to be investigated – are now drowned for ever. Nor is this all. Despite the great heat of the Nubian climate, its dry air enabled Egyptians to work there, and tourists to visit it, in comparative comfort, besides protecting the antiquities, whether exposed or still buried. The High Dam has created a huge, straggling expanse of turbid water, which has increased not only the rainfall but, more importantly, the humidity of Upper Egypt, making the summer unbearable. Lake Nasser offers warm hospitality to the malaria-carrying mosquitoes and to the snails which spread the curse of Egypt, bilharzia. The rich sediment which the annual Nile flood once spread over all its fertile banks, and was the key to the country's agricultural prosperity for most of its history – as Herodotus noted, the Egyptian peasant had as a rule an easy time – now settles on the bottom of the lake. There has also been a sinister increase in salinity. It is claimed that, as a result of the High Dam, about two million acres of fertile land have been reclaimed or perennially irrigated. But other land is being lost in consequence. Deprived of natural fertilizer, the farmers use expensive chemicals which, among other noxious side effects, have produced a dramatic growth in weeds which not only disfigure the river but reduce its effectiveness and make much of the littoral unworkable.

Two further consequences have a direct effect on antiquities. First, vast quantities of water leak from the lake, drift downstream underground, and rise in unwanted places, especially some of the sites, undermining and destroying yet more precious relics of the past. Second, the level of the Nile has been lowered permanently, and in some years this has a dramatic effect on its navigability. Not enough water flows through the locks in some of the barrages to allow the larger Nile boats through, and it is now unusual for Nile tourists to be able to travel all the way from Cairo to Aswan. They have to be content with the Luxor-Aswan trip alone. This deprives them of the opportunity to visit in comfort many of the sites of the Old Kingdom and some of the Middle Kingdom. Visitors confined to the Luxor-Aswan stretch, though they may not be aware of it, are essentially visiting New Kingdom Egypt only. To these disadvantages are added new hazards, provoked by Nasser's revolutionary changes in Egyptian society. The rise of Islamic fundamentalism in Lower Egypt, especially Cairo, poses threats both to Egypt's past, and to our enjoyment of it. The fundamentalists care nothing for antiquities, which to them are relics of infidel paganism, better destroyed than

preserved. They are actively hostile to the tourist trade, which they see as responsible for many vicious infidel customs. So tourists visiting the sites are a prime target for their atrocities, and Egyptologists working on the sites are also at risk.

However, it must be added that these misfortunes, great though they are, are no worse than others endured by Egypt during her immensely long and chequered history. The Egyptians are a resilient people, and will survive to enjoy their wonderful, God-gifted country. Visitors will always come to see the incomparable artefacts of the past, and no hazards will prevent new generations of international scholars from continuing to expand our knowledge of them. It is such scholars – archaeologists, cartographers, numismatists, linguists, historical sociologists and the like – who have together succeeded, during the twentieth century, in placing ancient Egypt, for the first time, in its correct historical context, and in relating its development to that of other ancient civilizations. It is worth dwelling on this point briefly, and using it to draw some conclusions about the way Egypt illustrates the historical processes of antiquity. All civilized men in the second and first millennia BC thought that Egypt's was the oldest culture in the world. They attributed to the Egyptians the invention of writing and the foundations of all knowledge. This belief was handed on, by Greek and Roman writers, to the Renaissance and the early modern world. It was attested by calculations based on the regnal years given by Manetho which, added up, give an immensely long chronology to Egypt's early history. The opening up of the Nile valley to historical exploration seemed, at first, to confirm the 'long chronologies', and Egypt's primacy in civilized living. John Kenrick, the first true modern historian of Egypt, writing in 1850, claimed: 'There is no difficulty in fixing on the country from which Ancient History must begin. The monuments of Egypt, its records and its literature, surpass those of India and China by many centuries.' But even in Kenrick's day, historical research was beginning to bring the founding of the united kingdom of Egypt closer to our own times. Champollion estimated the date at 5867 BC; Mariette put it at 5004 BC; Lepsius brought it down to 3892 BC. In the lifetime of Flinders Petrie it was still possible for serious scholars to opt for comparatively long chronologies. Thus he dated unification and the beginning of the First Dynasty at 4777 BC, and placed the Old Kingdom entirely in the first half of the fourth millennium. Petrine datings are given occasionally in works on Egyptian history still in print. Breasted, however, gave the unification period at approximately 3400 BC, and Gardiner at 3100, plus or minus 150 years. The figure of 3100 BC is now generally accepted by scholars, though it is of course a mere approximation. On the basis of this anchor-figure, the Old Kingdom, the first great epoch of Egyptian civilization, is forced to float in the middle centuries of the third millennium BC, with the reign of Djoser calculated at about 2700 BC or slightly later.

While the maturing of Egyptian civilization was being placed by scholars at a later and later date, other scholars were opening up the archaeology of Mesopotamia, Palestine and Turkey, and dating the origins of city-civilization in western Asia further and further back. Between the wars, it was established that the city-civilization of Sumer and the emergence of the first script antedated the dynastic period in Egypt by several hundred years. We now know that this city-culture was itself based upon what Professor Gordon Childe called the 'neolithic revolution' of the late Stone Age, when men first began to farm and breed cattle, to build villages and to write, and the archaeology of the 1950s and 1960s suggests that the revolution first seems to have

taken place in the area around Jericho, and at Hacilar and Catal Huyuk in Turkey, though there is also evidence of very early settlements in Cyprus and in the southern Balkans. It is now fairly clear, therefore, that Egypt was not the cradle of civilization, at any rate in this sense, and that it did not begin to catch up with the economically and culturally progressive areas of western Asia until towards the end of the fourth millennium BC.

Thereafter, however, Egypt's progress was rapid, and the actual take-off into a mature civilization before and during the reign of Djoser seems to have been accomplished over a mere fifty years or so. Then, within less than a century, Egyptians were building the Great Pyramid. Throughout the rest of the third millennium, and for four-fifths of the second, Egypt was the greatest and most civilized power in the world, surviving two internal breakdowns and a foreign occupation, and maintaining the matrix of its religion, culture and political system with astonishing continuity. Such stability over so long a period is unique in human history, and alone justifies the study of Egypt's past.

It seems to me that there are two principal aspects of this story worth pondering. Egypt was not the first civilization, but it was the first to emerge as a national, as opposed to a city, culture. Egypt was not only the first State, it was the first country: it was the product not only of human ingenuity but of racial grouping and, above all, of a felicitous geography. Therein lay Egypt's initial strength. But the durability of the State which thus evolved was ensured by the overwhelming simplicity and power of its central institution, the theocratic monarchy. Egyptian art, as we have seen, is a struggle to produce absolute clarity by the ordering and simplifying of forms. The supreme masterpiece of Egyptian art was not built of stone or carved in granite or painted on papyrus: it was the throne itself, uniting the fundamental philosophy of *maat* and the institutions of religion and politics, in one stupendous monolith. All power and, to begin with, all personality and all rights whatever, rested in the king. Let no one say that dictatorship cannot work in human societies: the throne of Egypt, legitimized as it was not by any doctrine of human selection but solely by its own divine sanction, lasted for 3,000 years. And it was the principal reason why the civilization of Egypt produced such riches and lasted so long, for it provided a framework of absolute certitude.

But the second point we should ponder is a necessary corrective: clarity and certitude are not enough. There was no freedom in the Egyptian State, and in the end its absence was fatal. In the course of the second millennium, Egyptians secured for themselves individual rights in eternity – as opposed to those subsumed in the divine person of the pharaoh – but they never won any rights on earth. Their attachment to *maat*, to the principle of order, hierarchy and submission, inhibited them. They were not only disciplined from above: in their hatred and fear of disorder, and of the anarchy they believed lay hidden in their own personalities, they imposed on themselves a degree of self-discipline which no culture can indefinitely survive. They refused to admit their individuality as earthlings and killed their own creative spirit. They sought safety, justice and spiritual equality in the collective and so forced themselves to move at its glacial pace. Inevitably, they fell behind in the human Olympiad. Egypt was a great Bronze Age power but it was already technically backward even during the glory of its Nineteenth Dynasty, and by the middle of the Twentieth it was a culture in rapid and manifest decline. Its ruling class might have restored its old energy and innovatory spirit

if, during the first millennium, it had made possible the emergence of the fierce, creative individualism which, in the cities of Phoenicia and Greece, brought into existence new forms of commercial enterprise and a middle class of traders and intellectuals. Such a new class for the first time offered a dynamic alternative to the repressive division of the archaic class structure – into the rulers and the ruled. Egypt might have taken this way. Instead, it retreated into its past and reinforced the regulated collectivism of its society. Only the Greek merchant communities were granted the freedom to conduct their own affairs, and in time it was they, the minorities, who took over the country. Egypt finally entered the Iron Age not by its own efforts and as an independent state but as a helpless and leaderless colony. It is a sombre tale. But all civilizations are born to die. Those fortunate enough to live in one should study the past to learn from its errors, and with the wisdom of hindsight strive to keep at bay for a while the drifting sands of decay.

Below: *Sarcophagus and tomb of Tutankhamun.*

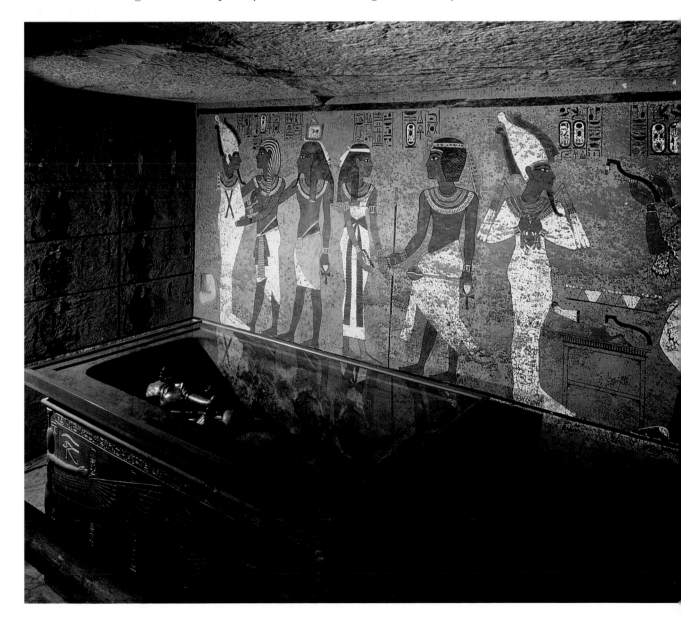

General

The best general introduction to Egyptian history and culture is Sir Alan Gardiner: *Egypt of the Pharaohs* (Oxford, reprinted 1974). Authoritative articles on Egyptian history, with comprehensive bibliographies, are published in the Third Edition of the *Cambridge Ancient History* (Cambridge 1971–). Excellent brief summaries are: *A General Introductory Guide to the Egyptian Collections in the British Museum* (London 1975), and P.R.S. Moorley: *Ancient Egypt* (Ashmolean Museum, Oxford 1970). Other good general surveys are Margaret A. Murray: *The Splendour that was Egypt* (London, reprinted 1972), John Ruffle: *Heritage of the Pharaohs: an introduction to Egyptian Archaeology* (Oxford 1977), and Cyril Aldred: *The Egyptians* (London 1961). J.R. Harris (ed.): *The Legacy of Egypt* (Oxford 2nd ed., 1971) contains valuable essays by experts on aspects of Egyptian history and culture. The *Journal of Egyptian Archaeology*, published annually by the Egypt Exploration Society in London, contains the results of recent research and reviews all material in the field. For terms, G. Posener and others: *A Dictionary of Egyptian Civilization* (London 1962), B.J. Kemp: *Ancient Egypt: Anatomy of Civilisation* (London 1989), T.H.H. James: *Egypt: The Living Past* (London 1992), J. Vercoutter (ed.): *L'Egypte et la vallée du Nil*. Vol 1: *Des origines à la fin de l'Ancien Empire: 12,000-2,000 av*. By J. Vercoutter: Vol 2: *De la fin de l'Ancien Empire à la fin du Nouvel Empire* by C. Vandersleyen (Paris 1992 and 1994), N.C. Grimal (trans.): *A History of Ancient Egypt* (Oxford 1992).

History

J.A. Wilson: *The Burden of Egypt* (Chicago 1951) is a brilliant and imaginative interpretation of dynastic history. For the origins: William C. Hayes, edited by Keith C. Seele: *Most Ancient Egypt* (Chicago 1965); W.B. Emery: *Archaic Egypt* (London 1961). For the Old Kingdom, Cyril Aldred: *Egypt to the end of the Old Kingdom* (London 1965). For the First Intermediate Period, William A. Ward: *Egypt and the East Mediterranean World, 2200-1900 BC* (Beirut 1971). For the Middle Kingdom, H.E. Winlock: *The Rise and Fall of the Middle Kingdom in Thebes* (New York 1947). For the Second Intermediate Period, John Van Seters: *The Hyksos, a New Investigation* (Yale 1966). For the New Kingdom, G. Steindorff and K.C. Seele: *When Egypt Ruled the East* (Chicago 1963), E. Riefstahl: *Thebes in the Time of Amenhotep III* (Oklahoma 1964), Cyril Aldred: *Akhenaten, Pharaoh of Egypt: a new study* (London 1968), F.J. Giles: *Ikhnaton, Legend and History* (London 1970). For later history: K.A. Kitchen: *The Third Intermediate Period in Egypt* (Warminster 1971), H.I. Bell: *Egypt from Alexander the Great to the Arab Conquest* (Oxford 1948), A.J. Spencer: *Early Egypt: the rise of Civilisation in the Nile Valley* (London 1992).

Social, Political and Economic Structure

Herman Kees: *Ancient Egypt, a Cultural Topography* (ed. by T.G.H. James, London 1961) is the most valuable survey of ancient Egypt on a geographical basis. Pierre Montet: *Everyday Life in Ancient Egypt* (trans., London 1958) deals with the Ramesside period. H.E. Winlock: *Models of Daily Life in Ancient Egypt* (New York 1958) surveys tomb-models. On technology, science and medicine: A. Lucas (edited by H.R. Harris): *Ancient Egyptian Materials and Industries* (London 4th ed., 1962); S. Clarke and R. Engelbach: *Ancient Egyptian Masonry: the Building Craft* (Oxford 1930); C. Singer, E.J. Holmyard and A.R. Hall (eds.): *A History of Technology*, i-ii (Oxford 1954–6); F.R. Hodson (ed.) *The Place of Astronomy in the Ancient World* (London 1974); R.A. Parker: *Calendars of Ancient Egypt* (Chicago 1950); P. Ghalioungui: *Magic and Medical Science in Ancient Egypt* (London 1963); J.B. de C.M. Saunders: *The Transition from Ancient Egyptian to Greek Medicine* (Kansas 1963); on the place of women, see Stefan Wenig: *The Woman in Egyptian Art* (trans., Leipzig 1969), and on comparative

economic and political structures, Jacquetta Hawkes: *The First Great Civilizations* (London 1973); for the peasants, Dorothy J. Crawford: *Kerkeosivis: an Egyptian Village in the Ptolemaic Period* (Cambridge 1971). B.G. Trigger et al: *Ancient Egypt: a Social History* (Cambridge 1985).

Religion and Intellectual Life

Siegfried Morenz: *Egyptian Religion* (trans., London 1973) is the best general survey; J. Gwyn Griffiths: *The Origins of Osiris* (Berlin 1966); R.O. Faulkner (trans.): *The Ancient Egyptian Pyramid Texts* (Oxford 1969); E.H. Sugden: *Israel's Debt to Egypt* (London 1928); E.R. Evans-Pritchard: *Theories of Primitive Religion* (Oxford 1965); H. and H.A. Frankfort (eds.): *The Intellectual Adventure of Ancient Man* (Chicago 1946). E. Hornung (trans.): *Conceptions of God in Ancient Egypt: the One and the Many* (Ithaca and London 1982).

Art and Architecture

The most important study of Egyptian art is Heinrich Schäfer: *Principles of Egyptian Art*, edited with epilogue by Emma Brunner-Traut and translated by John Baines (Oxford, third revised edition, 1986); a further important guide to the theory is E. Iverson: *Canon and Proportion in Egyptian Art* (London 1955). Also of prime importance are the publications of W. Stevenson Smith: *A History of Egyptian Sculpture and Painting in the Old Kingdom* (Harvard 1946), *The Art and Architecture of Ancient Egypt* (London 1958) and *Interconnections in the Ancient Near East: a study of the relationships between the arts of Egypt, the Aegean and Western Asia* (Yale 1965). For Sakkara, see Jean-Philippe Lauer: *Sakkara: the Royal Cemetery of Memphis* (London 1976); for the pyramids, I.E.S. Edwards: *The Pyramids of Egypt* (London 1947) and A. Fakhry: *The Pyramids* (Chicago 1961); for painting, Nina M. de Garis Davies and A.H. Gardiner: *Ancient Egyptian Paintings* (3 vols., Chicago 1936). G. Robbins: *Egyptian Painting and Relief* (Aylesbury 1986), D. Arnold: *Building in Egypt: Pharaonic Stone Masonry* (Oxford 1991).

Language, Literature and Texts

Alan Gardiner: *Egyptian Grammar, an Introduction to the Study of Hieroglyphs* (Oxford 1976); Gardiner also translated and edited a large number of texts. There is a prime collection of texts in J.H. Breasted: *Ancient Records of Egypt* (5 vols., reissued New York 1962). Most of the more significant Egyptian texts, along with contemporary texts from Western Asia, are in James B. Pritchard (ed.): *Ancient Near Eastern Texts Relating to the New Testament* (Princeton, 3rd ed., 1969). Also valuable are: W.K. Simpson, R.O. Faulkner and E. Wente: *The Literature of Ancient Egypt* (Yale 1923), William Kelly Simpson (ed.): *The Literature of Ancient Egypt* (London 1973), M. Lichtheim: *Ancient Egyptian Literature* (London 1975) and J. Cerny: *Paper and Books in Ancient Egypt* (London 1952). W.V. Davies: *Egyptian Hieroglyphs* (London 1982) H.G. Fischer: *L'Écriture et l'art de l'Egypte ancienne* (Paris 1986).

History of Egyptology

W.R. Dawson: *Who was Who in Egyptology* (London, 2nd ed., 1972); J.C. Herold: *Buonaparte in Egypt* (London 1963); E. Iverson: *The Myth of Egypt and its Hieroglyphs in European Tradition* (Copenhagen 1961); Sir Wallis Budge: *The Rosetta Stone in the British Museum* (London 1929); Sir Flinders Petrie: *Seventy Years of Archaeology* (London 1931); J.D. Wortham: *The Genesis of British Egyptology, 1549-1906* (London 1971); J.A. Wilson: *Signs and Wonders Upon Pharaoh* (Chicago 1964); C.W. Ceram: *Gods, Graves and Scholars* (London, reissued 1967); F. Gladstone Bratton: *A History of Egyptian Archaeology* (London 1967); Brian M. Fagan: *The Rape of the Nile: Tomb Robbers, Tourists and Archaeologists in Egypt* (London 1977) P. Clayton: *The Rediscovery of Egypt* (London 1982) T.G.H. James (ed): *Excavating in Egypt* (London 1982).